NASHVILLE
THEN & NOW

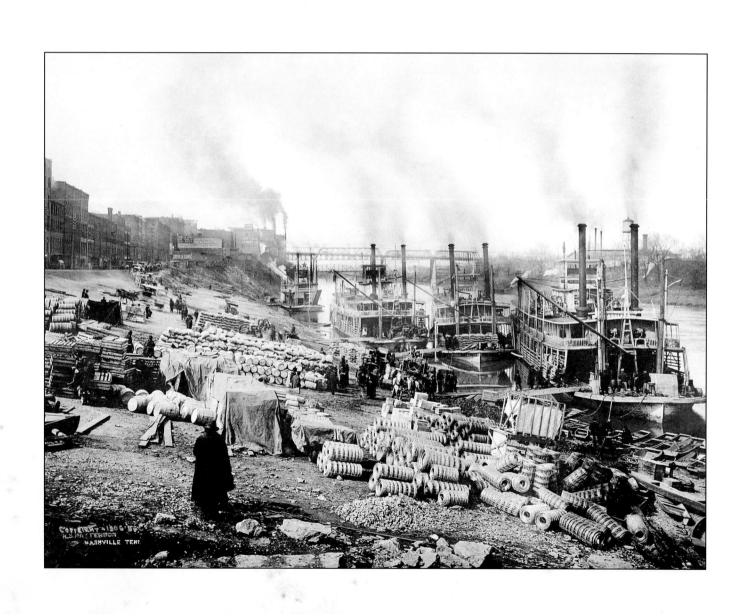

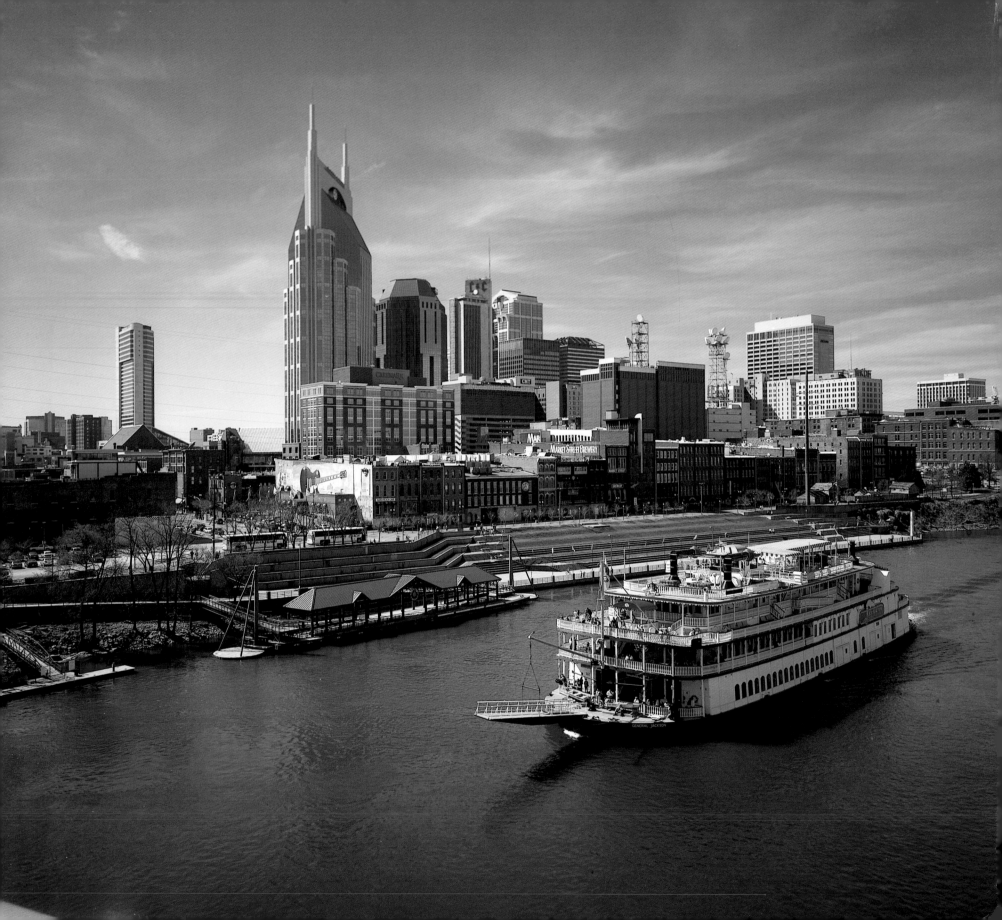

NASHVILLE
THEN & NOW

KARINA MCDANIEL

THUNDER BAY
P·R·E·S·S

San Diego, California

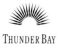

Thunder Bay Press
An imprint of the Advantage Publishers Group
5880 Oberlin Drive, San Diego, CA 92121-4794
www.thunderbaybooks.com

Produced by PRC Publishing
The Chrysalis Building
Bramley Road, London W10 6SP, United Kingdom

An imprint of Chrysalis Books Group plc

ISBN-13: 978-1-59223-503-2
ISBN-10: 1-59223-503-4

Printed and bound in China

1 2 3 4 5 09 08 07 06 05

Acknowledgments:

For their invaluable assistance I extend a special thanks to Carol Roberts, Amber Barfield, Darla Brock,
Marylin Hughes, Susan Gordon, Chaddra Moore, and Stewart Southard with the Tennessee State Library
and Archives. I would also like to thank the following for providing information and photographs for this
book: Margaret A. Davitt for Woodlawn, Maggie Jackson with Cheekwood, Rob DeHart with Travellers
Rest Plantation and Museum, David Underwood with Music City Motorplex, Debbie Cox with the
Metropolitan Nashville-Davidson County Archives, and Ann Toplovich with the Tennessee Historical
Society.

INTRODUCTION

Nashville, located in the middle of Tennessee on the bluffs of the Cumberland River, is a city with a rich history and culture. The first colonists to visit what would become Nashville were French-Canadian fur trappers who discovered a salt lick north of the bluffs on a river the Indians called the Warioto. Jean du Charleville, a French-Canadian fur trader from New Orleans, established a trading post at the salt lick around 1710, using a deserted Shawnee fort as a warehouse. The French tried to establish a foothold in the western territory, but hunters from British colonies in the east soon paved the way for settlers from Virginia and the Carolinas to populate the land west of the Allegheny Mountains.

The first permanent settlement was established in 1779 when two groups of pioneers arrived in the area, which was then part of North Carolina. One group of mostly men and boys, led by Captain James Robertson, came overland with livestock through the Cumberland Gap, crossing the frozen Cumberland River on Christmas Day. The second group, mostly women and children, came in a flotilla of flatboats under the leadership of Colonel John Donelson, arriving on April 24, 1780, after a 1,100-mile voyage. Originally named Fort Nashborough in honor of General Francis Nash, a Revolutionary War hero, the community soon grew from a frontier outpost to a town. In 1783 the State of North Carolina created Davidson County and, one year later, Fort Nashborough became the city of Nashville.

The city developed quickly—in 1785 the first school, Davidson Academy, was chartered, and by 1787 real estate taxes were being collected and city laws passed, which required someone to enforce them. A young, ambitious lawyer from North Carolina arrived: Andrew Jackson was hired to serve as Nashville's first public prosecutor.

In 1796 Tennessee became the sixteenth state to be admitted into the Union. The town on the frontier soon became a city. Wooden structures were torn down and replaced with brick buildings, industries developed, sawmills and factories sprang up, and merchants, educators, farmers, doctors, bankers, and craftsmen established businesses. The first steamboat arrived and tied up at a shallow slope of land on Front Street in 1817. More steamboats followed and with them came the hardware and goods needed by the factories and merchants. These steamboats also brought more commerce and more people. Saloons, hotels, barbershops, and gas streetlamps lined the streets. Churches and schools were built in new neighborhoods as the city grew outward. By 1843 Nashville had become the permanent capital of Tennessee.

The dark shadow of slavery hung over Nashville, as it did in other cities in the South. When the question of slavery led to the Civil War, Nashville was spared the fate of Atlanta. Occupation early in the war made Nashville an unwitting federal city in 1862. The battle of Nashville and the Union occupation cost lives on both sides and created deep resentment that lasted well into the next century.

In the years after the war, Nashville grew and prospered. The people of the city took great pride in their many schools and colleges, calling it "the Athens of the South." Steamboats gave way to railcars, and Nashville was connected to more cities, which increased trade. The city eventually became a hub of commerce connected by air, highways, railroads, and the river.

The years following World War II saw growth and prosperity that continues today. Nashville enjoys a diversified economy of banking, higher education, publishing, printing, tourism, music, and health care. The Vanderbilt University Medical Center ranks among the top medical centers in the country, and Hospital Corporation of America, founded in 1968 by businessman Jack Massey and Dr. Thomas Frist Sr. and his son, Dr. Thomas Frist Jr., is headquartered in Nashville. With a population of over 600,000, metropolitan Nashville is the largest of Tennessee's cities.

Nashville is known today as Music City. Even before that term was used, a group of newly emancipated black college students from Fisk University was traveling the world after the Civil War, singing songs of their ancestors. Some would say the Fisk Jubilee Singers were the first "Nashville sound." On an average day in Nashville, one can hear classical, blues, bluegrass, gospel, jazz, rock, and country music all performed live. Nashville's recording facilities, record producers, and musicians are legendary.

In 1925 the National Life and Accident Insurance Company formed a new radio station, WSM. The letters represented the company logo, "We Shield Millions." A weekly broadcast of hillbilly music featuring an old-time fiddler, Uncle Jimmy Thompson, became a local hit. One evening the announcer, George D. Hay, who called himself "the solemn old judge," announced after a network broadcast of the Metropolitan Opera that the listeners had just heard some "grand opera." Now they were about to hear some "grand ole opry." The Grand Ole Opry is still going strong in a modern theater in the Opryland Hotel complex. Thousands of country music fans visit Nashville weekly, for Friday night and traditional Saturday night performances of the Opry, the longest continuous radio program in the country. With the introduction of satellite radio, the Opry is now heard nationwide.

It's not just country in Music City, though. The Nashville Symphony Orchestra is moving into a grand performance hall in 2006, and members of the symphony have contributed much to the "Nashville sound" in recordings produced on Music Row.

This book looks at the history of Nashville and compares historic images with modern scenes to show how the city has developed over the years. Nashville is a work in progress, though. Construction cranes emerge and disappear, creating steel, concrete, and glass towers that transform the skyline, seemingly overnight. Nashville has matured into a city that appreciates its past while looking to its future.

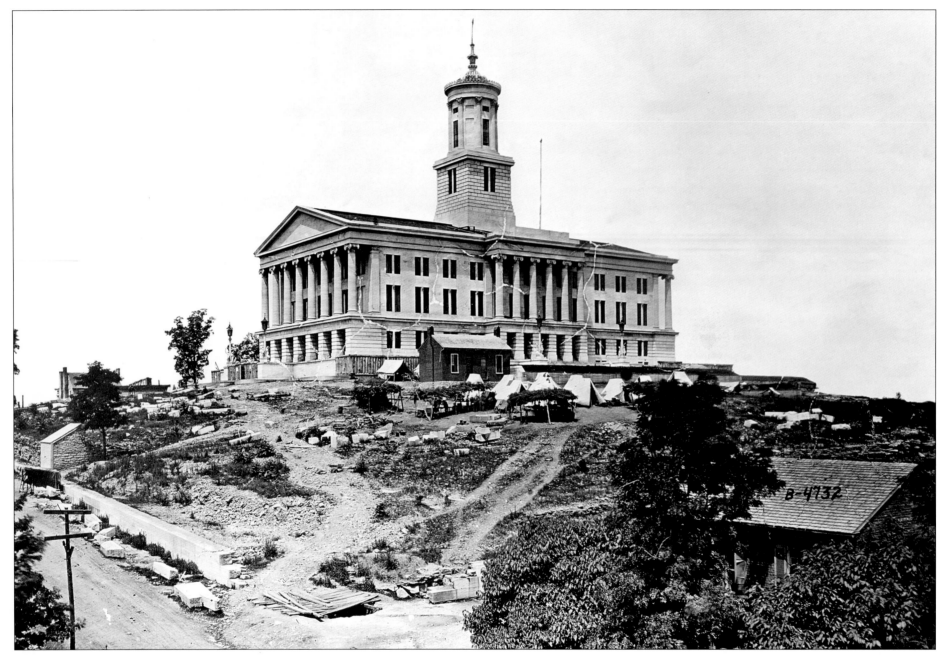

Nashville was chosen as the permanent capital of Tennessee in 1843 after its citizens raised $30,000 to purchase Campbell's Hill for the state office. Before then, the capital was at various times located in Murfreesboro, Knoxville, Kingston, and Nashville. Work began in 1845 when a building site was selected and the state legislature appointed Philadelphia architect William Strickland to design and oversee construction of the Greek Revival building.

The cornerstone was laid on July 4 of that same year. Strickland died on April 7, 1854, before the building was completed. His funeral was held in the Hall of Representatives and he was entombed in the north portico. Work continued under the guidance of his son, W. F. Strickland, until 1857 and was completed by Harvey M. Akeroyd in 1859. This picture, taken in 1862 by George Barnard, shows Union troops camped on the grounds.

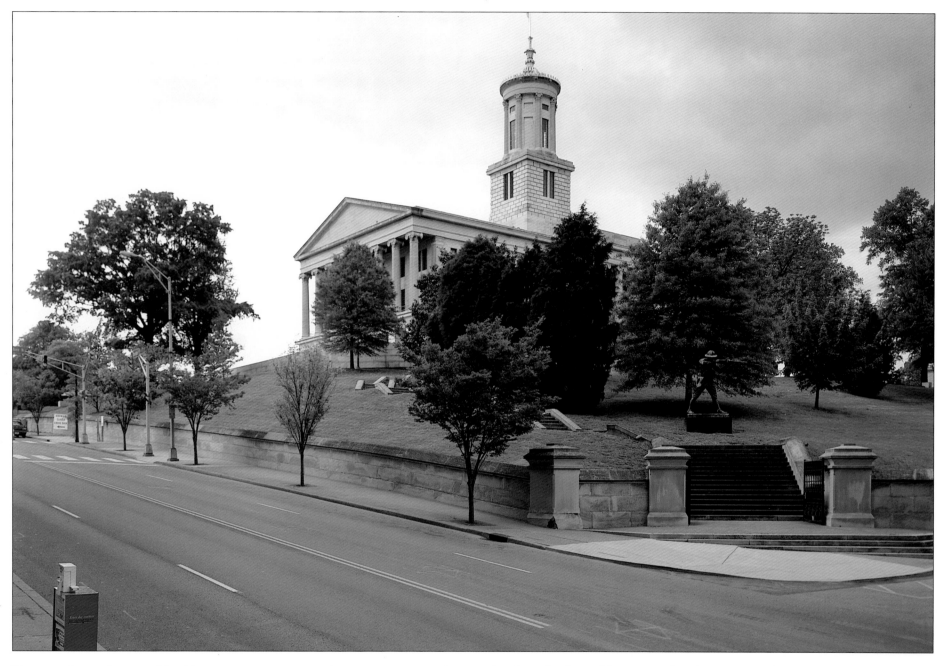

Tennessee's stately capitol building remains a commanding presence over the city, and Campbell's Hill is now called Capitol Hill. Within the walls of the state capitol are the offices of the governor and the secretary of state, the senate chambers, and the house of representatives. Portraits of all Tennessee's governors line the walls of the public spaces. Galleries provide seating in both chambers for the public to view legislative proceedings. Murals depicting Tennessee's early history adorn the walls of the governor's outer office. The governor's office is on the east side of the capitol, overlooking a bronze statue of Andrew Jackson on horseback. Recent renovations have restored the interior to its original elegance.

Park Place was a short section of High Street, later named Sixth Avenue, which ran north from Broadway and bordered the east side of the capitol. The wall on the left of this circa 1900 photograph is the east retaining wall of the capitol grounds. A large gated entrance to the capitol can be seen just behind the pedestrian. Before the turn of the twentieth century High Street was a desirable address. These stately two- and three-story houses had indoor plumbing, and by 1890 many of the homes had electric lights and coal-fired steam heat. When electric streetcars were introduced in 1890, the population of downtown began a migration to what were called the "streetcar suburbs."

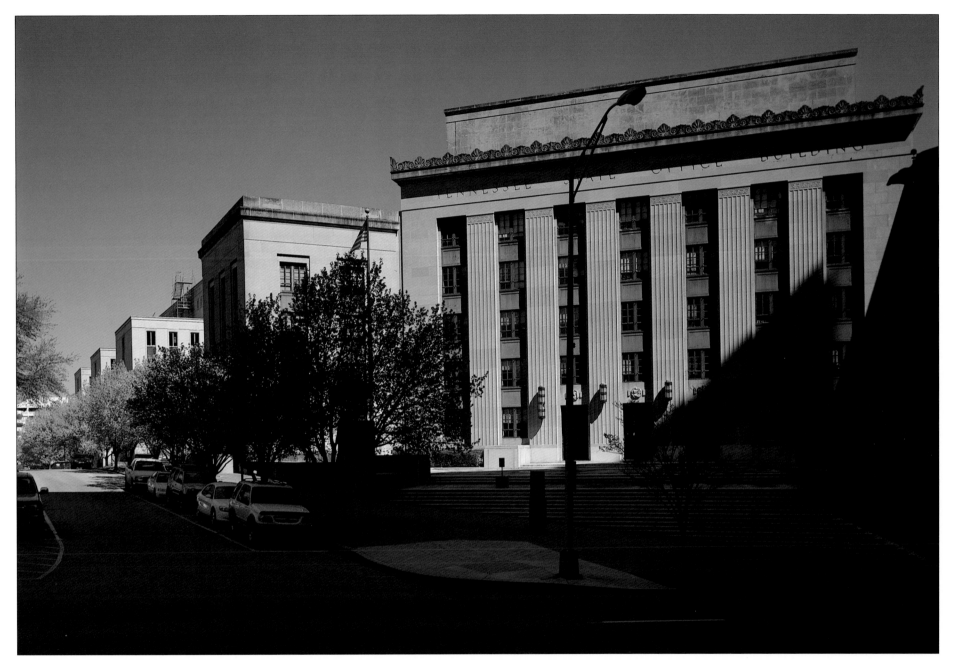

The state bought the land along Park Place in the 1930s and demolished the houses, which by then were in a run-down condition. In 1939 the first of two government buildings went up on the site. The State Office Building was completed in 1939 and was later renamed the John Sevier Building in honor of Tennessee's first governor. In 1954 the Cordell Hull Building was added. This building was named for U.S. secretary of state and Nobel laureate Cordell Hull. Park Place is no longer a named street; it is a connector to a large parking lot for the capitol and state employees.

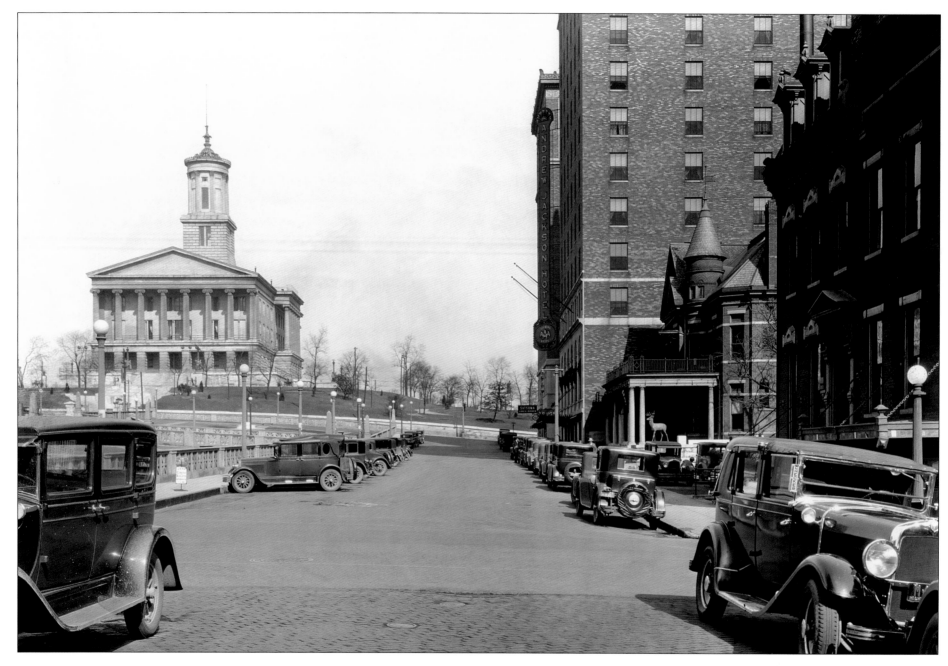

The Andrew Jackson Hotel stood on the southeast corner of Sixth Avenue North and Deaderick Street, in the shadow of the state capitol, from September 29, 1925, until it was demolished on June 13, 1971. With 350 rooms, the twelve-floor Andrew Jackson building was the largest hotel in Tennessee. One reporter wrote that the hotel was equipped "with every known modern convenience including a luxurious bath and telephone."

To the right of the hotel was the Elks Lodge. Once a residence, the Elks Lodge had a library and in the small front yard stood a nearly life-size bronze elk. In this 1929 photograph, one can see in the distance a small sign on the opposite corner of Deaderick Street for the Satsuma, a popular downtown restaurant that was doing business a few blocks from this location until it closed in March 2005.

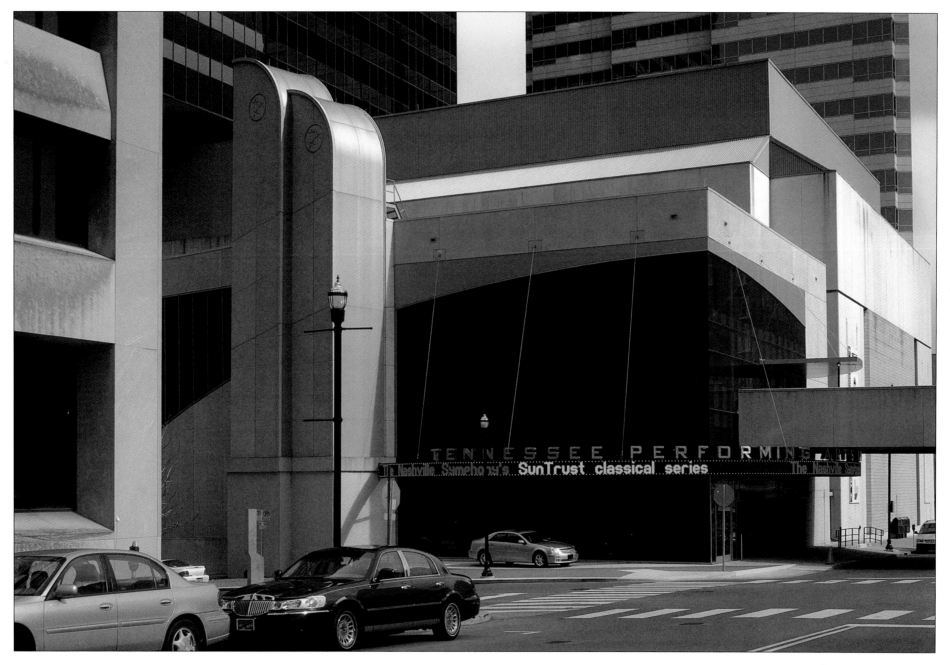

Soon after the Andrew Jackson Hotel and the Elks Lodge were razed, work began on the James K. Polk State Office Building and Cultural Center to house both the Tennessee State Museum and the Tennessee Performing Arts Center, as well as state government offices. The building was completed and dedicated in 1980. The museum is one of the largest state museums in the country with more than 60,000 square feet of permanent exhibits, displaying items that range from Andrew Jackson's top hat to a working gristmill, and a 10,000-square-foot changing exhibit hall. The Tennessee Performing Arts Center consists of three auditoriums with a combined seating capacity of 3,803. The TPAC, as it is usually called, is home to the Nashville Symphony Orchestra, the Nashville Ballet, the Nashville Opera Association, the Tennessee Repertory Theatre, and touring Broadway companies.

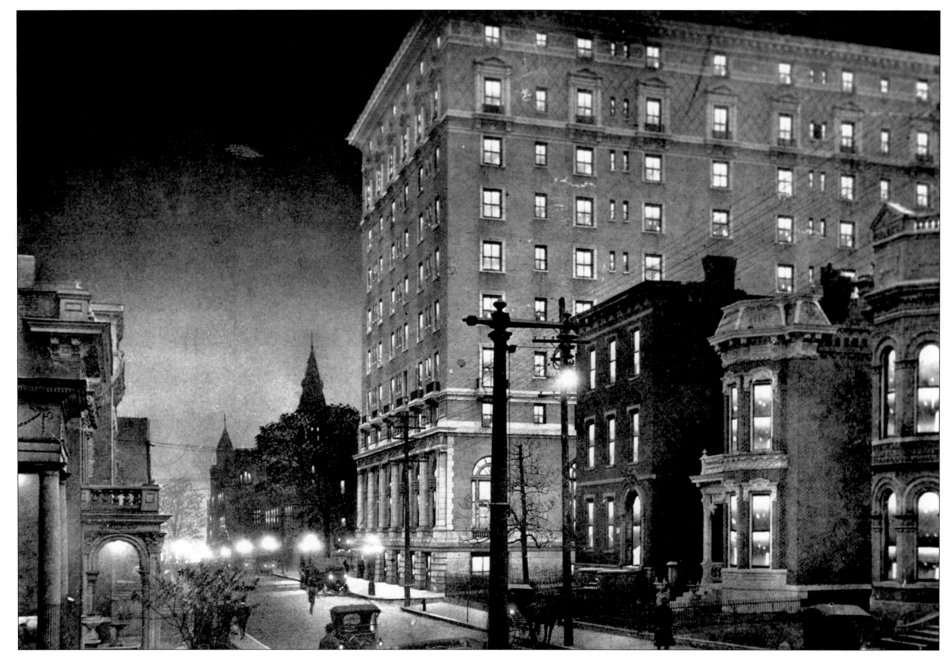

Nashville's first million-dollar hotel opened for business on September 17, 1910, having been commissioned by 250 Nashvillians. Upon its completion, it advertised its rooms as fireproof, dustproof, and soundproof, with prices starting at $2 a night. Italian sienna marble was imported for the entrance and the walls were paneled with Russian walnut. The vaulted ceiling in the lobby was cut stained glass, and adding to the elegance were Persian rugs, overstuffed furniture, and large potted plants. From 1929 to 1949, a music program by Francis Craig and his orchestra was broadcast nationally by NBC from the Oak Bar and Grill Room on the radio station WSM. A young singer from Winchester, Tennessee, named Frances Rose Shore was introduced on this program, singing Craig's composition "Near You." She later changed her name to Dinah and became one of America's most popular singers.

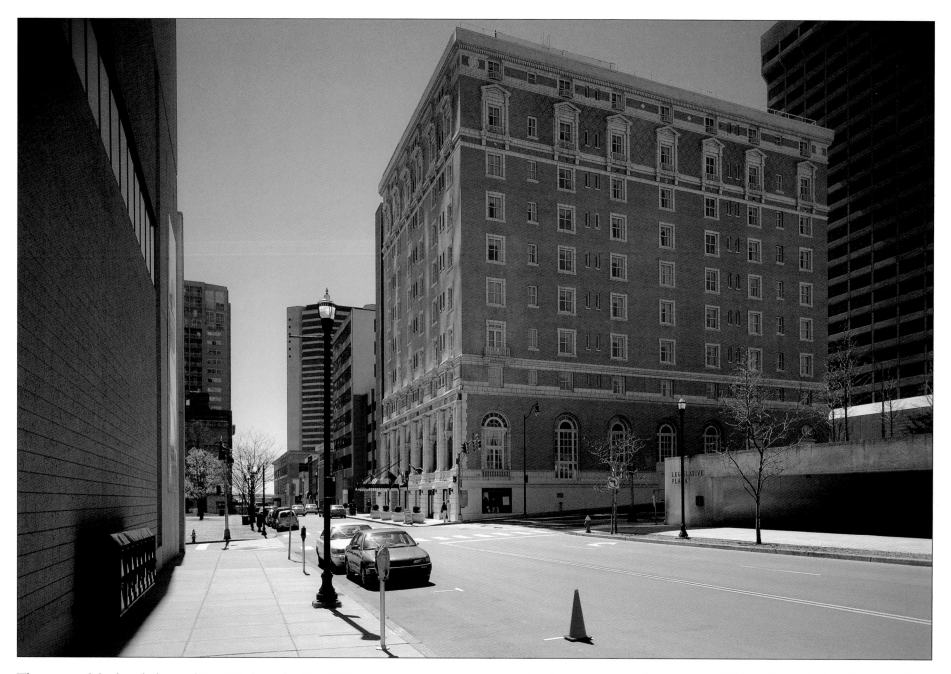

The name of the hotel changed in 1940 from the Hotel Hermitage to the Hermitage Hotel. It continued operations under several different owners and was purchased in June 2000 by Historic Hotels of Nashville LLC. The new owners wanted to return the hotel to its original grandeur. After an extensive restoration lasting ten months at a cost of $17 million, the hotel reopened on February 14, 2003. Including the original purchase price, the total cost of Tennessee's only remaining Beaux Arts commercial building amounts to a $30 million investment by its owners, which comes to $270,000 per room.

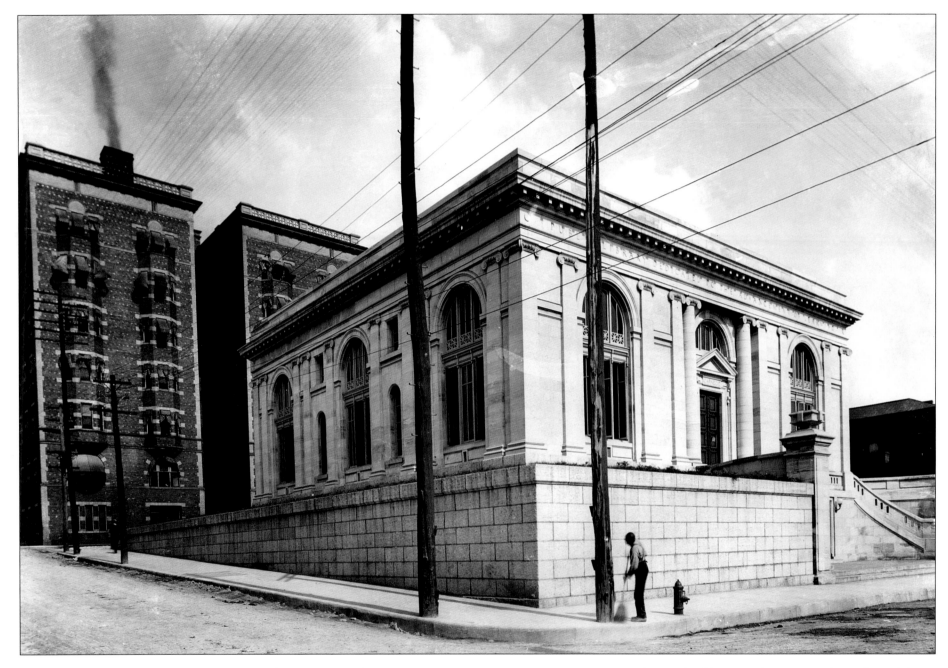

The Carnegie Library on the corner of Eighth Avenue North and Union Street was funded by a $100,000 grant from the estate of Scottish-born steel industrialist Andrew Carnegie. Carnegie's will required that the city provide land and operational funding for the library. The cornerstone was laid on April 27, 1904, and the building opened to the public on September 19 with 27,000 books. The land occupied the former site of the stables on President James K. Polk's property. The two buildings in the rear are the Polk and the Watauga apartment buildings, erected about the same time as the library. The Polk, seen here on the left, was later razed to make way for a hotel; the Watauga is still in use today. The Carnegie Library was replaced in 1965 with a modern structure. A few architectural features were saved and used in the landscape of the new library.

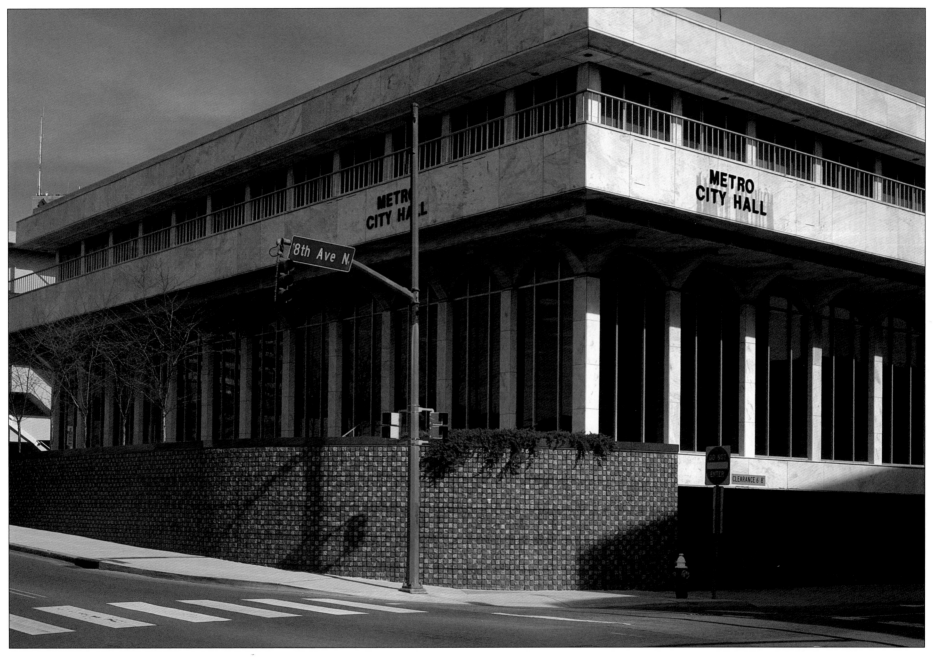

The building seen here is the temporary location for city hall while the courthouse is undergoing restoration. When the courthouse restoration is complete, the offices of the mayor, city council, and others will return to the courthouse. This building will be used for other city offices, including the Metro Archives. Named the Ben West Library for Mayor Ben West, under whose administration the project was funded in 1961, it was Nashville's main library with 171,000 books and a staff of over fifty employees. The local architectural firm Taylor and Crabtree designed the building, which was built by W. F. Holt and Sons. The total cost for the demolition of the old building, site preparation, construction, landscaping, and fixtures was about $1.5 million. The Ben West Library was closed in 2001 when the new Nashville Public Library opened on Church Street.

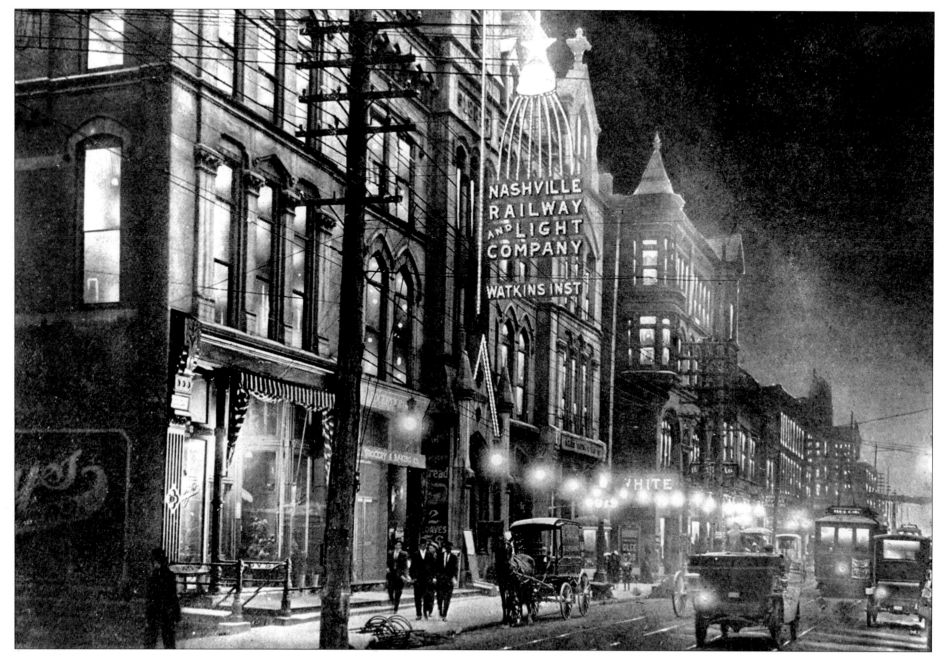

This simulated night photograph of the 600 block of Church Street was likely used for an advertisement for the Nashville Railway and Light Company. The building in the foreground, at the corner of Sixth and Church, is the Watkins Building, home of the Watkins Institute, a night school for adults that was endowed by Samuel Watkins. Watkins, a successful Nashville businessman, left $100,000 and five acres of land on the corner of Spring and High streets (now Sixth Avenue and Church Street) in his will for a free night school. He stipulated that the street level of the building be rented to businesses to finance the school's operation. A large number of immigrants studied English at Watkins, and leading artists taught its art classes. This building was replaced in the mid-1950s. The Watkins Institute is now the Watkins College of Art and Design, located in Metro Center just north of here.

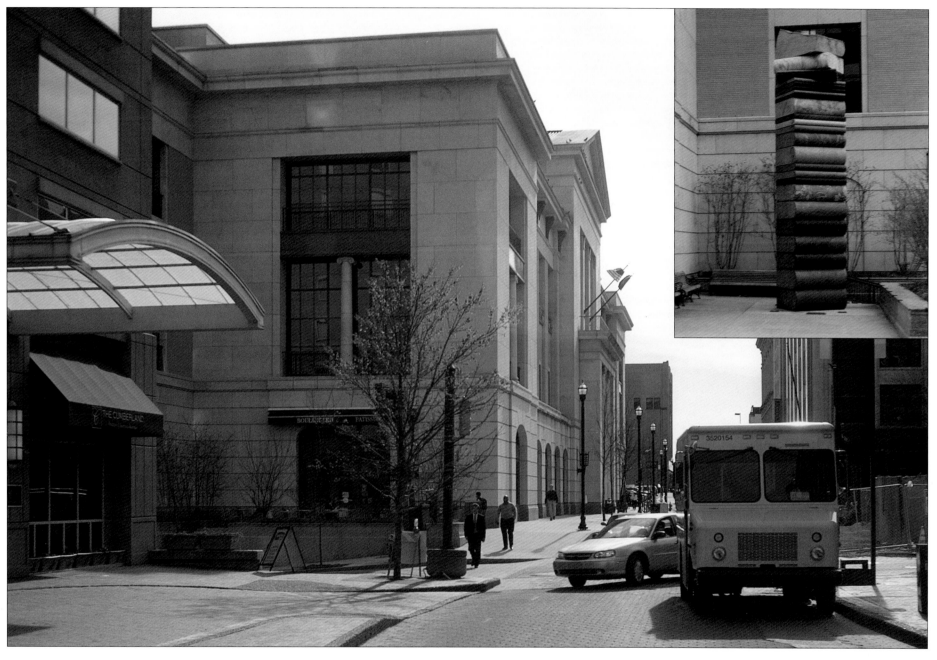

A succession of structures occupied this block after the Watkins Building was demolished in the 1950s. A modern building went up on the corner to house the Watkins Institute on the upper levels and Grant's, a variety store, took up the street level at the corner. That building and several smaller shops, as well as a short-lived downtown mall, were leveled to make way for the 300,000-square-foot Nashville Public Library, which opened on June 9, 2001, at a total cost of around $85 million. Designed by Robert A. M. Stern Architects, this modern classical building takes up the 600 block of Church Street. The library has over 600,000 books on its shelves, with room for one million volumes, and a 4,500-square-foot reading room. The inset shows a sculpture, *La Storia della Terra*, on the northwest corner of the library; it was designed by Anna Kubach-Wilmsen and Wolfgang Kubach of Germany.

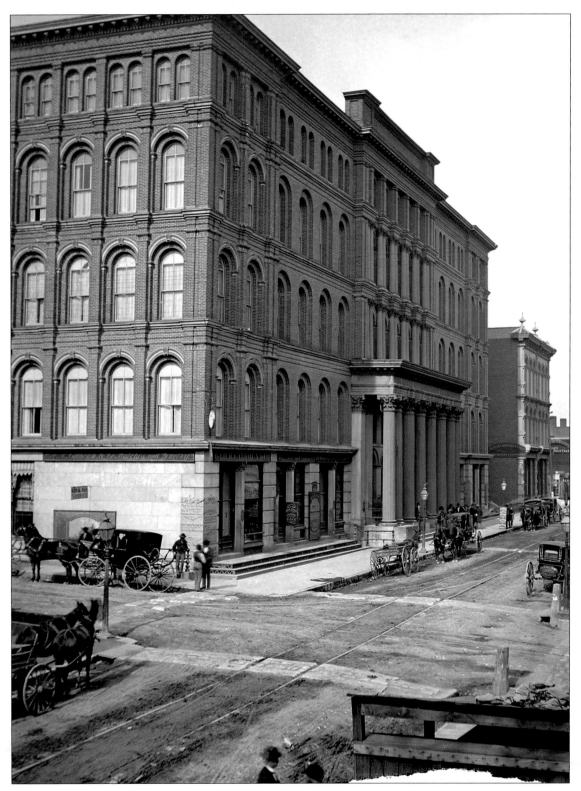

When John Overton Jr. built the Maxwell House hotel on the corner of Cherry and Spring streets, locals called it "Overton's Folly" because they considered it too large for a city the size of Nashville. History proved them wrong. The Maxwell House was designed by Isaiah Roberts and named for John Overton's wife, Harriet Maxwell Overton. Work commenced in 1859 using mostly slave labor, and ceased during the Civil War. During the war, the Confederate army used the hotel as a barracks, and the Union army later used the unfinished hotel as a prison hospital. After the war, Overton completed the Maxwell House at a total cost of $500,000 and opened for business on September 22, 1869. The 240-room, six-story hotel advertised steam heat, gas lighting, and a bath on every floor. This photograph was taken in the 1920s. The Maxwell House was destroyed by fire on Christmas night 1961. But for one Nashville coffee company, the Maxwell House would be just another old hotel with an interesting history. However, when Joel Cheek blended a coffee and, together with his brother Leslie, named it for the hotel, they made Maxwell House a household name.

After the Maxwell House burned in 1961, the intersection of Fourth Avenue North and Church Street changed completely. Third National Bank, a locally owned bank established in 1927, built an office building on the Maxwell House site. Rising above the four-story base, out of view in this photograph, is a sixteen-floor office tower designed by the firm of Brush, Hutchinson, and Gwinn. This was the first of several high-rise banking buildings erected in the 1960s and 1970s. In 1986, Third National Bank became a subsidiary of Atlanta-based SunTrust Banks Inc., one of the largest financial institutes in the United States, and Third National adopted the SunTrust name in 1995. In addition to the main bank, SunTrust has twenty-two neighborhood branches in Nashville.

It is only fitting that many people refer to the Ryman Auditorium as the "mother church" of country music. The Reverend Sam Jones, with the financial help of steamboat captain Thomas Ryman, constructed the building between 1888 and 1889 as the Union Gospel Tabernacle. The structure was designed by a local architect, Hugh Thompson, and built at a cost of around $100,000. In 1897 the Confederate Veterans Association donated money to install a balcony and the size of the stage was increased to accommodate touring opera companies from New York and New Orleans. The name was changed after the death of Captain Ryman in 1904 at the request of Reverend Jones. The Ryman Auditorium was the home of the Grand Ole Opry from 1943 until 1974, when they moved into new quarters at the Opryland complex.

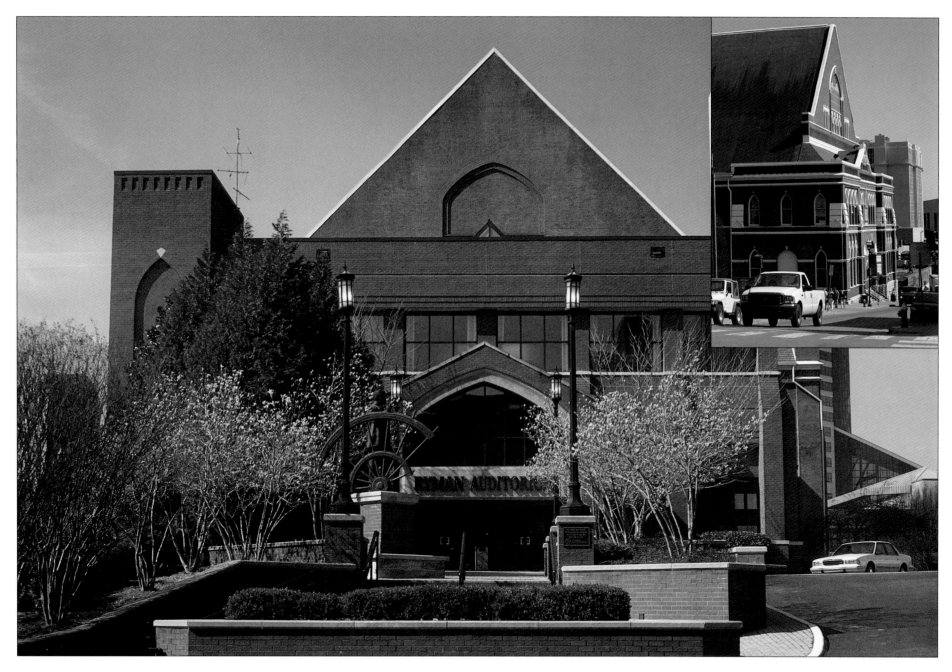

After the Grand Ole Opry left the Ryman in 1974, the building's future was in doubt. It was used for a few television productions and an occasional performance but was in need of repairs and contained asbestos. The building was stabilized between 1989 and 1990 and completely restored as a grand performance hall in 1993 by its owners, the Gaylord Company. A new entrance and lobby were designed by the Nashville architectural firm Hart Freeland Roberts and were built on what had been the rear of the building (the inset shows a view of the original front entrance). The Grand Ole Opry, the oldest continuous radio program in the country, comes back to the Ryman for a few weeks each year. It continues to be a venue for music productions, from bluegrass performers to rock legends. Those who have played at the Ryman include Enrico Caruso, Rachmaninoff, Paderewski, and Bob Hope.

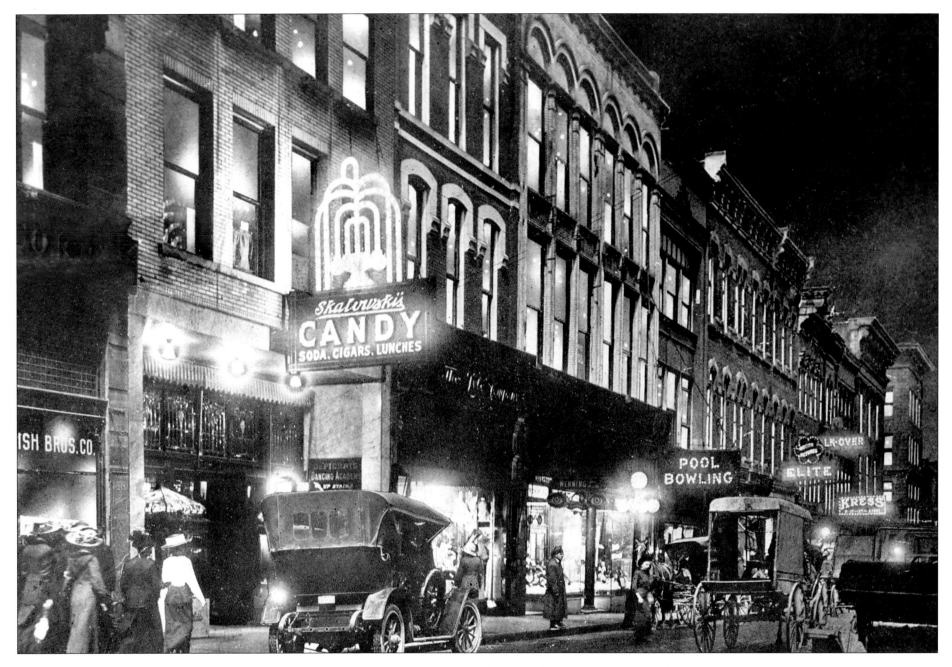

When this photograph was taken around 1915, the businesses listed in the city directory on Fifth Avenue included Skalowskie's Candy Store and Fish Brothers Company, which sold household furnishings, glassware, and toys. All the stores by then had electric lights, and the larger stores had electric ceiling fans. Further down Fifth Avenue toward Union Street were a pool hall, bowling alley, the Elite movie theater, and the Kress Five and Ten Cent Store. The Elite lasted into the 1940s, and Kress continued until the 1970s, when most retail businesses left downtown for the suburbs and malls. Two other popular stores that occupied these buildings were Woolworth's and McClellan's, both five-and-dime stores.

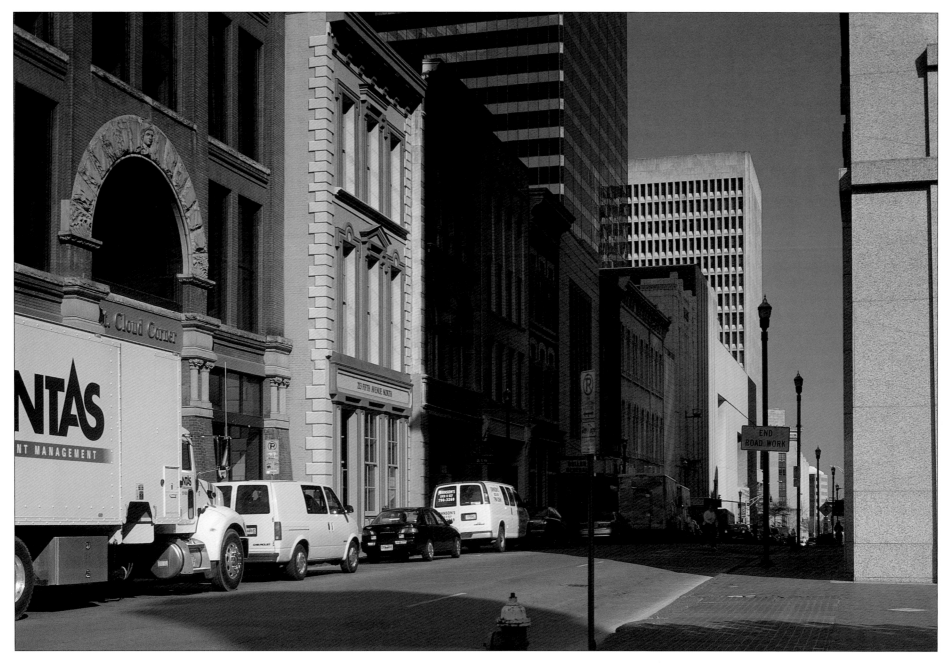

Many of the old buildings along Fifth Avenue got facelifts in the 1930s and 1940s. Canvas awnings were replaced with marquees or removed, air conditioning was installed, and glass and aluminum facades disguised the nineteenth-century architecture at sidewalk level. In 1960, black students from Fisk and Tennessee State universities, protesting the racial segregation policies of the time, staged sit-ins at white-only lunch counters in Woolworth's, which eventually led to the complete desegregation of Nashville. Beginning around 1990, some of the facades were removed, revealing the buildings' classic architecture. Various offices, a bank, an art gallery, small retail stores, and restaurants catering to the lunch crowd now line both sides of the street.

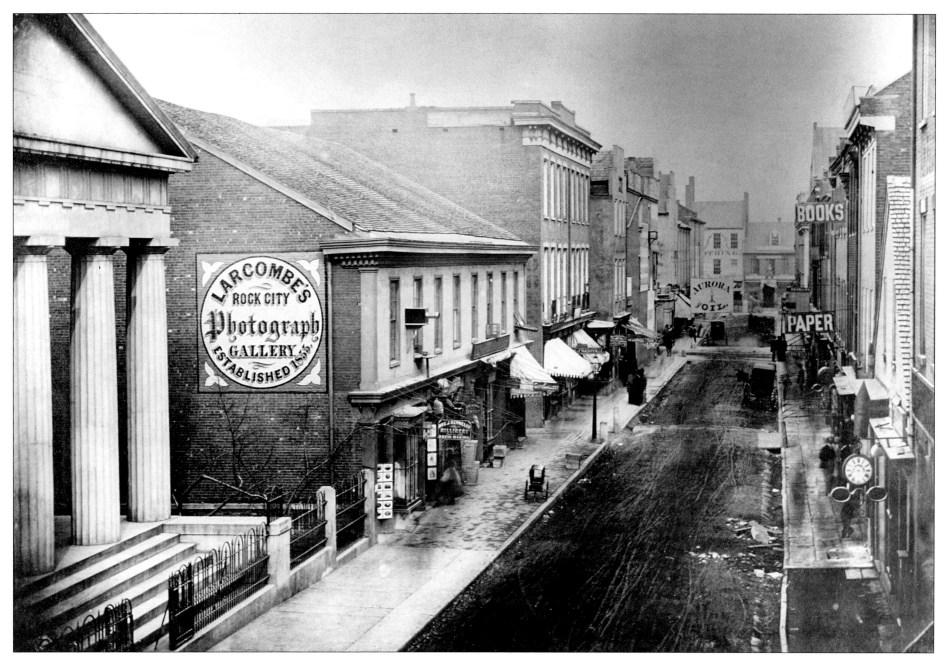

Union Street, seen here around 1875, was a bustle of retail businesses. Most prominent in this photograph is Larcombe's Rock City Photograph Gallery, established in 1855. The "Rock City" in Larcombe's name is in reference to one of Nashville's early nicknames. In 1855, photography had only been around for about thirty-five years and galleries such as Larcombe's represented the latest technology of the time. Early photography galleries or studios had posing rooms on the second floor, with large skylights to take advantage of natural light. Other businesses identified in this photograph are: Geir's Gallery, another photography gallery; a dentist; a dressmaker; a bank; Aurora Oil, which sold lamp oil; a bookstore; a stationer; and an optometrist. The building partially seen at the far left was the Nashville Library Association.

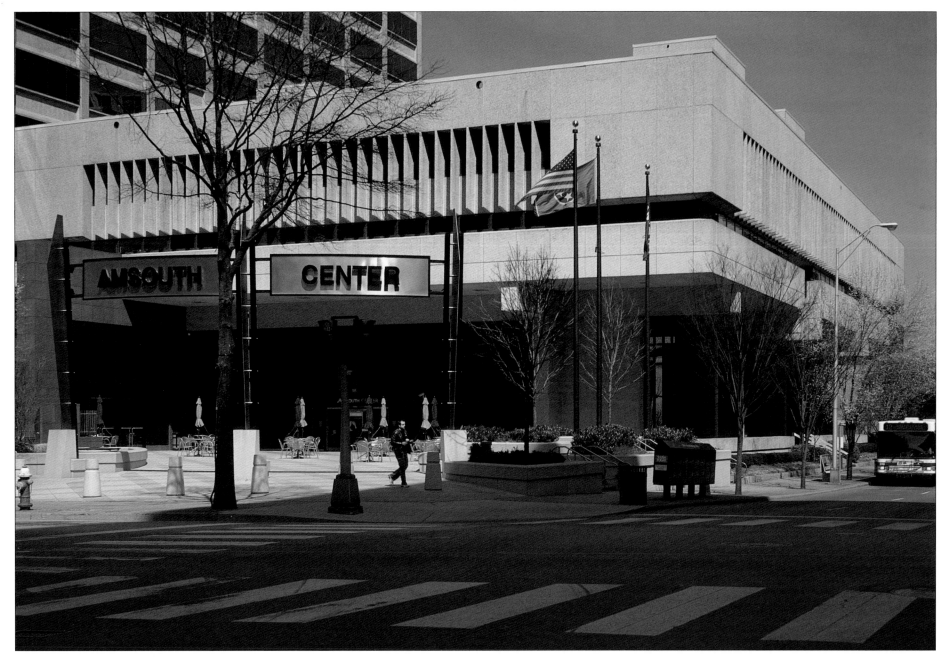

AmSouth Center now takes up the block of Union Street from Fourth Avenue east to Third Avenue and north to Deaderick Street. Situated on the northwest corner of Fourth and Union, AmSouth Center's welcoming courtyard at the Union Street entrance provides a comfortable respite from downtown hustle for pedestrians and bank customers alike. This was originally First American National Bank's main office. AmSouth Bancorp acquired First American in October 1999; the name was changed in 2000. During excavation of the site, the remains of a saber-toothed tiger were unearthed and are now on display in the lobby. The National Hockey League's Nashville Predators adopted the saber-toothed tiger for their logo and mascot.

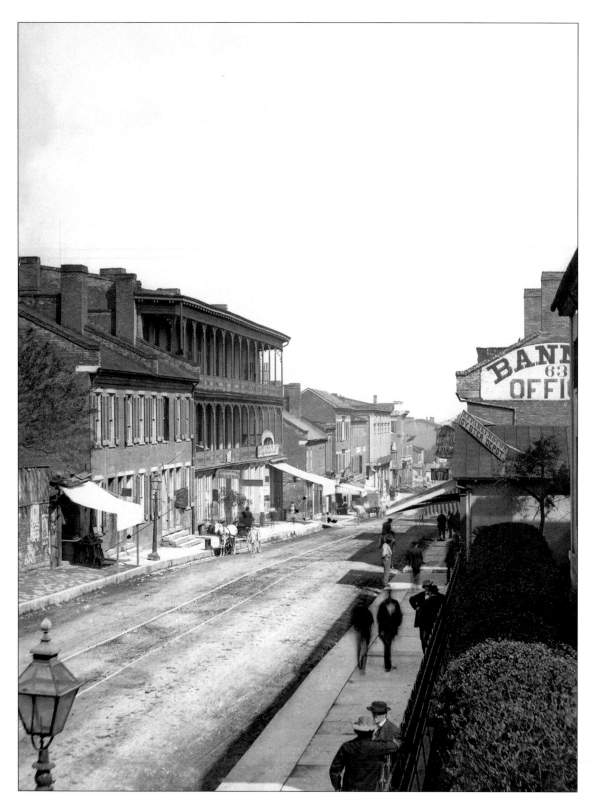

The building in the right foreground with the wrought-iron fence was the Nashville Library Association, which faced Union Street. Behind the library was R. F. Parker and Company's Oyster Depot. Oysters were shipped live from New Orleans in water-filled barrels aboard steamboats. This photograph was taken around 1875. A tailor and shirt maker are on the right. The makeshift awning in the left foreground was probably a street vendor. Buildings such as these with gable roofs only lasted about another thirty years. By 1890 most downtown buildings had flat roofs. The streetlamp seen in the left foreground is a gaslight.

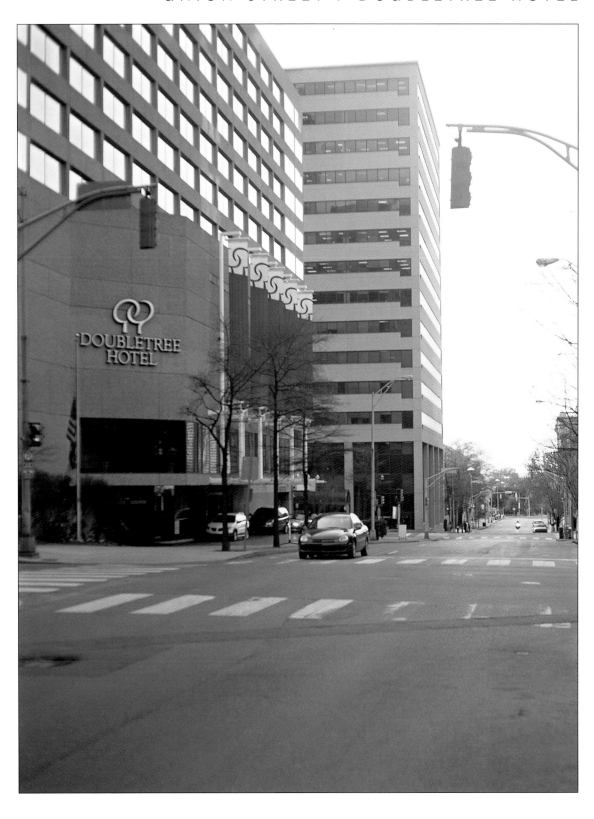

The east side of Fourth Avenue has been completely overtaken by AmSouth Center and on the west side the Doubletree Hotel occupies the block from Union Street north to Deaderick. A generation of buildings was built on this site in the late 1890s and early 1900s, after the opposite photograph was taken. They were removed around 1970 during the downtown renewal project. Entrances to buildings such the Doubletree Hotel are set back from the sidewalk, giving the street a wider appearance. The building beyond the Doubletree is the Citizens Plaza State Office Building.

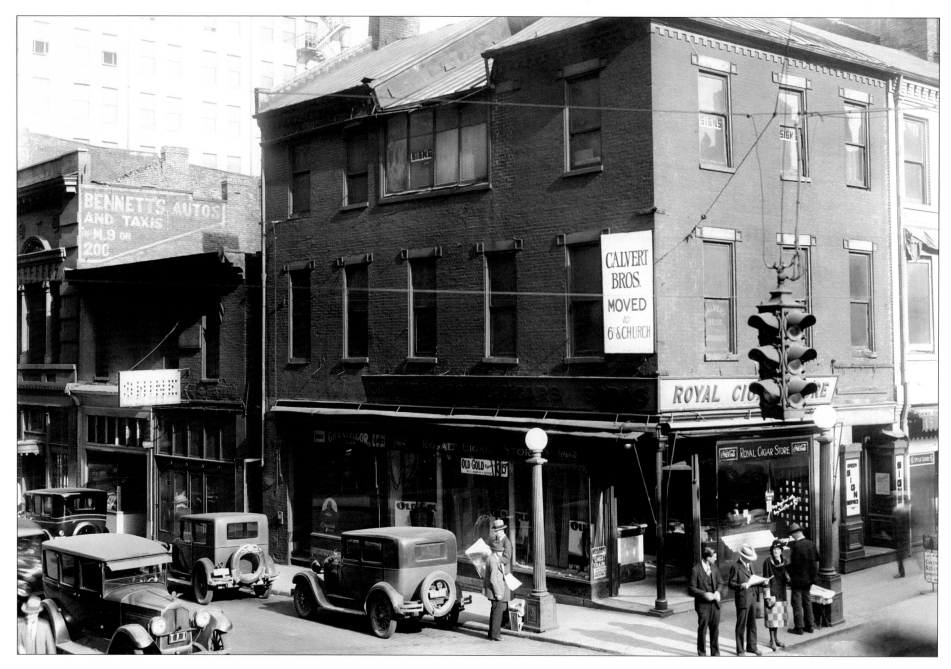

This photograph from 1930, during the Great Depression, was taken at the northeast corner of Fourth Avenue and Union Street. The Royal Cigar Store occupied the street level; Calvert Brothers Studio had already outgrown the top floors of the building and had moved to a new address on the more fashionable Church Street. The business partially in view to the right of the cigar store is J. B. Strauss, a clothing store whose slogan was "From Maker to Wearer." The entrance to a sign shop in the old Calvert Brothers space on the upper level was between the Royal Cigar Store and Strauss's store. A recessed skylight, necessary for portrait photography, can be seen on the roof over Calvert Brothers Studio on the Union Street side. The sign on Union Street behind the cigar store identified a shoe-shining parlor.

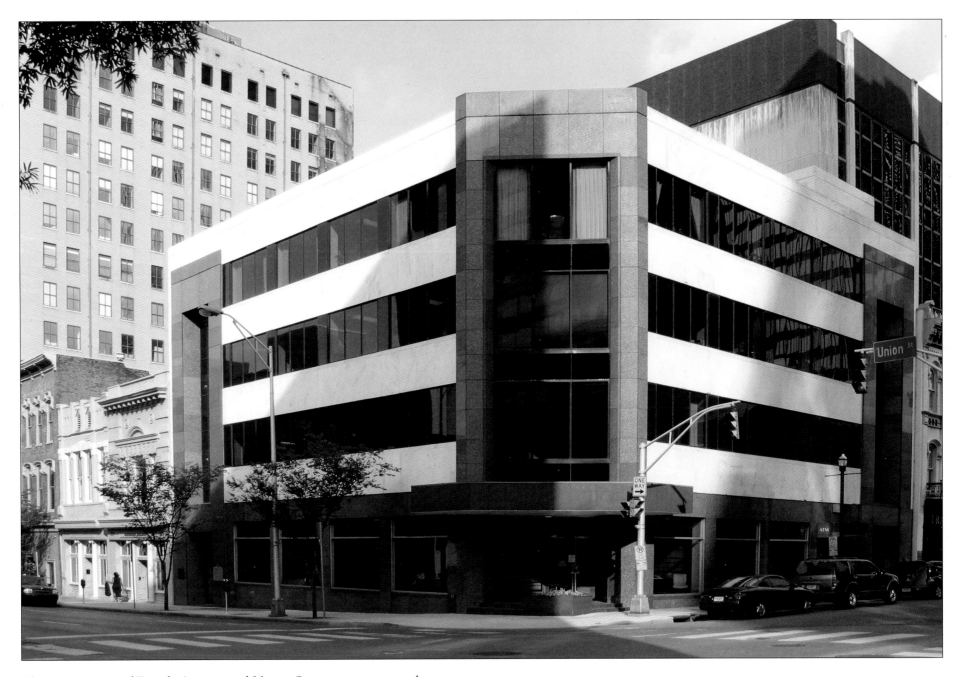

The intersection of Fourth Avenue and Union Street continues to change today. Retail businesses that remain downtown are no longer located here, but are near the sections of town visited by tourists on Lower Broadway and Second Avenue. The last few nineteenth-century office buildings that are left on Union Street are behind this corner building. These old structures now house law offices.

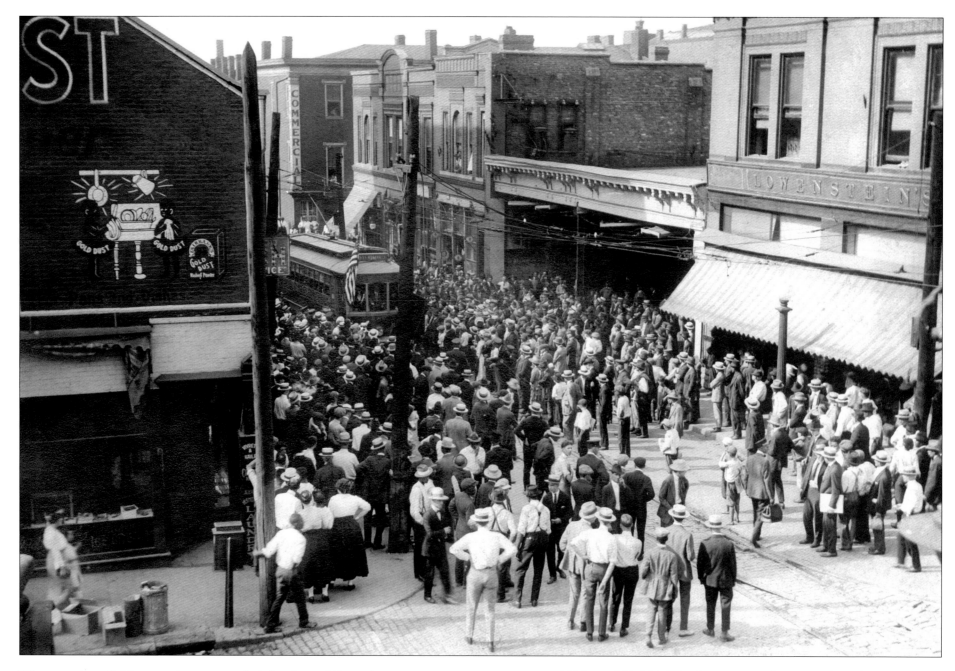

The occasion of this event is not recorded, but it could have been a celebration of the success of Nashville's electric streetcar service. In 1919, the estimated date of this photograph, streetcars traveled over 485,000 miles and the Nashville Railway and Light Company was the largest industry in the city. The next year the company showed a payroll of over $1,300,000 and paid more than $700 a day in taxes to the city. The purchase price for a streetcar in 1920 was $11,500. The fare increased in 1920 from five to seven cents. To encourage people to use streetcars, the company built Glendale Park, a zoo on the southern outskirts of the city. It was estimated at the time that a streetcar crossed the intersection of Fourth Avenue and Church Street every twenty-five seconds.

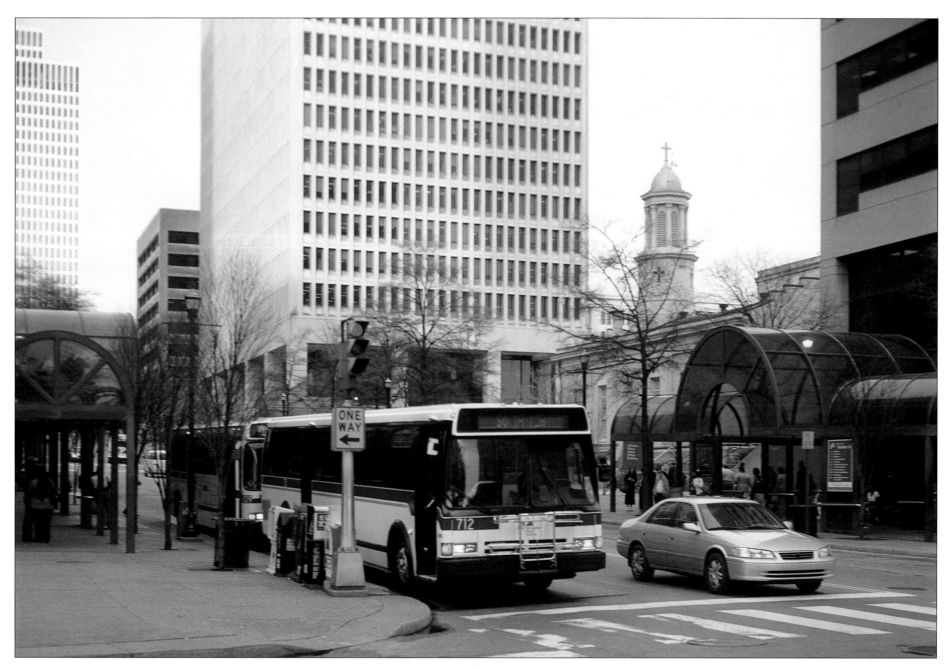

Buses now move people about the city on many of the routes that were once traveled by the streetcars. Deaderick Street from Third to Fifth avenues serves as a hub for the Metro Transit Authority (MTA) buses. In addition to regular passenger services, MTA operates buses for people with special needs. A few buses have bike racks mounted on the front to encourage students to ride. Plans are underway to build the MTA Downtown Transit Center to serve as

a hub for all bus services, with the capacity to serve an estimated 14,000 passengers a day. The move from Deaderick Street will no doubt be a relief for pedestrians as well as for bus drivers who must navigate streets that date from streetcar days. The fare for public transportation has gone from seven cents in 1920 to $1.10 today.

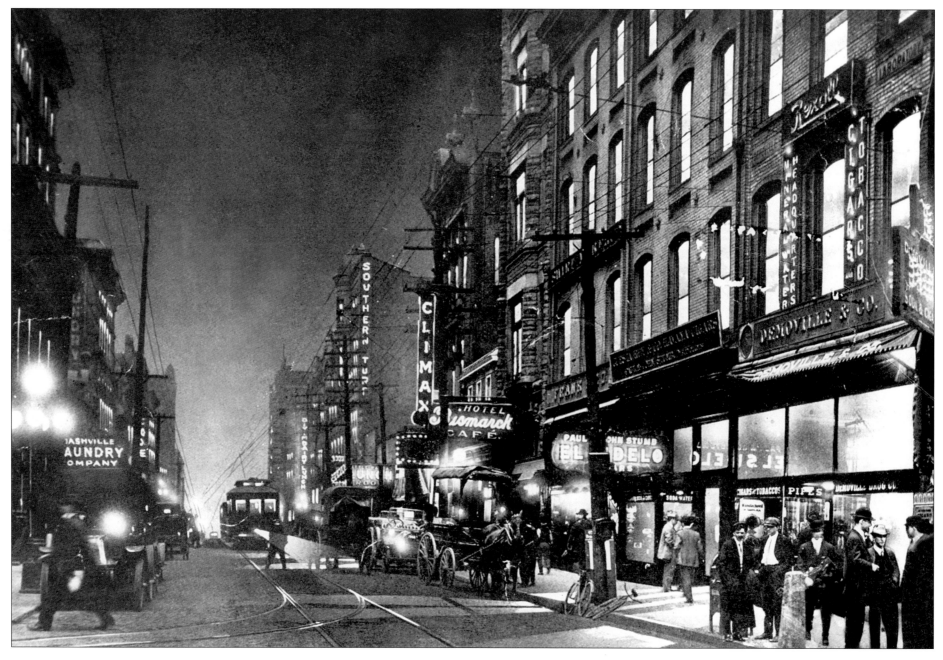

The Men's Quarter was a short section of Cherry Street between Church and Union streets, named for the businesses in the area—most notably the Utopia Hotel, the Climax Saloon, and the Southern Turf Saloon built in the late 1890s. The Climax, Utopia, and Southern Turf provided entertainment for the city's wealthy gentlemen. All three businesses were in elegant new buildings, but the Southern Turf was the finest with mahogany woodwork,

large mirrors, bronze statuary, racing prints, oil paintings, and exotic tropical plants. Offices for Nashville's two newspapers of the day, the *Banner* and the *American*, and several law offices were in the Men's Quarter. Across the street on the west side from the Utopia Hotel was the main entrance to the Maxwell House hotel. Ladies were provided another entrance around the corner on Church Street.

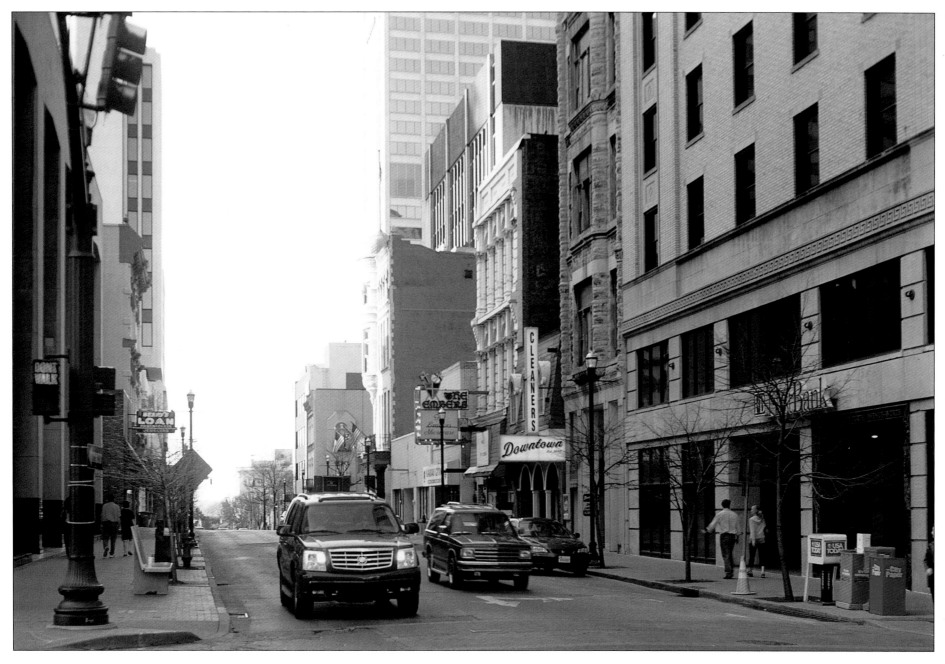

The Men's Quarter literally dried up in 1909, when it became illegal to sell alcohol. The saloons tried to circumvent prohibition laws and stay in business by selling soft drinks to strangers and hard drinks to known customers. Those opposed to saloons pushed for stronger enforcement of the prohibition laws, and in 1913 the Nuisance Act was passed, closing down all the city's saloons. The sixty-room Utopia Hotel became the Bismarck and the others were used for various businesses. The Southern Turf is now an office for a law firm and remains an elegant building. The Bismarck is now occupied by Downtown Cleaners on the ground level while the upstairs is currently vacant. A restaurant occupies the street level of the Climax. The building in the right foreground became the Noel Hotel; it is now a bank.

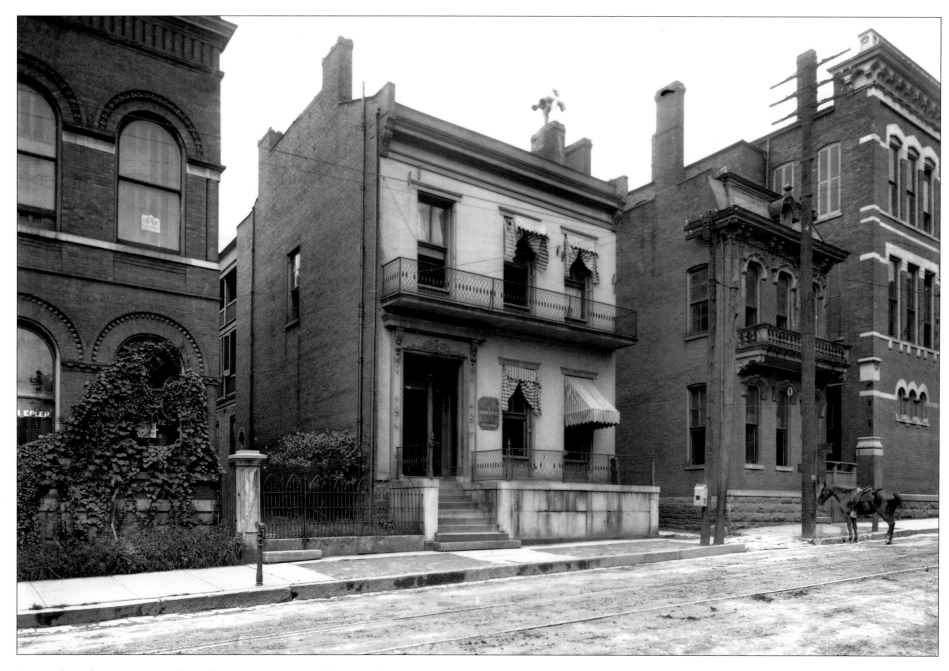

As residents began moving from downtown, many of the town houses were used for offices. One such building was at 167 Fourth Avenue North. The address reflects the name change from named streets to numbered streets. In 1904 the city renamed all the streets running north and south to make it easier for shoppers from the outlying areas to find addresses. Avenues were designated North and South in relation to Broadway. On the east side of the river, Main Street was the dividing line. The house in the center of this photograph was the office of the Baptist Sunday School Board, founded in 1891 by the Southern Baptist Convention to publish its own literature. The Baptist Sunday School Board moved into an office building on Eighth Avenue around 1900 and has since grown to cover several city blocks.

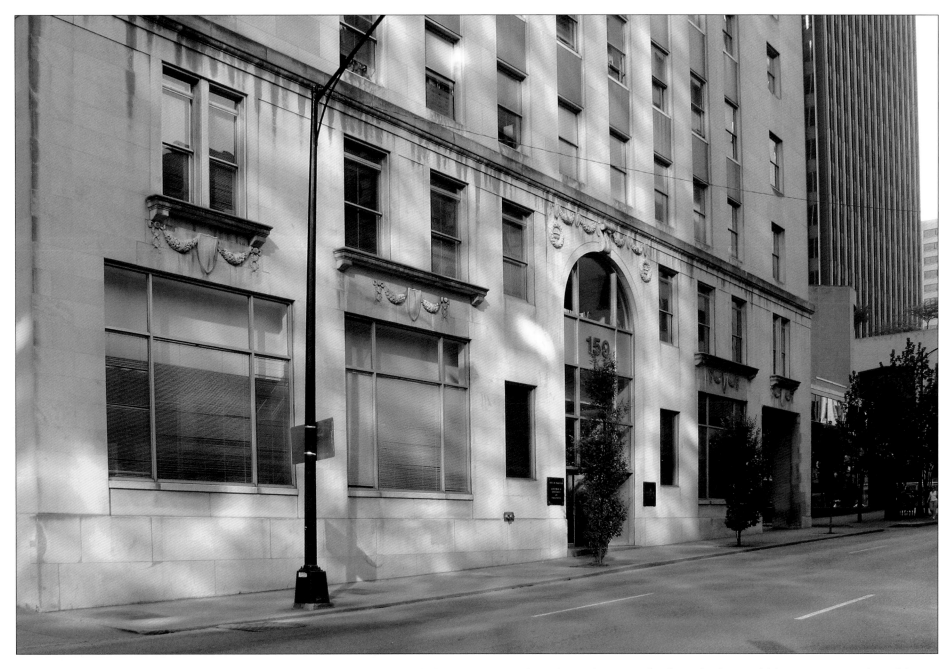

This building housed the Life and Casualty Insurance Company, founded locally in 1903. When the new Life and Casualty Tower was completed in 1957, this became the Annex until American General Insurance Company of Texas acquired Life and Casualty in 1968 and vacated the two buildings. WLAC Radio, owned by Life and Casualty, was in this building and became known for its late-night broadcasts of rhythm and blues music. Broadcasting on a clear channel, many of today's rhythm and blues artists were heard for the first time on WLAC in the early 1950s. Entertainers such as Ray Charles, B. B. King, Little Richard, Muddy Waters, Fats Domino, and countless others asked that their records be played on WLAC. Today, the building houses the offices of the Tennessee Department of Environment and Conservation and other private businesses.

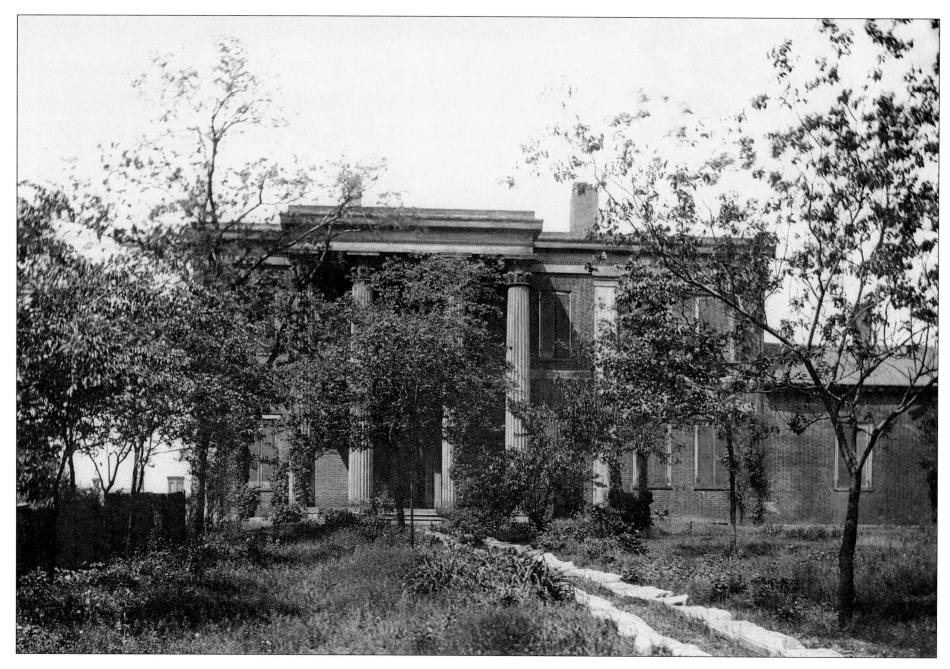

Felix Grundy built this house on Vine Street, now Seventh Avenue North, in 1815 in sight of Campbell's Hill. James K. Polk, a close friend and political ally of Grundy, lived here while he was governor of Tennessee from 1839 to 1841. Polk purchased the home after his term as president of the United States ended in 1849. He died here of cholera on June 15 of that same year.

Polk's wife, Sarah, continued to live here for another forty-two years. She died in 1891 and was laid to rest beside her husband in a tomb on the grounds. The Polks had no children, and relatives sold the home to settle the estate. The house was demolished in 1901.

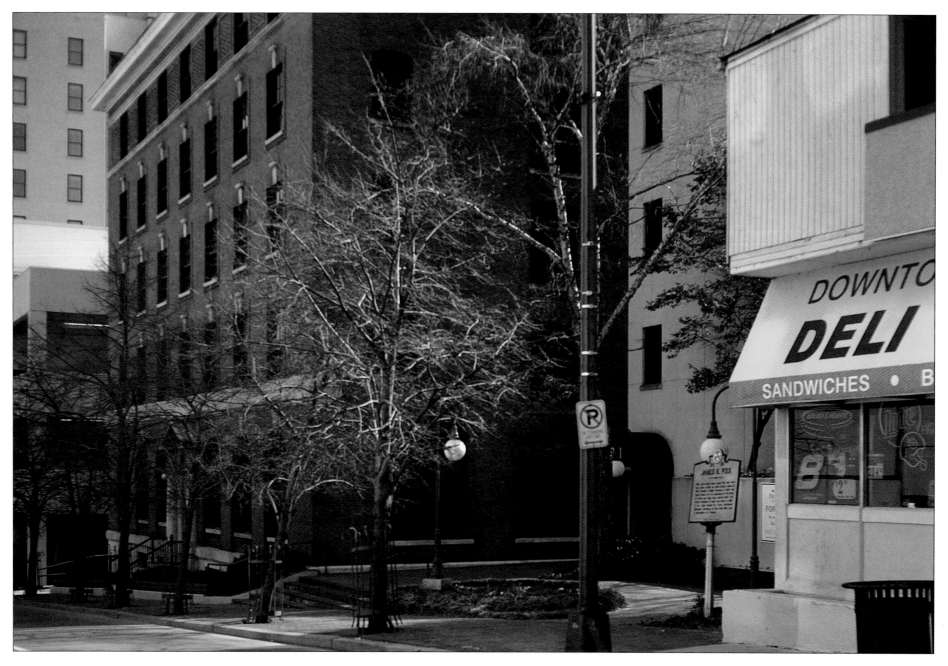

The property on which the Polk house stood covered an area from Union Street to Spring (Church) Street, north to south, and from Vine Street (Seventh Avenue) to Spruce Street (Eighth Avenue), east to west. The house itself faced Vine Street. Several buildings now occupy the property, including this building, erected around 1904 to house the Young Women's Christian Association (YWCA). The building has been converted to offices and the primary occupant is a public relations firm. The Post Bennie Dillon Apartments and a parking garage are on the south side. The Stone Building, a delicatessen, and a Days Inn hotel on the north side flank the YWCA Building. A marker in the courtyard of the Stone Building on the right of this view is the only remaining evidence of the Polk house.

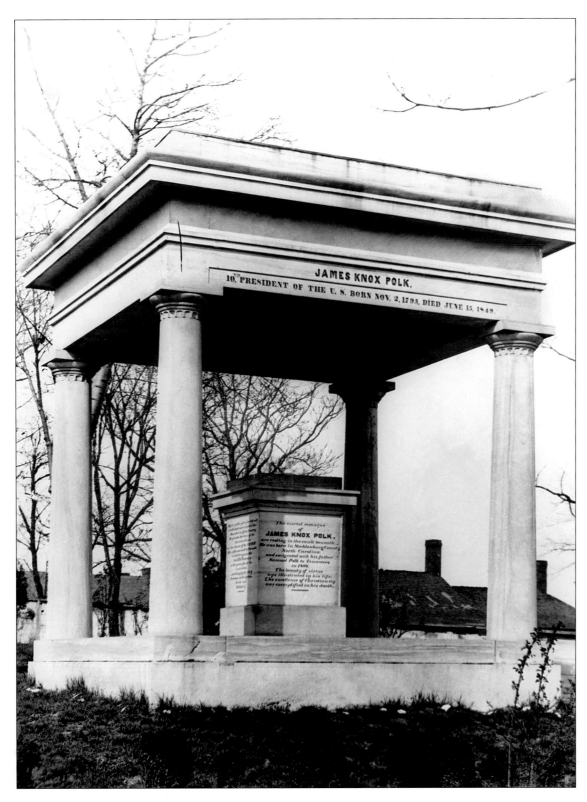

When President James K. Polk died in 1849, his funeral was held at Polk Place. Ida Clyde Clark described it in her book *All About Nashville*, published in 1912: "The honorable James K. Polk, eleventh president of the United States, died at his residence June 15, 1849, and was placed in a vault in the old city cemetery with Masonic honors. On May 22, 1850, his remains were deposited in the elegant mausoleum prepared for the purpose on the eastern front of Polk Place. The Masonic fraternity, Governor and staff, Mayor and City council and all the city officials and many leading citizens attended in the procession, and minute guns were fired. The Masonic funeral rites were performed." A careful look at this old photograph reveals a nineteenth-century error. Polk was the eleventh president of the United States, not the tenth.

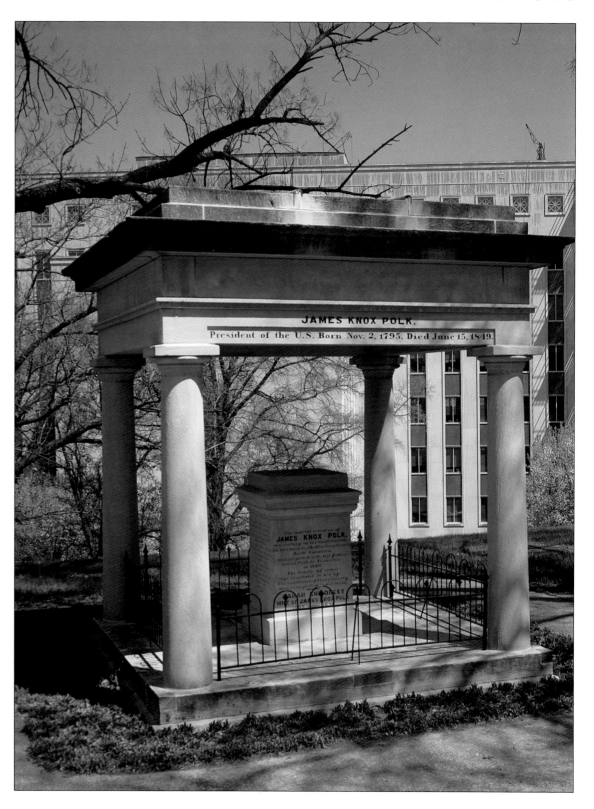

When the Polk home was razed in 1901, the remains of James and Sarah Polk were moved a few blocks north of the property. The simple mausoleum was relocated to the northeast lawn of the state capitol in the shade of stately magnolia trees. The structure in the background is the Cordell Hull Building. The words on President Polk's tomb summed up his life: "His Life was dedicated to public service. He was elected successively to the first places in State and Federal Governments. A member of the General Assembly, a member of Congress and chairman of the most important congressional committees. Speaker of the House of Representatives, Governor of Tennessee and President of the United States."

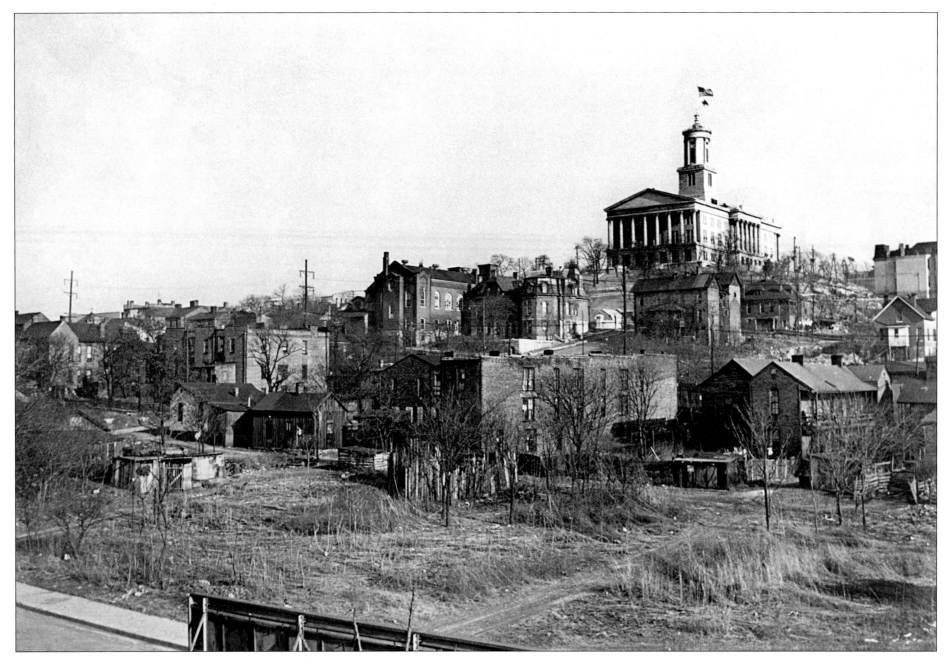

Even before this photograph was taken in 1939, the area surrounding Capitol Hill was in steady decline. Industry was encroaching on the once fine neighborhood, and old homes were broken up into low-rent apartments or boarding houses. The area became known as Hell's Half Acre. It was the city's red-light district; prostitution, bootleg whiskey, and gambling drove a thriving underground economy, all in view of the capitol. It was a filthy place as well; outdoor privies and livestock added to the squalor. It was especially bad in winter when the sky hung heavy with the gray mixture of coal smoke from fires and trains as well as fog.

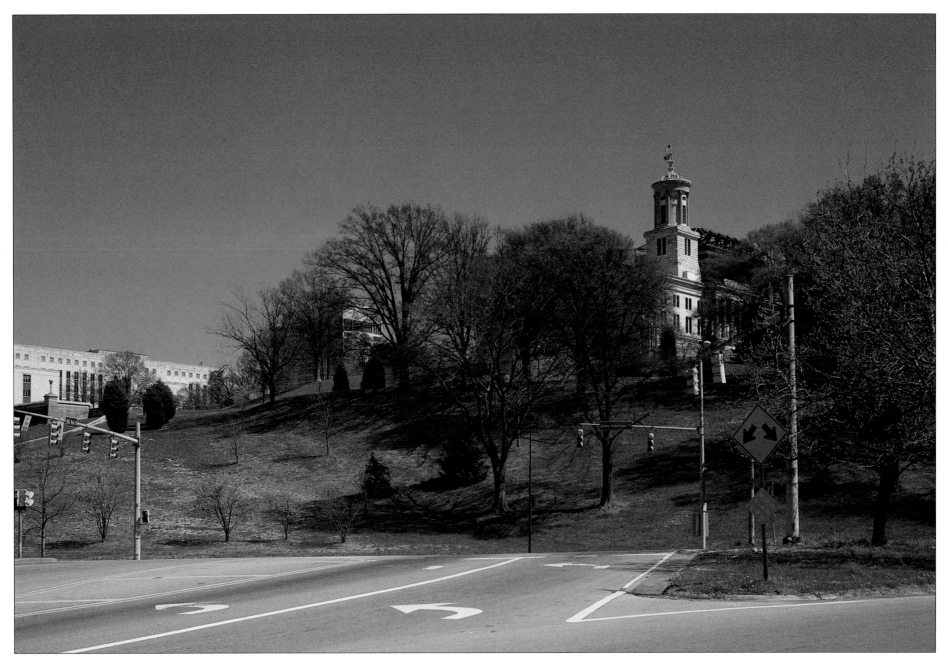

In 1954, Mayor Ben West initiated the Capitol Hill Redevelopment Project, one of the first such projects in the country. By the time the project was completed, ninety-six acres of slums north of the capitol had been cleared. James Robertson Parkway, a divided four-lane boulevard, now routes traffic from the east to the west side of downtown. New state office buildings, the Municipal Auditorium, the WLAC (now WTVF) television studio, parking for state employees, a church, and private businesses replaced the slums. Hell's Half Acre was relegated to the history books.

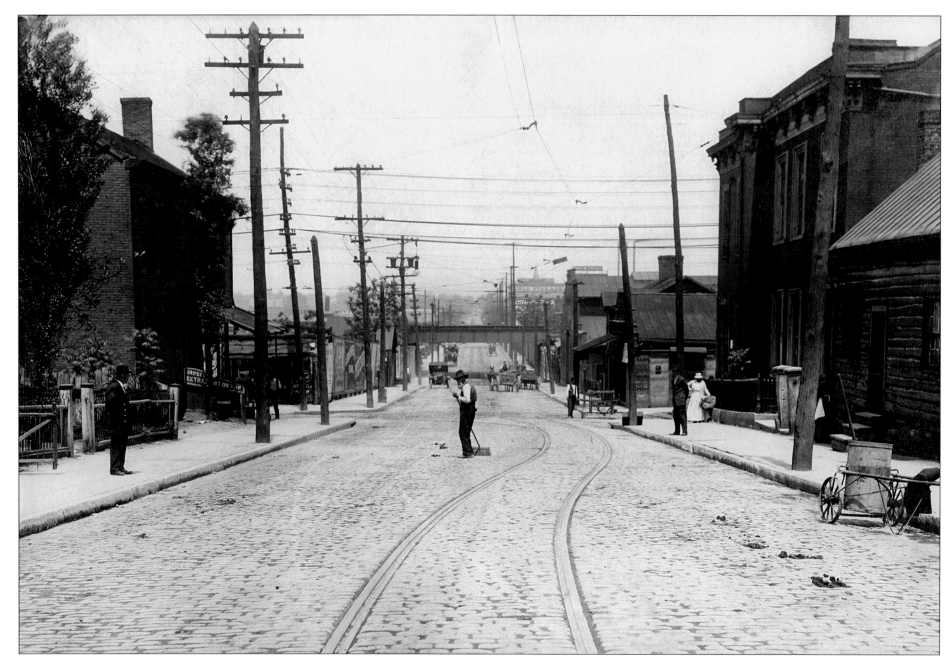

This photograph was taken from Jo Johnston Avenue, southeast of the capitol building in an area known as North Nashville. The picture was taken as evidence in a court case. The photographer posed the people, probably to serve as markers. The policeman on the left and the street sweeper in the center, the street sweeper's cart, and the people on the sidewalk all appear to be carefully placed. The condition of the buildings is more indication of the decaying neighborhood north of the capitol. This street is only four blocks west from the Cumberland River Railroad Bridge and is bisected by the railroad tracks.

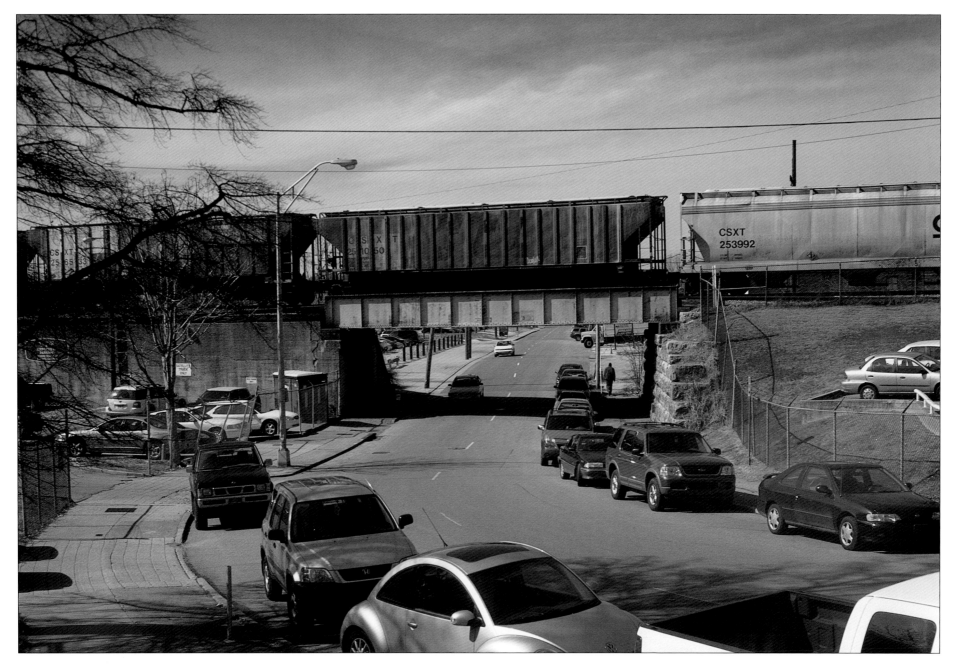

The only evidence that this photograph and the photograph shown opposite are the same place is the railroad trestle and an old map. James Robertson Parkway now dissects Fourth Avenue, which once ran uninterrupted from the southern city limits north through Germantown nearly to the river. Where it once ran straight, Fourth Avenue now curves around the parking lots of the WTVF television station and the offices of the Tennessee Regulatory Commission. This photograph was taken from that parking lot looking north. Six blocks of Jo Johnston Avenue have been removed.

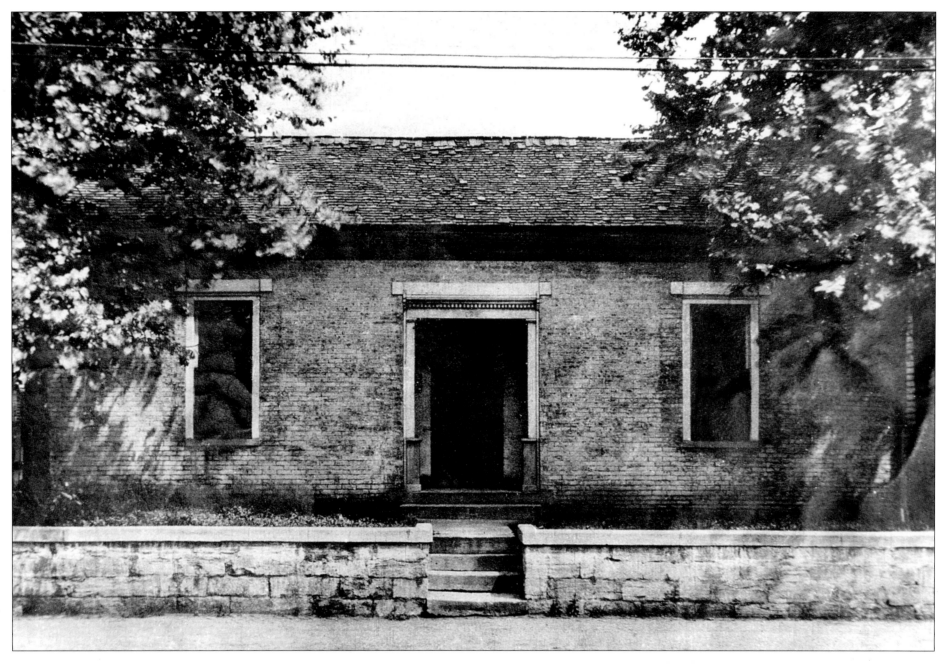

This simple cottage on Jefferson Street was the home of Mrs. Mary Ann Schaub, who would have lived in anonymity except for a celebrated boarder. William Strickland, the Philadelphia architect who was working on the State Capitol Building, needed to escape from the city for a while in 1849 during an outbreak of cholera. Strickland and his dog Babe stayed at the Schaub home in what seemed like a rural setting beyond the northern limits of the town, in a section later known as Germantown. He stayed at Mrs. Schaub's home on another occasion during some uncomfortable legal matters involving several Nashville businessmen. A monument with the name Babe engraved on the face stood in the yard on the west side of the house, marking the grave of Strickland's beloved dog. Mrs. Schaub lived alone in the little brick house until her death in 1889.

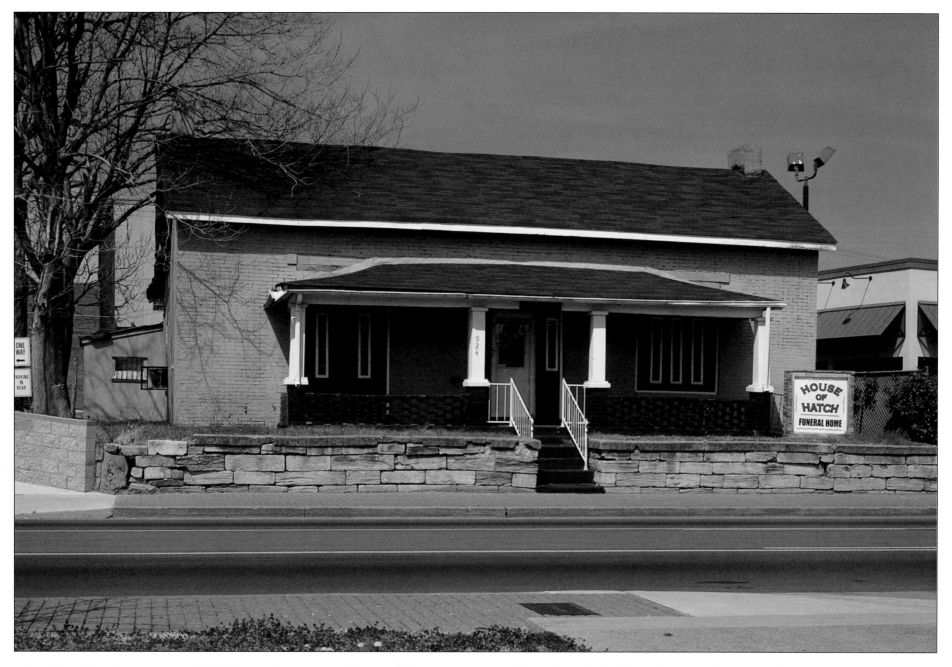

Mrs. Schaub's little cottage at 924 Jefferson Street is now House of Hatch, a funeral home surrounded by a supermarket and fast-food restaurants. Jefferson Street has been the heart of the black community since the Civil War, when the Union army set up "contraband" camps for freed slaves. Running west from the river, Jefferson Street developed through the years as a thriving residential and commercial neighborhood. It has been said that a person could live their whole life without ever leaving Jefferson Street. When Interstate 40 was built, it interrupted Jefferson Street in the area near Fisk University, cutting off the western end of the neighborhood from downtown. Most of the homes along Jefferson near the city have been torn down or converted for commercial use.

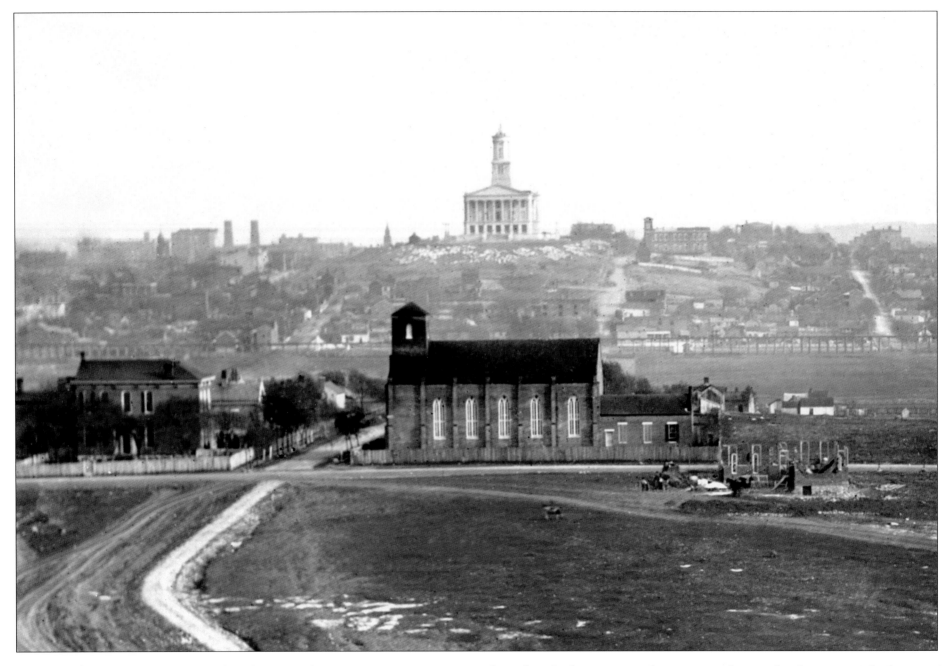

This view of the state capitol was taken from a rooftop in Germantown, north of the city, around 1860. The church in the foreground is the Roman Catholic Church of the Assumption. When the church was built, Bishop James Whelan thought it too far from town. German craftsmen working on the capitol building settled in this area, and other German immigrants, many of whom were in the meat processing business, arrived later. Germantown thrived in the late nineteenth century, and many fine homes were built. Adolphus Heiman, a noted architect and a colonel in the Confederate army, lived here in Germantown. The elevated railroad is in about the same location today. To the left of the capitol, one can see the twin towers of the First Presbyterian Church.

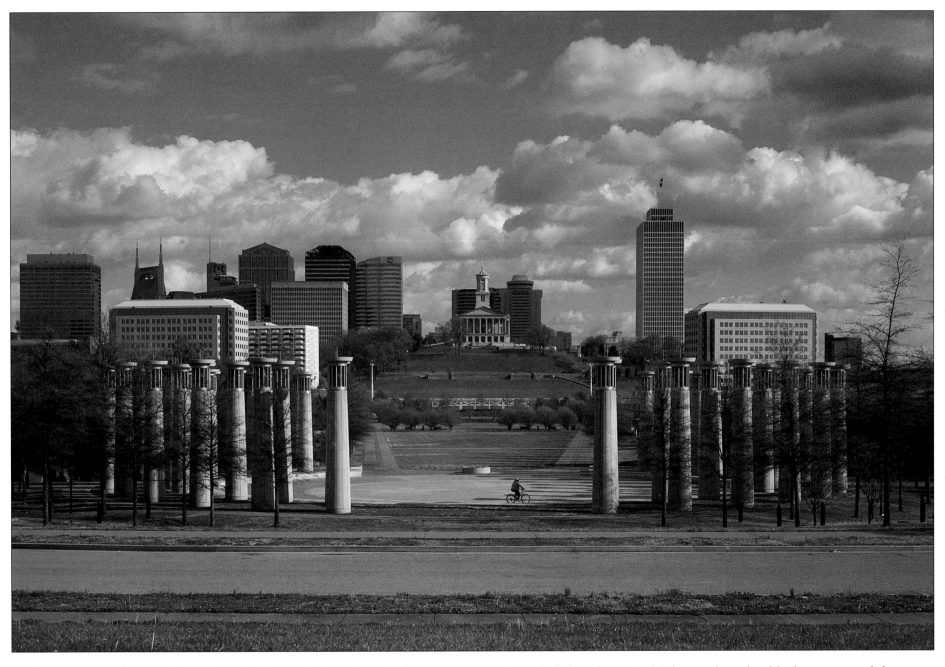

Today, Bicentennial Capitol Mall State Park extends from James Robertson Parkway north to Jefferson Street, covering nineteen acres. It was built to commemorate Tennessee's 200 years of statehood and was dedicated in 1996. The park is commonly known as Bicentennial Mall. The towers in the foreground contain bells that toll during the day. Throughout the park are symbols of Tennessee's history and topography. An elevated railroad is located in the park, below the capitol. The trestle and rail bed are new, and the trestle frames the main entrance to the park. The park is near the location of French Lick, the original settlement and trading post in central Tennessee, which was established near a salt lick around 1760 by French fur trappers from New Orleans and Canada. To the right of this picture, out of view, is the city's new farmers market.

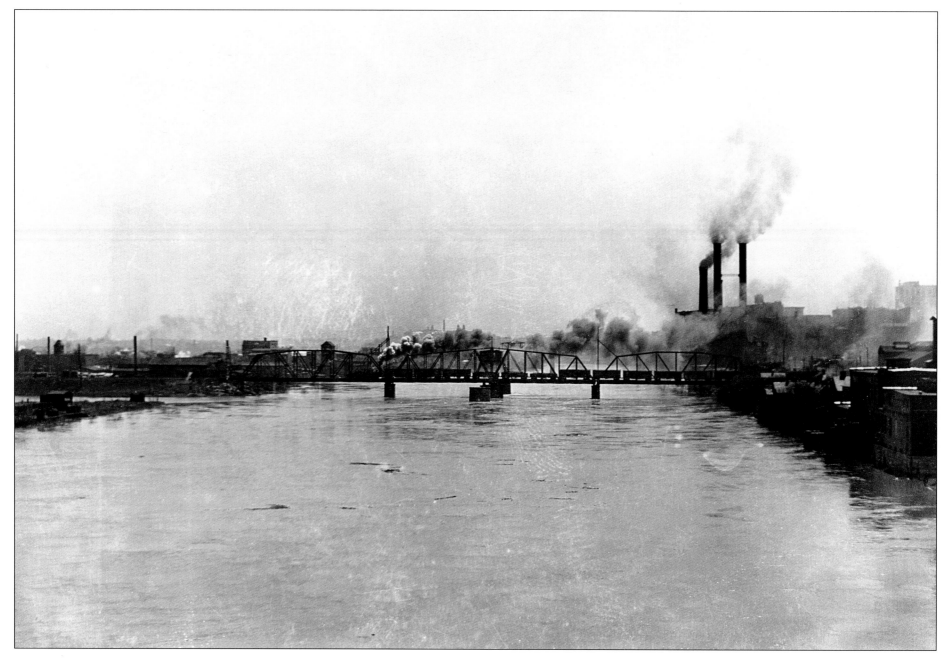

This is the second of two railroad bridges crossing the Cumberland River in Nashville at this site. The first was constructed from wood in the 1850s and was considered a marvel of bridge engineering at the time because it was a swing bridge, designed to pivot open to allow tall steamboat stacks to pass. The wooden bridge was replaced in 1859 by this steel truss bridge that sits on the original stone base. In 1890, its value was listed as $300,000. This view of the "new" railroad bridge was photographed from the Jefferson Street Bridge in 1910 during a flood. The buildings on the right were mills and factories. In the days before locks and dams controlled the water level, floods were a common occurrence.

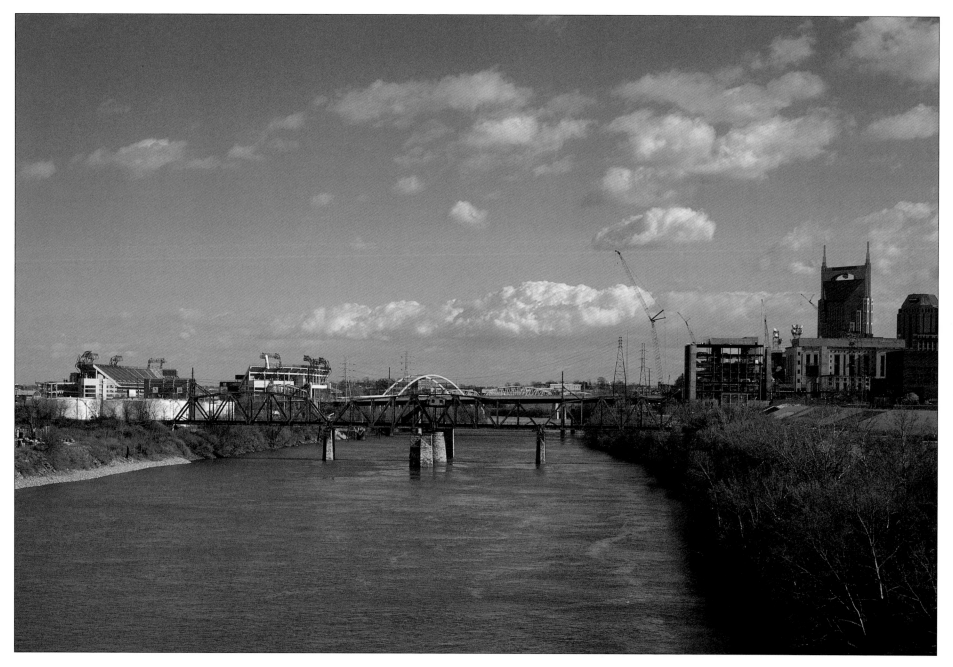

The bridge seen in this view today is the same steel truss swing bridge seen in the previous photograph. Nowadays, the water level is controlled by a series of locks and dams operated by the U.S. Army Corps of Engineers. Offices and apartments replaced the factories and mills that once occupied the west side of the river. The roofs of riverfront apartments can be seen through the trees on the right. Natural gas storage tanks can be seen on the left as well as the Coliseum, home to the National Football League's Tennessee Titans. The bridge is still opened sometimes when the river is high, to allow the passage of barges and riverboats. The two bridges upstream from the railroad bridge are the Shelby Street Pedestrian Bridge and the city's newest, Gateway Bridge, which opened in 2003.

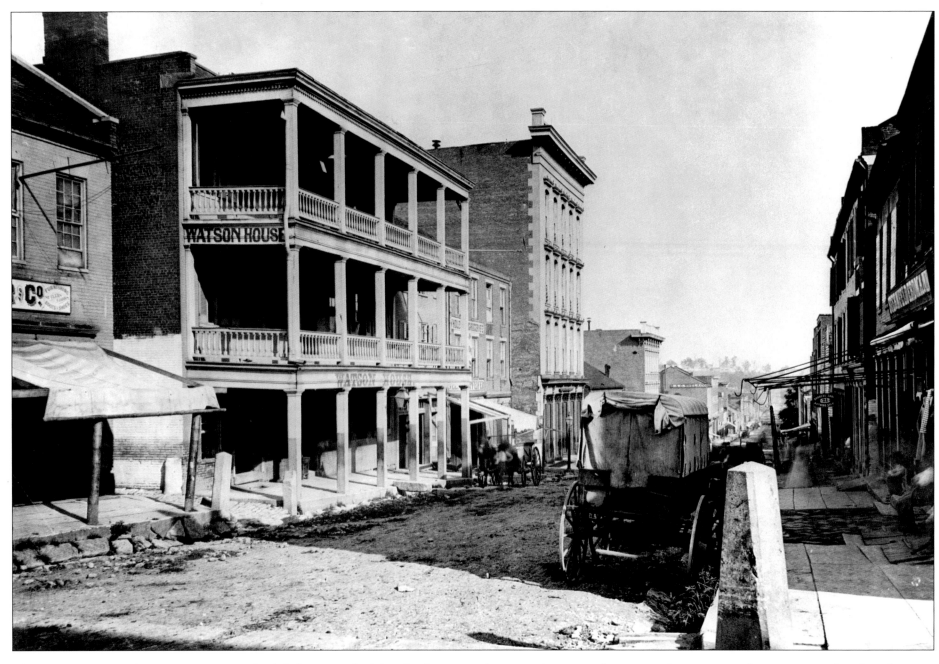

The Union army used Watson House, in the left foreground of this Civil War–era photograph, as part of Hospital Number Nineteen. The three-level Watson House hotel on the east side of Market Street (now Second Avenue) measured forty-two feet by forty-seven feet. The covered wagon across the street from the hotel is an army ambulance. The stone pillar in the right foreground prevented teamsters from cutting the corner too sharply, a feature designed to protect pedestrians. The building two doors down Market Street from Watson House is Morris and Stratton, a wholesale grocery. The Morris and Stratton building was also used as part of Hospital Number Nineteen, holding 300 beds.

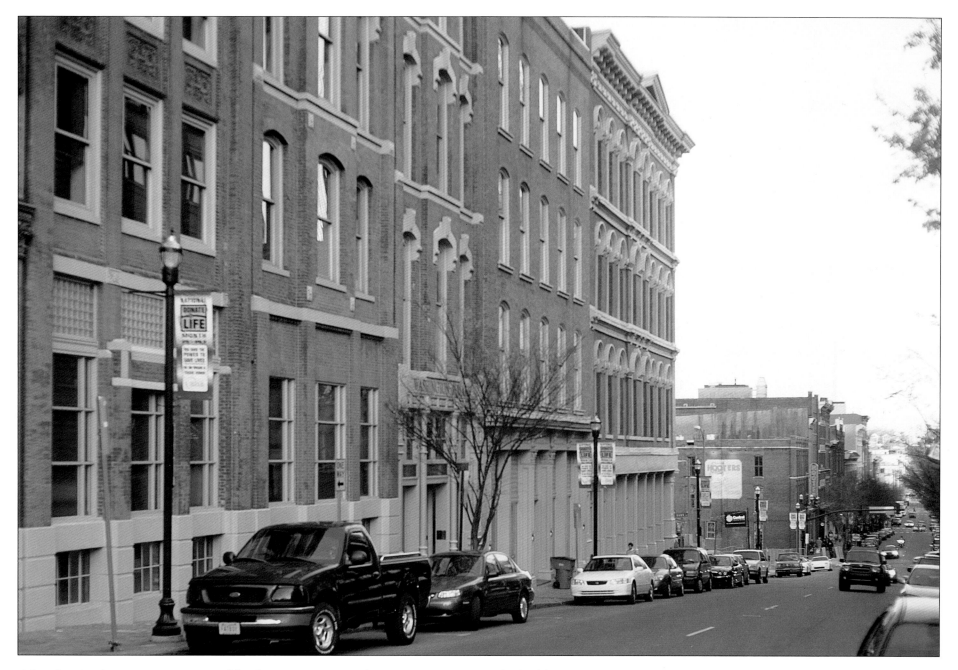

After the Civil War, K. J. Morris and his business partner, Thomas E. Stratton, bought the entire block of buildings on Market Street where Watson House once stood. Watson House was leveled sometime between 1861 and 1864. Washington Manufacturing Company then purchased this entire block in 1942 and continued doing business here until the late 1980s.

The building in the foreground on the left was built circa 1864. The interior of this building has been completely renovated for offices and is now called Washington Square. This section of Second Avenue is at the intersection of Union Street and Second Avenue North on the south side of the public square. Both photographs were taken looking south to Broadway.

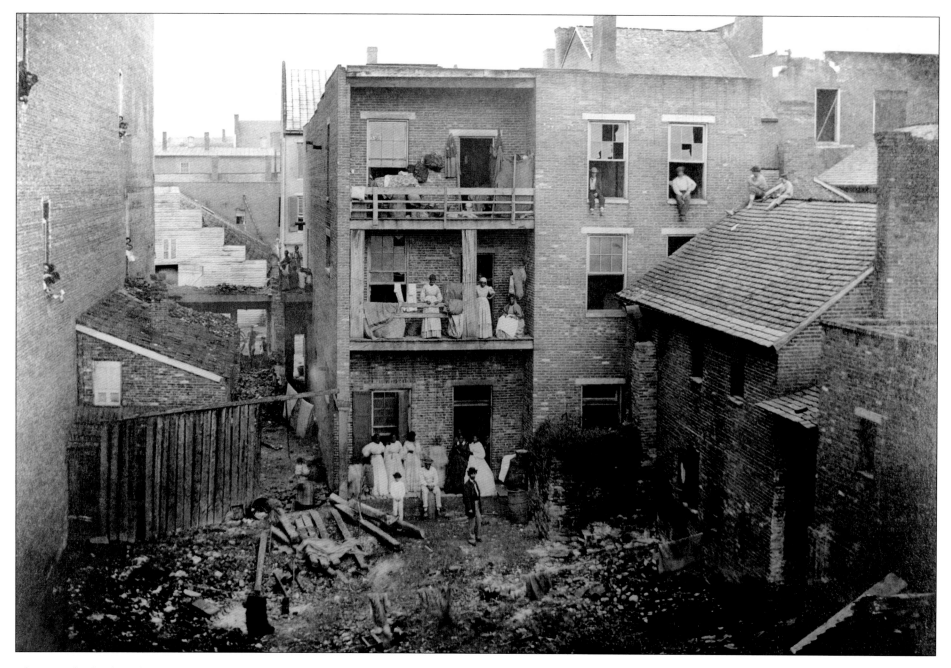

This was the backyard of Union Army Hospital Number Nineteen in the Watson House, seen on the right, and the Morris and Stratton building, seen on the left. It shows the deplorable conditions of the makeshift army hospitals. Sanitation was nonexistent. Wounded or sick soldiers who could walk were bathed, dressed, and assigned a bed. Amputation was the only treatment for serious gunshot wounds or compound fractures, and many such surgeries resulted in serious infection. Diseases killed more soldiers, both Union and Confederate, than combat. This photo was taken during the Civil War by George Barnard, who stood on the roof of a building on Front Street to photograph the hospital.

The site once occupied by the buildings associated with the hospital is now part of Washington Square and Riverfront Park. The yard shown in the previous photograph would have been in the center of this complex of restored buildings. Washington Square backs onto First Avenue, which was known as Front Street in the 1800s. Riverfront Park is situated where some of the earliest commercial buildings in the city were located.

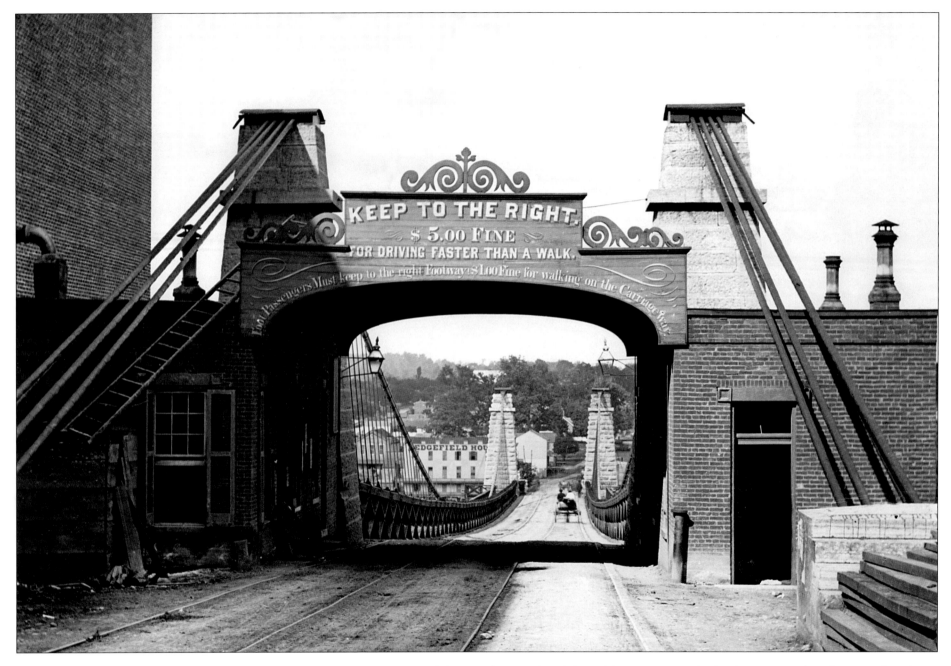

This is the third of five bridges built across the Cumberland River around this area, linking Nashville on the west with Edgefield on the east. The first was a simple wooden structure, while the second and third were suspension bridges. The first suspension bridge was destroyed in 1862 by the Confederate army when word of the approach of Union troops reached the city. Against the wishes of most people in the city, General John Floyd ordered the bridge to be destroyed and the cables were cut. The bridge seen in this photograph, taken circa 1890, used the towers of the earlier suspension bridge but the cables were much stronger, enabling it to carry a load of 7,368,000 pounds. Tolls were charged to pay for the bridge, with prices ranging from a penny for a hog to seventy-five cents for a four-horse carriage. Pedestrians could cross at no charge but would be fined one dollar for walking on the left side.

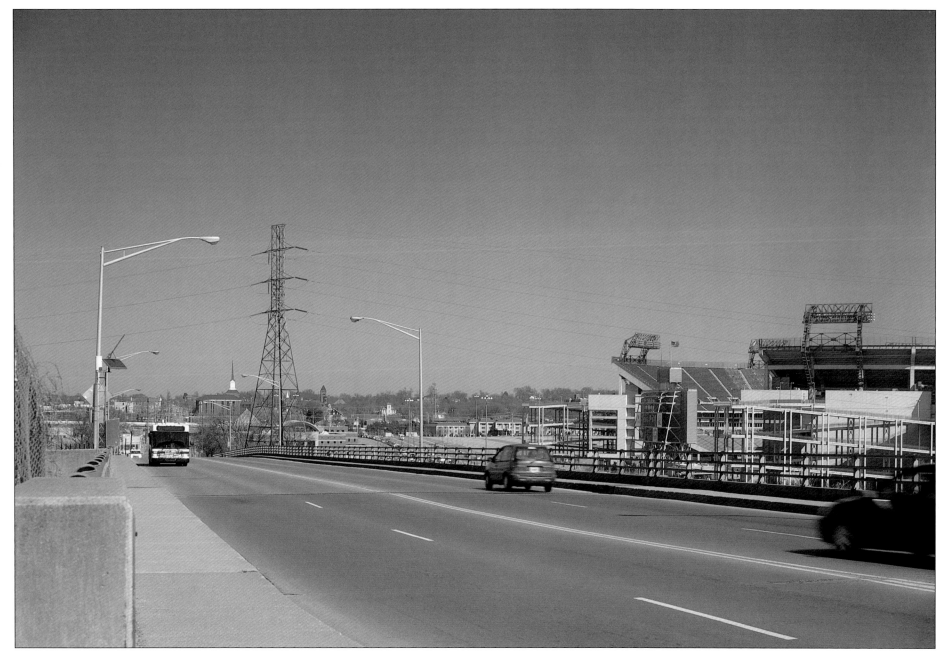

The Woodland Street Bridge today is a modern plate girder design completed in 1960. Woodland Street Bridge is also a memorial, dedicated to Nashville police officers who died in the line of duty. This view is looking east from downtown. The Coliseum is on the right, and the church steeple in the distance is First Church of the Nazarene at South Sixth and Woodland streets. Today, twelve bridges cross the Cumberland River from Old Hickory to West Nashville, including interstate and railroad bridges.

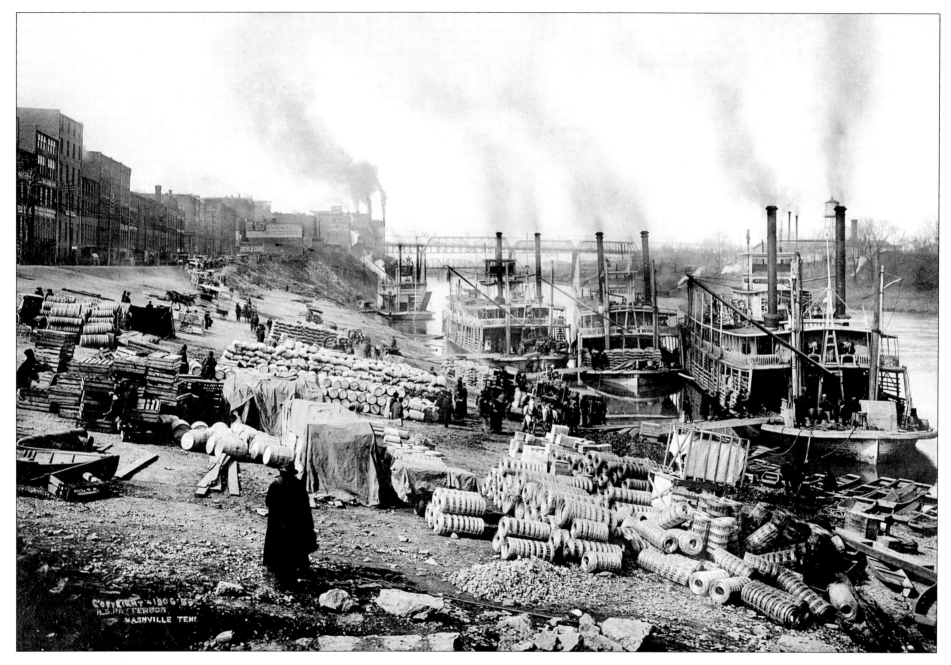

The Nashville Wharf was nothing more than a slope from Front Street to the riverbank, but it became a hub of commerce with the arrival of the first steamboat, the *General Jackson*, in 1817. Steamboats connected Nashville with a seaport in New Orleans and with St. Louis, Louisville, and Cincinnati in the north by way of the Ohio River. They also connected the city to the Mississippi and the Tennessee rivers. The steamboat trade flourished during the Civil War by supplying goods for the Union army. Nashville was a vital link for the Union army with the campaign in the west. Steamboats like those seen in this photograph unloaded rolls of fence wire, barrels, and crates of goods and were reloaded with tobacco, wool, cotton, and lumber. The small boat in the rear was a packet boat used to ply smaller rivers upstream from Nashville. Steamboats served Nashville until about 1925.

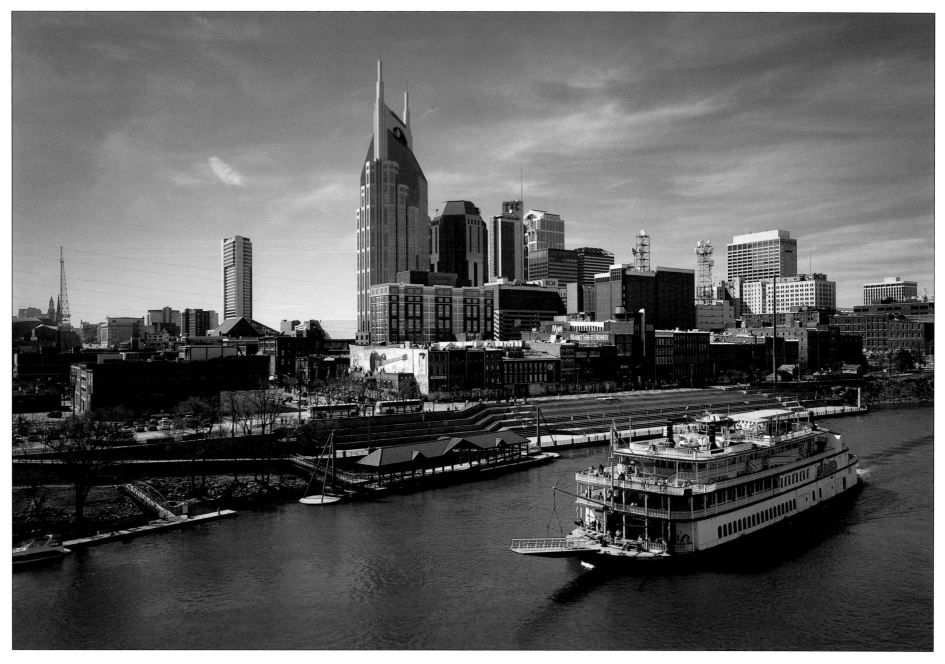

The advent of rail and highway shipping negated the need for a city wharf. Front Street is now First Avenue, and the wharf is now Riverfront Park. Seen here is the *General Jackson* showboat. The *General Jackson*, named for Nashville's first steamboat, makes regularly scheduled cruises from upriver at Opryland to the city. On special occasions, the *General Jackson* docks at Riverfront Park. During the football season, special cruises bring passengers to the opposite bank for football games. The buildings along First Avenue that were warehouses and wholesale businesses in the days of steamboats are now restaurants, clubs, and tourist-related businesses. River commerce continues today. Barges pushed by Nashville's Ingram Barge Company move sand and gravel on the river.

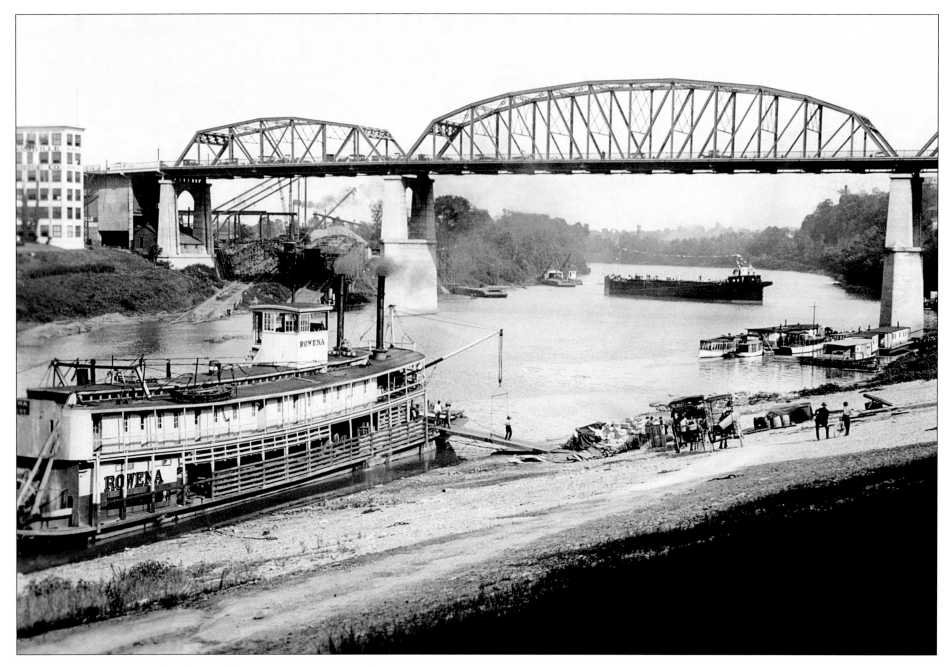

Business and government leaders at the turn of the nineteenth century determined that the city needed a bridge at the end of Broadway to Shelby Street on the east side of town. They felt that this would not only provide a commercial link with east Nashville but would help to clean up a slum area called "Black Bottom" along the river south of Broadway. Work began on the steel truss span in 1907 and the bridge went into service in 1909. The approaches to the bridge on both sides of the river were built of steel-reinforced concrete, an innovative construction process in those days. Soon after the bridge was put into service, its name changed to the Shelby Street Bridge.

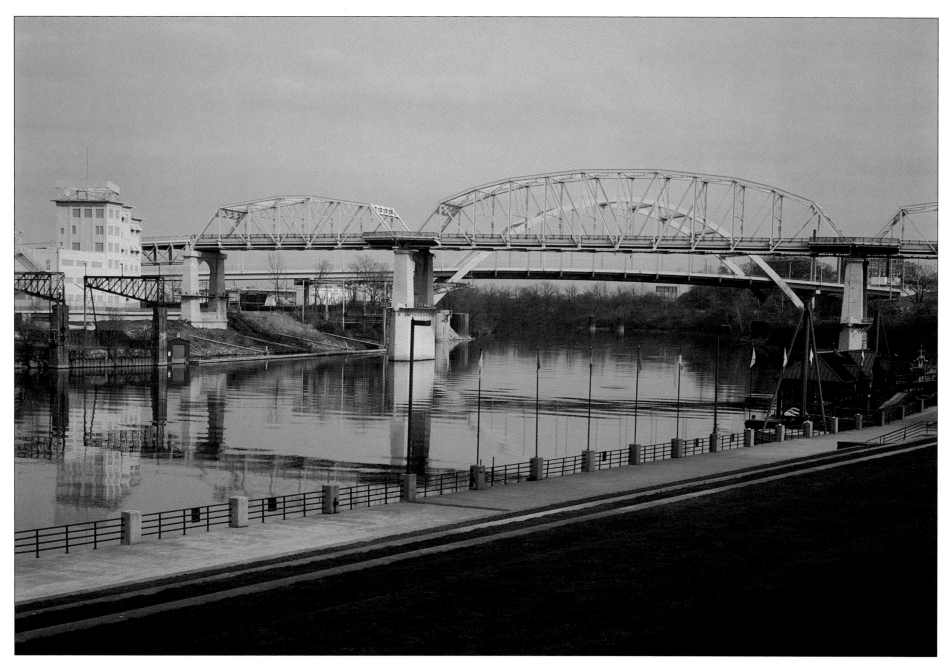

Shelby Street Bridge was in daily use with the exception of a few short closures for normal maintenance—but in 1998 the century-old span was deemed unsafe for heavy vehicle traffic. Rather than replacing the bridge with a new one, the city government decided to convert it to a pedestrian bridge and build a new four-lane bridge a few hundred feet upriver. During the early part of the renovation, the contractor mistakenly demolished the original approaches. The State of Tennessee put up the money to rebuild the approaches and hired a new contractor. The bridge is painted "Tennessee" silver and is lighted from underneath at night. Four balcony-like observation decks were added, one on each side, and the surface is covered with wood pavers. This structure is said to be the longest pedestrian bridge in the world.

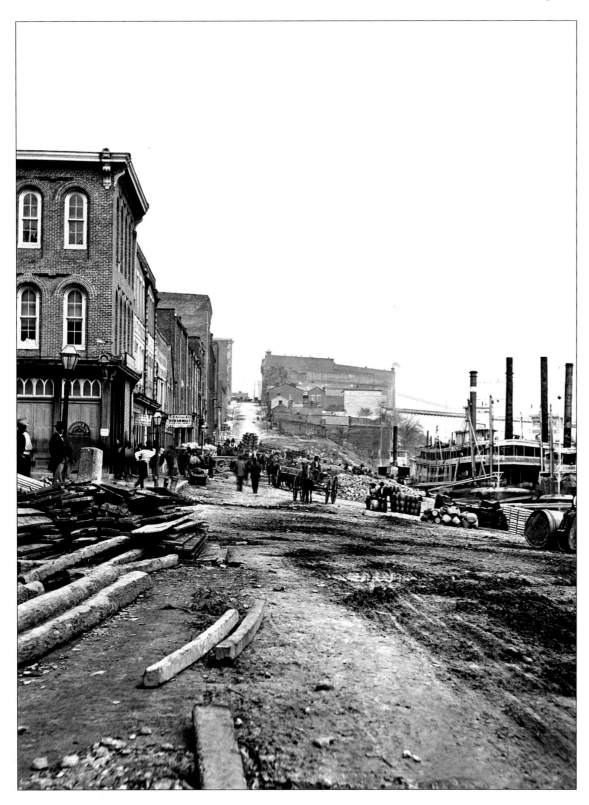

This photograph, dated around 1872, was taken when the river was high, as evidenced by the steamboats. The street directly in front and running up the hill is Front Street; Broad Street is to the left. The sign on the corner building reads "Hardison and Sons," and a business on Front Street is C. H. Arthur and Company, Steamboats. An annual report published in 1890 listed nineteen steamboats "plying" the Cumberland River out of Nashville, not taking into account boats from other cities. A partial list from that 1890 report listed 34,000 barrels of flour, 700,000 bushels of grain, 7,000 head of livestock, 7,000,000 feet of lumber, 15,000 tons of merchandise, and 21,000 passengers carried by steamboat above and below Nashville. Many of the steamboats working out of Nashville were built here.

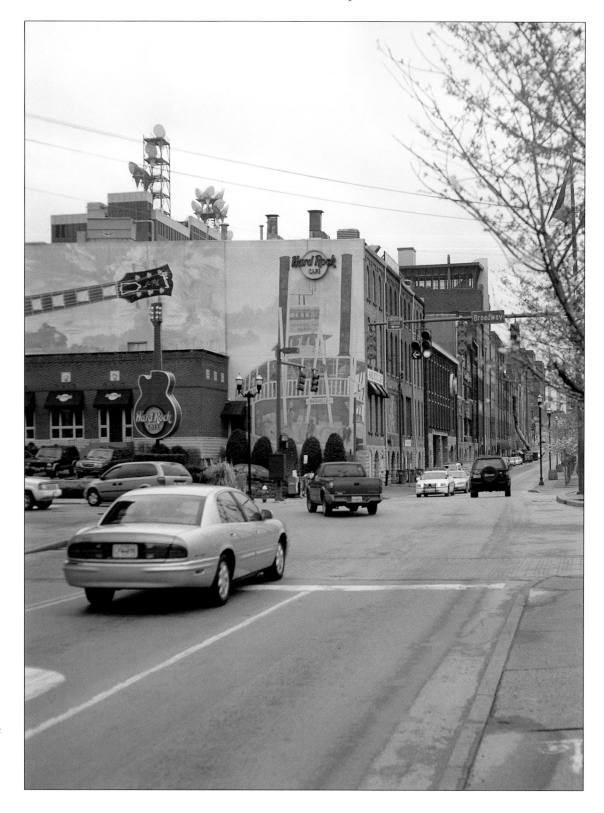

The corner of Broadway and First Avenue still bustles today, though the activity is of a different kind than that of the 1800s. Tourists have replaced steamboat passengers, and the warehouses are now all located on the fringes of the city. The Hardison building on the corner is now the parking lot for the Hard Rock Cafe. The Hard Rock building extends from First to Second Avenue. Tourists and Nashvillians alike visit downtown for the music, restaurants, and sports, converging in this area, which is referred to locally as "the District." On New Year's Eve and the Fourth of July each year, as many as 50,000 people gather at the riverfront for fireworks displays.

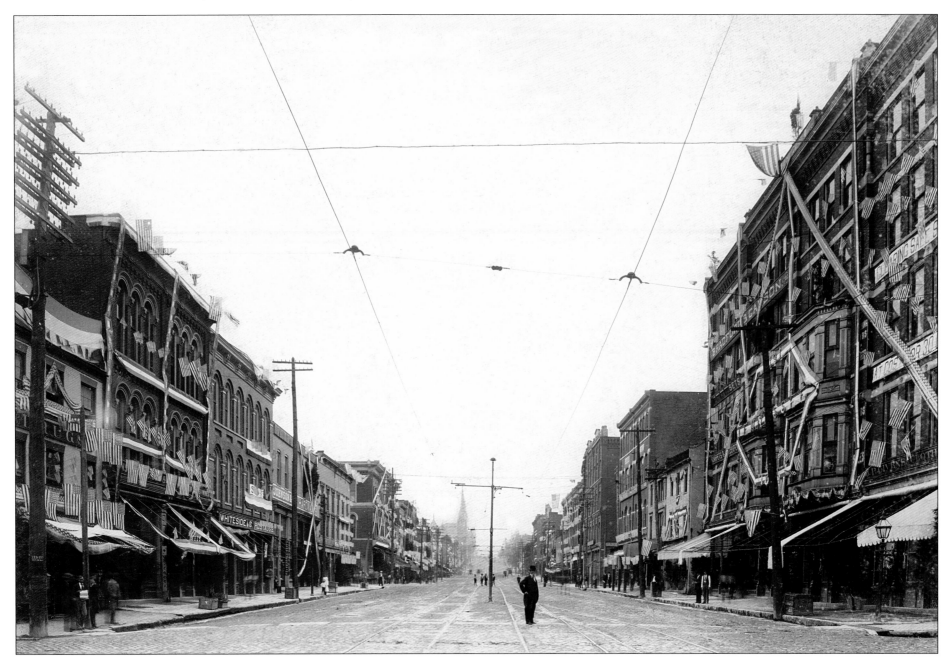

This photograph of Broad Street was taken looking west from Market Street in 1889. The buildings along both sides of the street were decked out in flags and streamers in celebration of Tennessee's centennial; the centennial grounds were two miles west of here. This photograph was taken from the middle of the cobbled street for use in a court case. The photographer probably placed the man in the center of the street as a point of reference.

The businesses along Broad Street included hardware, furniture, and clothing stores on street level, with offices and residences on the upper levels. On each of the buildings, next to the storefront, was a separate door opening into a stairwell. The crossed poles in the center were used to support overhead electric cables for the streetcars.

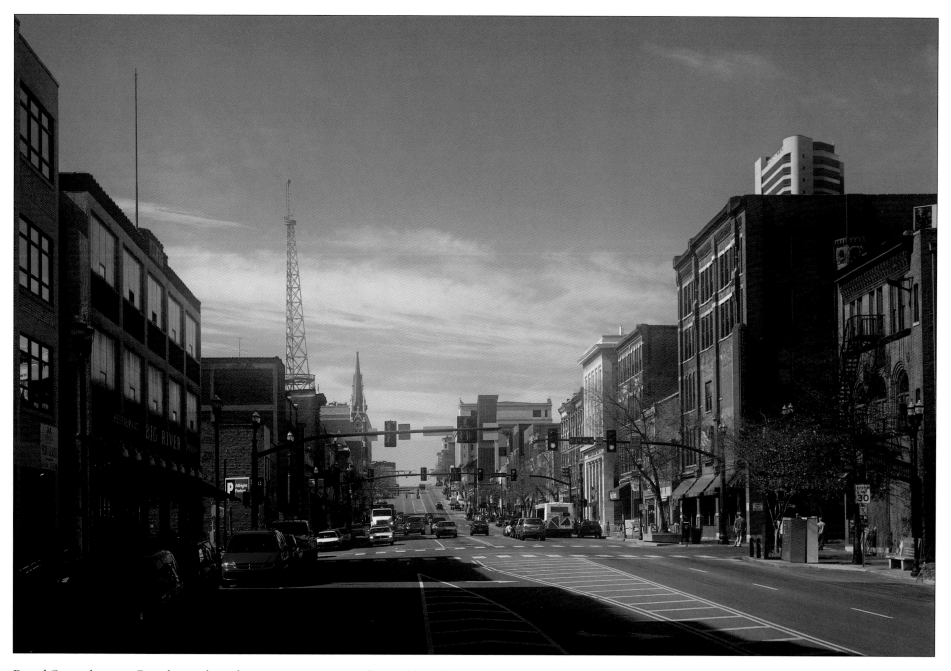

Broad Street became Broadway when the street names were changed in 1904. With the demise of the steamboat industry around 1925, the character of what came to be known as "Lower Broad" began to change. The big open buildings were perfect for businesses selling large items such as furniture and pianos. In time Lower Broad was populated with furniture stores, restaurants, pawnshops, honky-tonk nightclubs, and two banks. When the Grand Ole

Opry moved into the Ryman Auditorium in 1943, less than one block off Broadway, the character of the street changed even more. Today Lower Broad is a tourist destination of gift and record shops, restaurants, and music venues such as Tootsie's Orchid Lounge, a well-known honky-tonk. The tower in the left center of this photograph is the Gaylord Entertainment Center, home of the NHL's Nashville Predators and a venue for concerts.

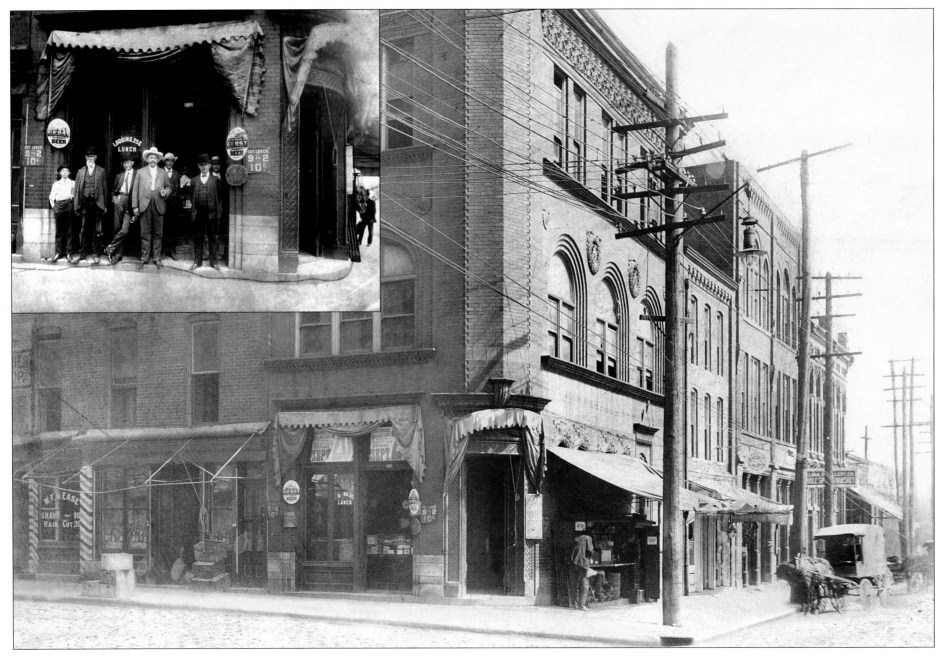

Around 1890, V. E. Schwab and his brother-in-law George A. Dickel hired architect Julius Zwicker to design a new building to house a saloon at the corner of Market and Broad streets in the heart of the wholesale district. It was named for the silver dollars embedded in every other floor tile. A glass case by the entrance, separated from the drinking area by swinging doors, was filled with cigars and tobacco. A gas burning pipe was suspended from the ceiling, providing a convenient flame to light cigars. Dickel also owned a wholesale business selling wine, whiskey, and cigars—George Dickel Tennessee Whisky is still distilled and bottled today in Tullahoma, Tennessee. From 1891 to 1901 the proprietor of the Silver Dollar was W. W. Parminter, a steamboat captain who catered to men brought in by the river trade. The inset shows patrons of the Silver Dollar posing for a snapshot.

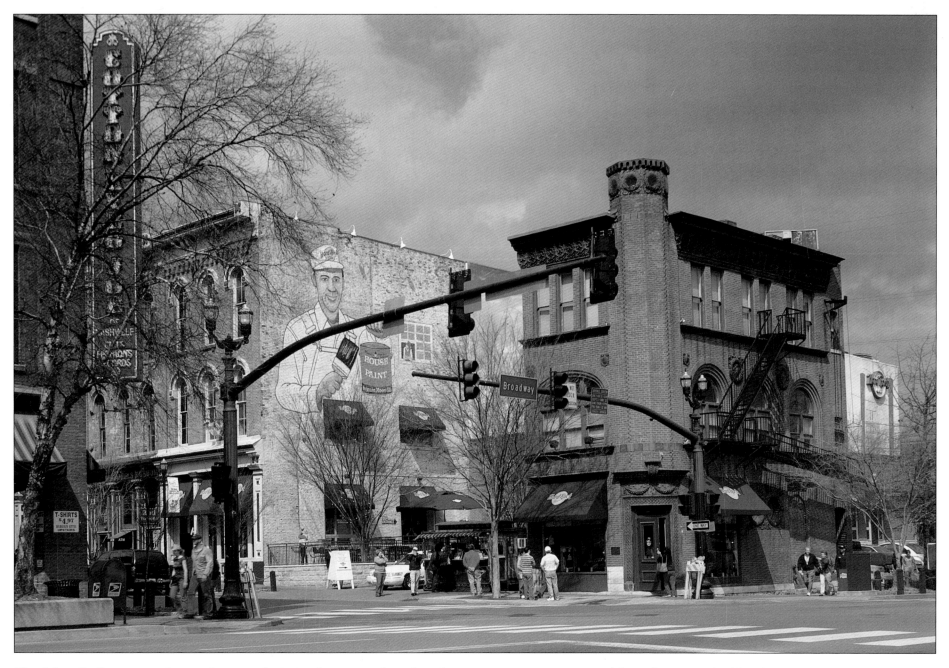

The Silver Dollar operated as a saloon until 1910, when it was forced to close its doors by a law encouraged by the Anti-Saloon League headquartered in Nashville. In the ensuing years the Silver Dollar building has been used for various restaurants and was for a short time the offices of the Metro Historical Commission. Whether by design or by good fortune, the exterior remains unchanged. Today it houses the gift shop for the Hard Rock Cafe. The restaurant is separated from the corner building by a narrow parking lot once occupied by the Hardison building. The unusual sign on the face of the main Hard Rock building is a remnant of the previous tenant, Phillips and Quarles Hardware Company, a wholesale hardware business. The sign advertising Moore Paints was touched up by the artist and integrated into the Hard Rock mural. The "Moore Man" has become a local landmark on Lower Broad.

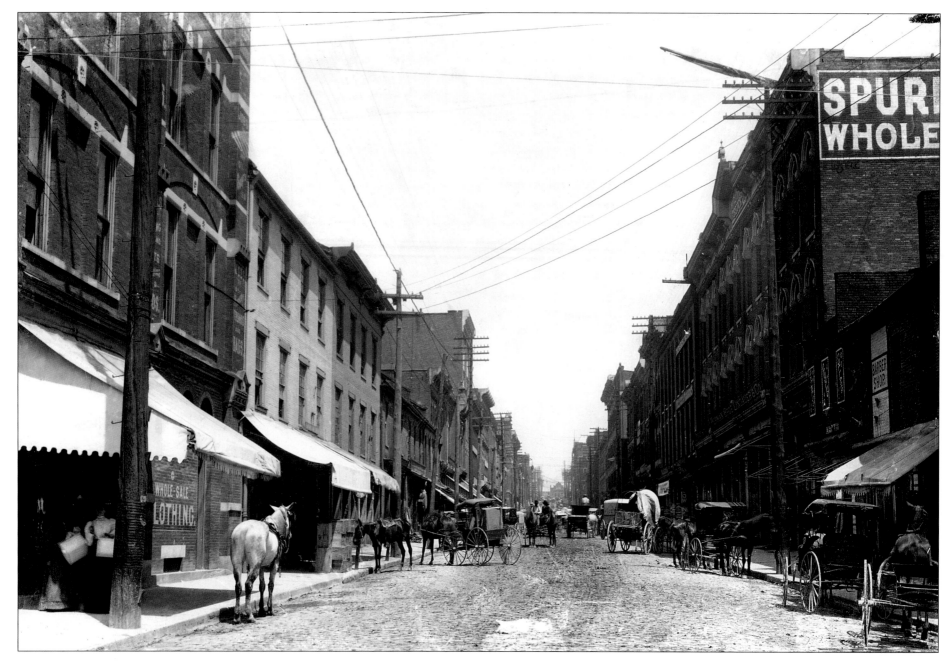

After the dust cleared from the Civil War and life began to return to normal in Nashville, businesses on Market Street once again thrived. Nashville had been spared the destruction experienced by other Southern cities. Some businesses in the city, especially the steamboat companies, prospered during the war. By the time this photograph was taken around 1890, all evidence of the Civil War had disappeared from Market Street. This photograph was taken from Broadway looking north. The buildings on the right were long and narrow, extending in the rear to Front Street. Basement doors in the rear of the buildings opened onto Front Street and the wharf. Wagons and stevedores only had to move a few yards to load and unload freight from steamboats. In later years, when the railroads played a larger part in moving freight, a spur line ended a few blocks from the wharf.

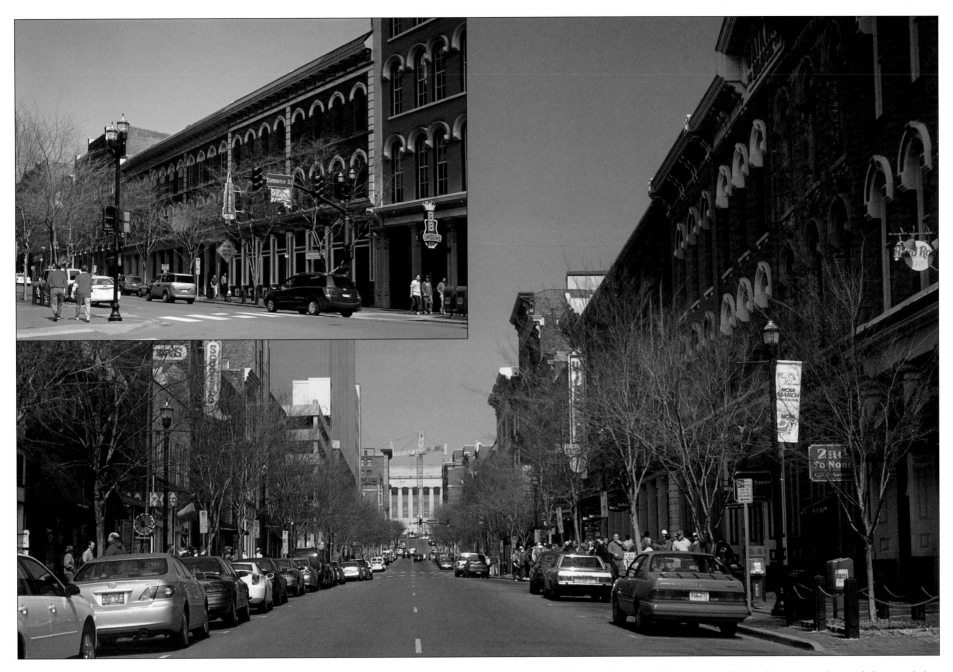

Second Avenue may be the only street in Nashville still referred to on occasion by its original name. Buildings on the north end of Second Avenue between the public square and Church Street have been converted into offices, many of which are occupied by lawyers. From the intersection of Church Street south to Broadway are restaurants, clubs, gift shops, and one saloon. One business that was instrumental in maintaining the character of the street is the Wild Horse Saloon, a multilevel country-themed dance club owned by the Gaylord Company. A utilitarian warehouse built in the 1930s was removed to make way for a new structure that would meet the city's fire codes. Gaylord Company replaced it with a building that is so well suited to the architecture of the street that most people don't know it is new. The inset shows B. B. King's Blues Club and Havana Lounge.

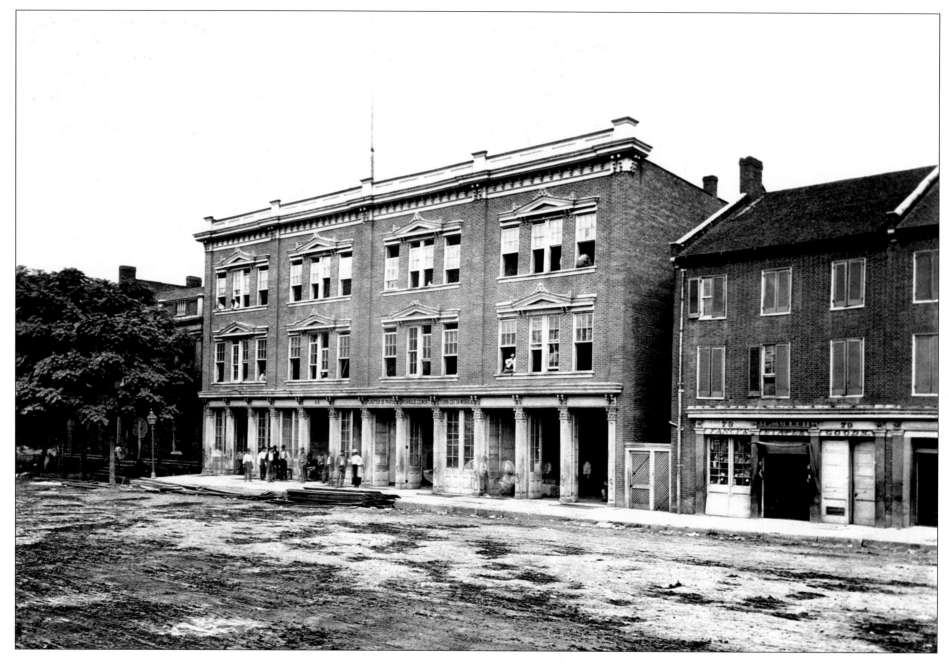

George Barnard photographed this business at 77 Broad Street, which was owned by William Stockell during the Civil War. Stockell sold cement products, plaster of Paris, plastering hair, hydraulic cements, fire bricks, fire clay, and terra-cotta ware. He also sold architectural features such as surrounding doors and windows, as well as porch columns cast in plaster or masonry. Judging by the size and quality of the building, it was a thriving business. This structure was recorded as a brick building measuring eighty-eight feet by ninety-two feet with a composition roof and a 250-bed capacity. It was part of Hospital Number Three during the Civil War.

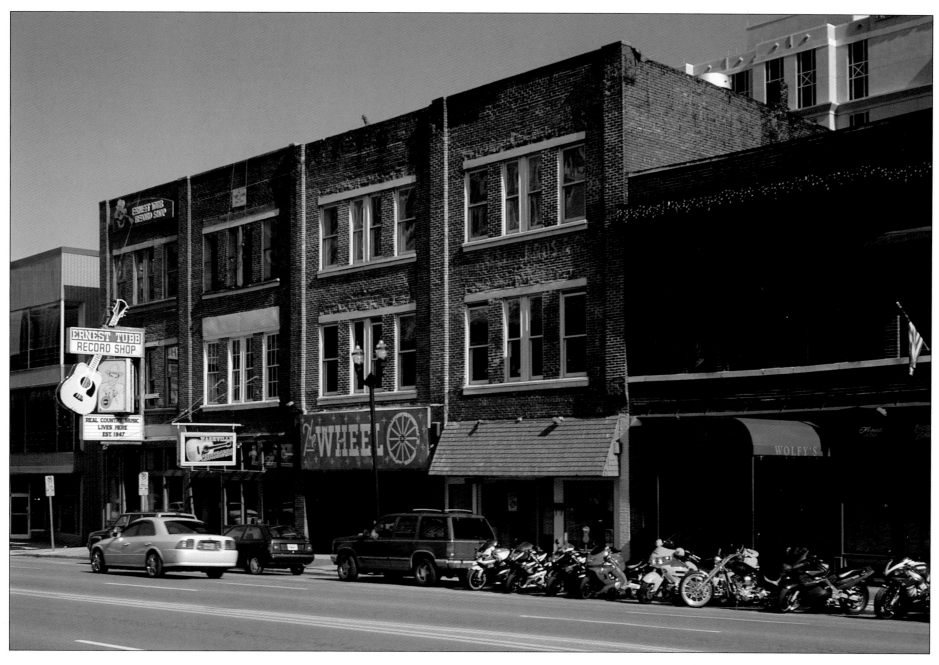

The building today between Fourth and Fifth avenues on the south side of Broadway is situated about halfway between the Gaylord Entertainment Center and Market Street. The Ernest Tubb Record Shop at 417 Broadway, opened in 1947, is one of the oldest businesses on Broadway. It's a time capsule of old country music posters and portraits of country music legends. The store was opened by Grand Ole Opry legend Ernest Tubb. On Saturday nights after the Grand Ole Opry, fans could walk around the corner and across the street for the Midnight Jamboree live radio show. The record store has a vast stock of hard-to-find country music CDs as well as songbooks, DVDs, cassettes, and videos. The Midnight Jamboree has moved to a second location near Opryland Hotel. The remainder of the building has seen a succession of bars and restaurants catering to music and sport fans.

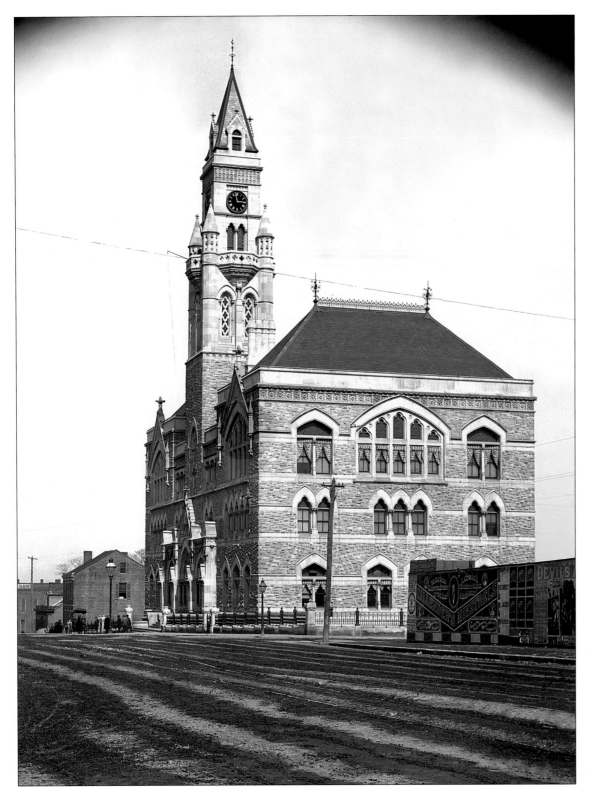

The U.S. Customs House was the first federal building in Nashville. President Rutherford B. Hayes laid the cornerstone at the corner of Broad and Spruce streets (now Eighth and Broadway) using a silver trowel in September 1877. The building was completed in 1882. *A History of Davidson County*, published in 1880, described the architecture as "Pointed Gothic." Prior to 1850, only coastal port cities had customshouses. In 1850 the federal government authorized customshouses for two interior cities, St. Louis and Cincinnati. Nashville had been promised a federal building and became one of thirty interior cities to get a customshouse. The U.S. Treasury Department had jurisdiction over customshouses and the name became an umbrella term to describe federal buildings. The Nashville Customs House was the post office, federal courthouse, and currency exchange office.

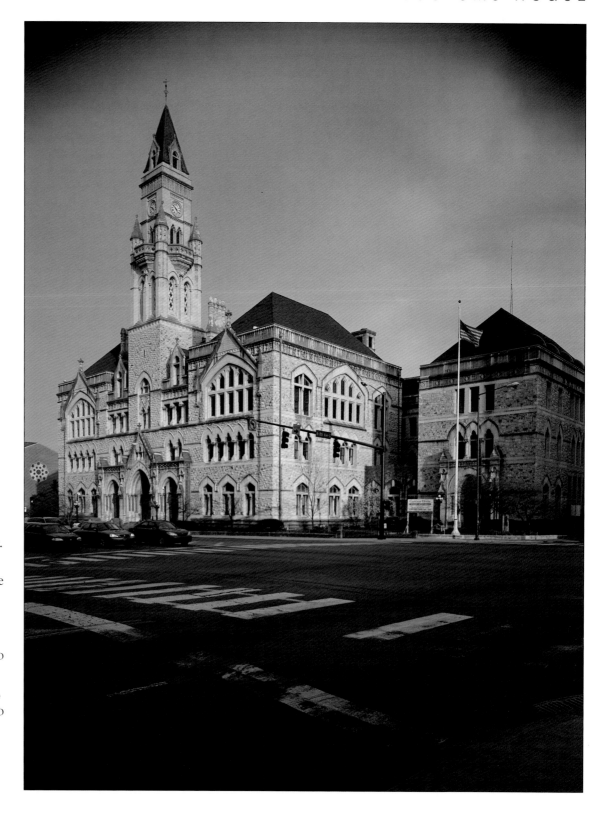

The Customs House was in service until 1952, when a new federal building was opened on the next block of Broadway, and most federal offices moved across the street. For a time the U.S. Army Corps of Engineers used one of the elegant courtrooms for a drafting room and painted the walls army green. In 1972 it was declared surplus property by the federal government. That same year it was placed on the National Register of Historic Places. In 1979 the Metropolitan Government of Nashville began looking into the prospect of taking it over. The Customs House now belongs to the city and houses the U.S. Bankruptcy Court, as well as some offices. The courtroom has been restored to it original elegance.

Hume High School opened in 1855 at the corner of Broadway and Spruce Street; it was Nashville's first public school. In 1875, Fogg High School opened on the same property, facing Broadway. The two schools were combined and moved into this newly built building in 1912. The school was named for David Hume, an early advocate of public education, and for Francis Fogg, an attorney and a member of the city's first board of education.

Hume-Fogg High School became the first school in Tennessee to be accredited by the Southern Association of Colleges and Schools. From the school's opening until 1940, it followed a classic curriculum that included Latin, English, advanced mathematics, and science. In 1953 the curriculum was changed to include technical and vocational subjects.

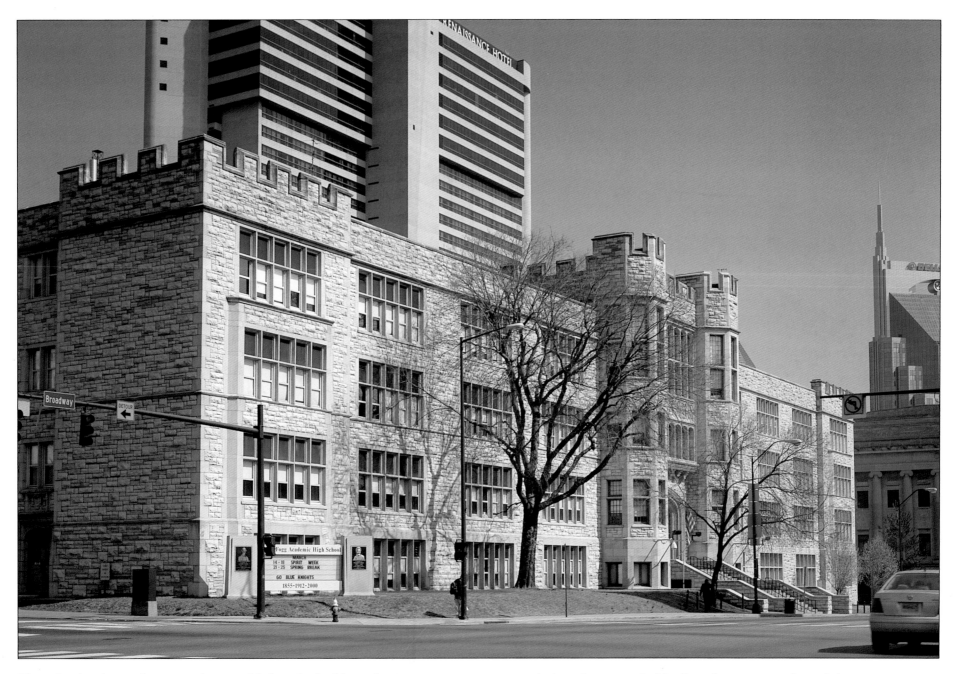

The school today, with a second wing added to the building, draws academically gifted students from all of Nashville and Davidson County. Under a court-ordered desegregation plan, the school's new program was designed to draw gifted students regardless of race. Enrollment began with grades nine and ten and added one grade per year until 1985. The first class graduated in 1986. Only 60 percent of students who apply for enrollment are accepted. A student must hold a B grade average with no failing scores in order to be accepted. The school's enrollment today is around 850 students representing every socioeconomic, cultural, and racial group throughout Nashville. Of the forty-four faculty members at Hume-Fogg, thirty-nine hold advanced college degrees.

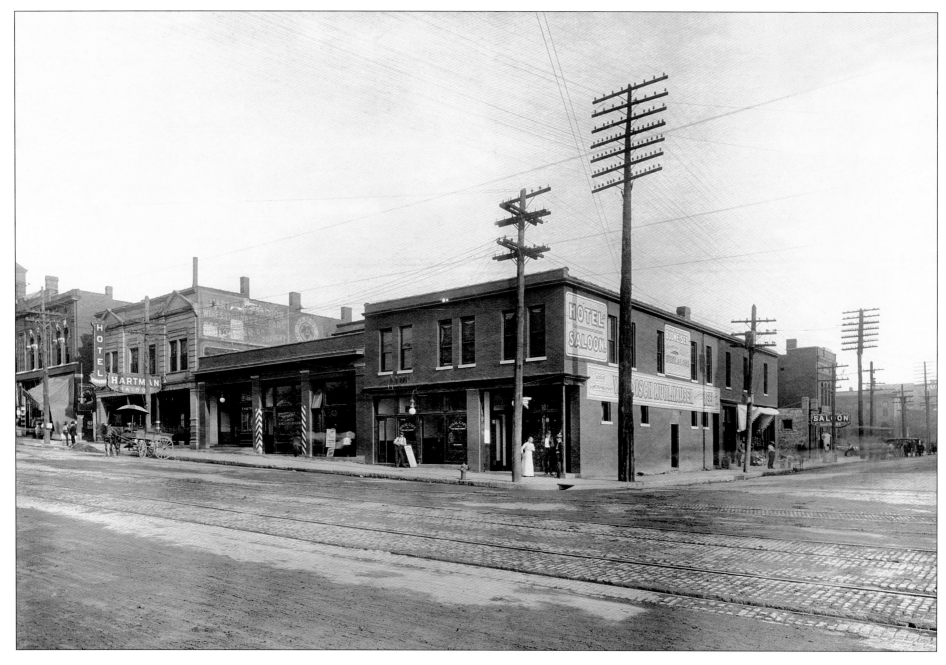

This photograph was taken after 1900. The buildings taking up the block from Ninth to Tenth avenues on the south side of Broadway provided facilities for layover rail passengers, especially traveling salesmen and businessmen. A hotel and saloon stands on the corner in this view. Behind the hotel on Tenth Avenue are a market and a sign for the Hartman Saloon. To the left of the hotel/saloon facing Broadway is the Royal Café. Left of the Royal Café between two unidentified buildings are the stripes for a barbershop. On the far left stands the Hartman Hotel. A newly arrived rail traveler could get a cool mug of beer, a haircut and a shave, dinner in the Royal Café, and a room for the night. Union Station is to the right of the photograph, out of view.

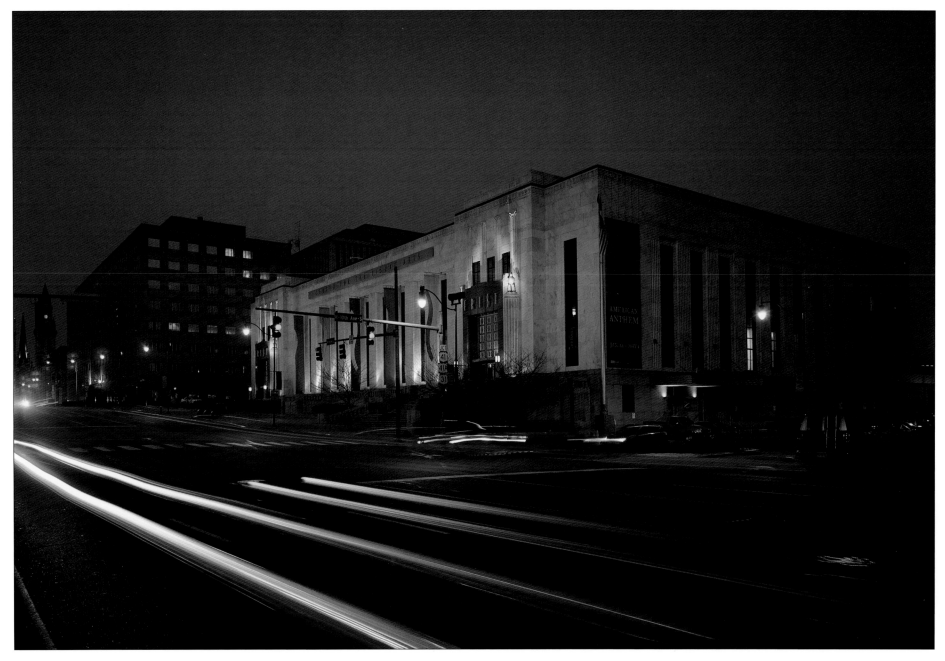

This was Nashville's main post office from 1934 to 1987. When the U.S. Postal Service opened a new main post office near the airport, other uses were considered for the building. In 2000, it was reopened as the Frist Center for the Visual Arts. It was remodeled at a cost of around $35 million, of which $25 million was donated by the Frist Foundation and the family of Dr. Thomas F. Frist Jr. The Art Deco interior was left intact, the large mail handling room was turned into galleries, and the street-level offices are now a gift shop. Art exhibited at the Frist ranges from old masters and folk art to stage clothes designed by Manuel, a renowned Nashville designer. Jazz performances are held in the courtyard, and live chamber music can be heard inside. A post office is located on the lower level on the Tenth Avenue side, designed to blend in with the 1930s style of the building.

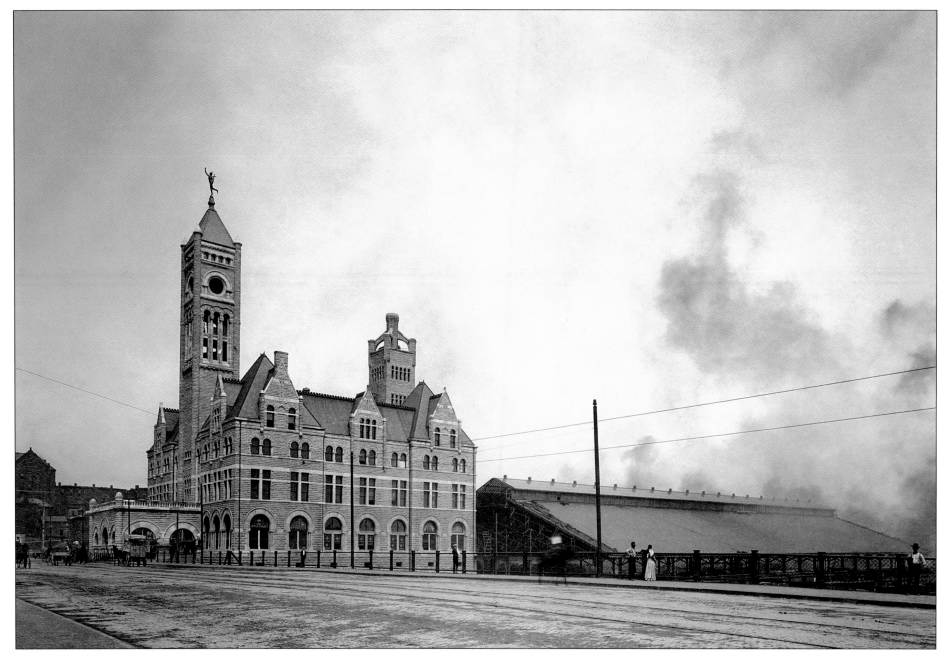

Union Station was opened for business in 1900 by the Louisville and Nashville (L&N) and the Nashville, Chattanooga, and St. Louis (NC&StL) railroads. The first train to leave the station was pulled by NC&StL's engine number five. Richard Monfort, chief engineer for L&N, designed Union Station. The architectural style was described as Richardson Romanesque. The entire building and tower were built of gray stone and Tennessee marble at a cost of $300,000. The interior of the station had a vaulted stained glass skylight ceiling and marble floors. A bronze statue of Mercury, the mythical Roman god of speed, topped the clock tower, which housed an early version of a digital clock. The statue was blown off in the 1950s by a tornado. This photograph was taken before the clock was installed.

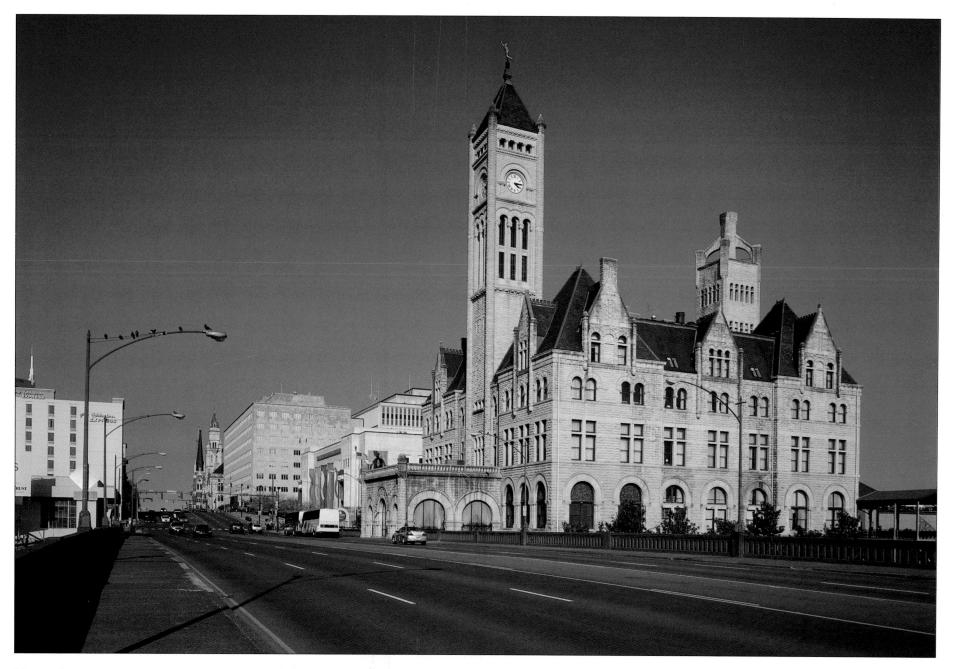

Union Station was in constant operation until the last passenger train left the station in 1978. There were preliminary plans to convert it to a federal office complex. Instead, it was purchased by hotelier Leon Moore of Gallatin, Tennessee, who converted it into a hotel. Careful attention to detail kept the building faithful to its original design. A local craftsman extended the stair rails and banisters to a height to meet building code requirements. Moore

eventually sold the hotel. Today, Union Station Hotel is a Wyndham Historic Hotel. The statue of Mercury has been replaced with a somewhat smaller silhouette of the original design, painted to appear three-dimensional. The train shed remained in its original condition. It deteriorated until it was unsafe to use and was removed.

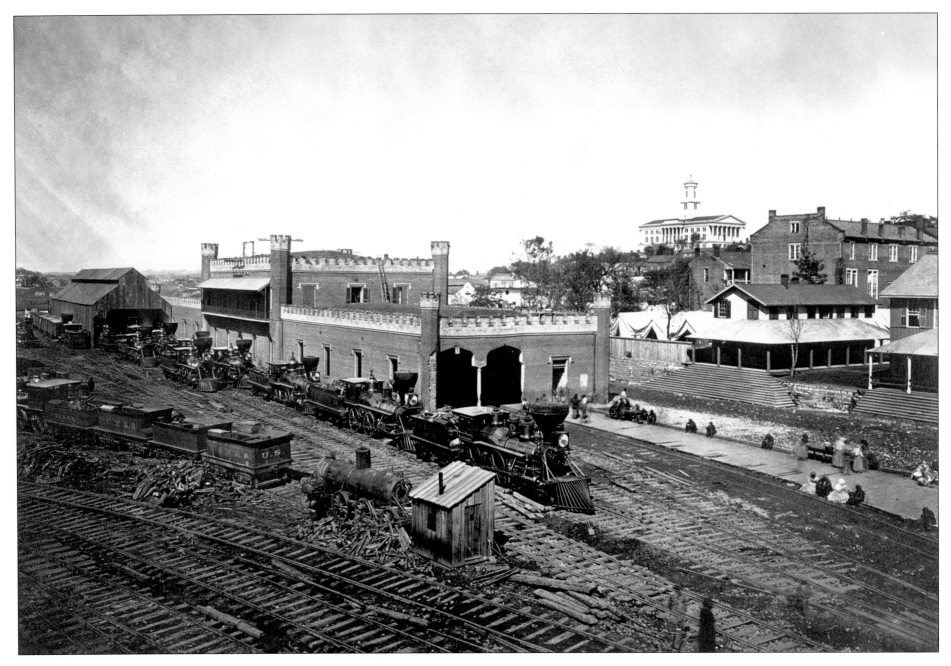

This picture shows the rail yard of the Nashville, Chattanooga, and St. Louis Railway during the Civil War. Thirteen engines are in this view from south of the capitol, seen in the background. The railroads were a vital link for supplying the Union army in Nashville, and Nashville became the main supply depot for the Union army in the western area. The army built a warehouse in the rail yard to hold food, clothing, and ammunition and added a printing shop to the passenger depot (the castellated Gothic brick building in this photograph). The army expanded the size of the rail yard and added more shops, including a new roundhouse to repair rolling stock.

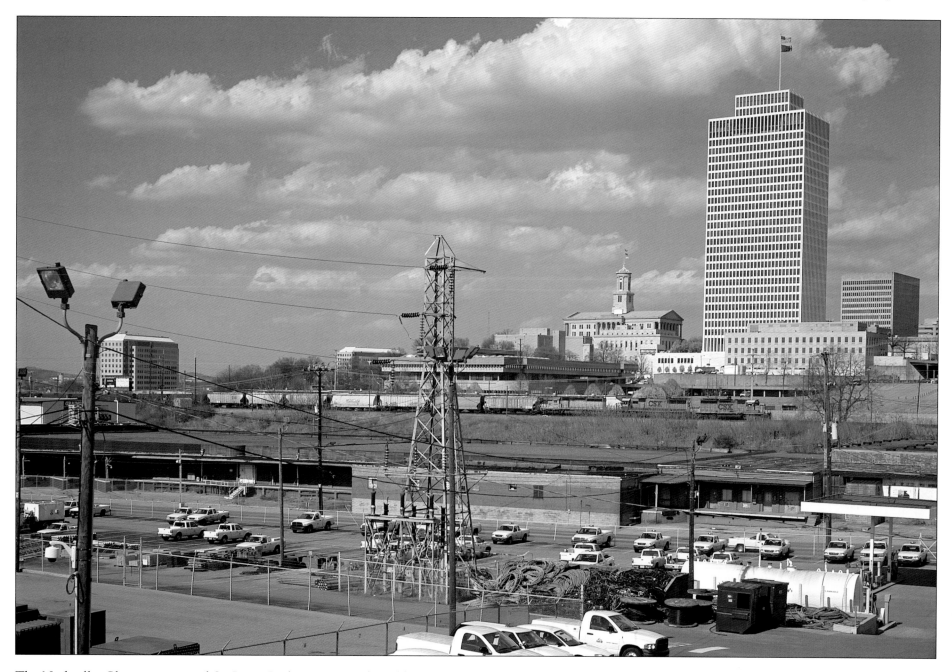

The Nashville, Chattanooga, and St. Louis Railway was purchased by the L&N shortly after the opening of Union Station. The NC&StL depot building sat unused well into the 1950s. The area today is referred to as the Gulch, and trains continue to travel on rail beds near the old site. This photograph was taken looking northeast from the elevated parking lot of the Nashville Electric Service office. Union Station is on the right, out of view from this angle. The building from which the Civil War photograph was taken would have been underneath this location. The original tracks have been removed and commercial businesses as well as the Nashville Electric Service offices occupy the site.

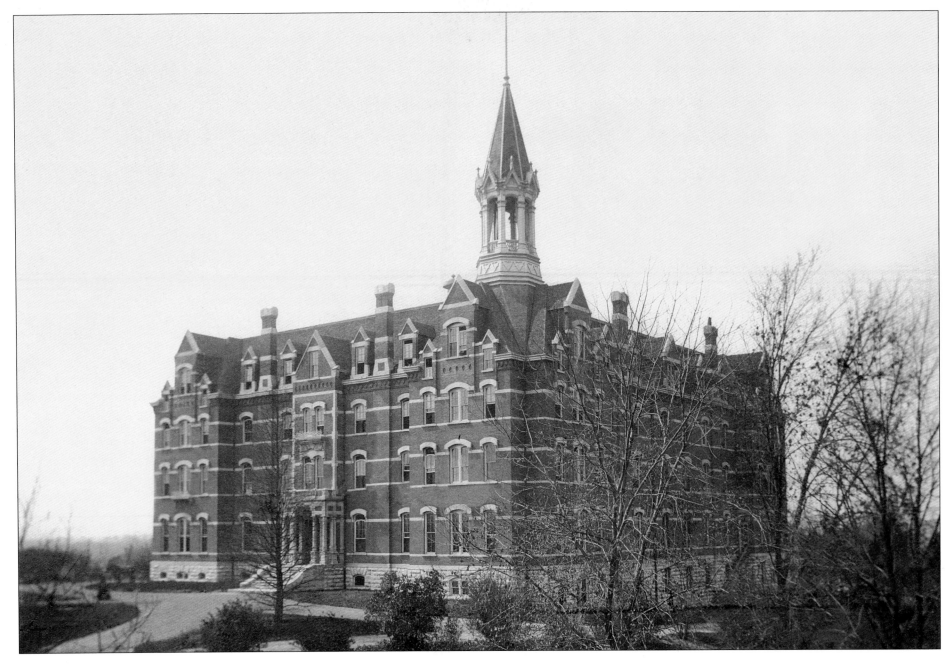

Jubilee Hall has held a place of honor on the campus of Fisk University since 1876. It's named for the Fisk Jubilee Singers, who took their name from the Old Testament's year of Jubilee, which marked the deliverance of the Jews from bondage in Egypt. Fisk University was founded shortly after the close of the Civil War to educate the newly freed blacks of Nashville. Early in the school's existence, its future in doubt, a small group of singers coached by teacher George L. White began touring the country in 1872 to raise money for the school. They were not always accepted openly at first, but once they began singing, tearful audiences stood for them. They came home from that first tour with $20,000 for their school. Jubilee Hall was paid for by money raised on tours by the Jubilee Singers.

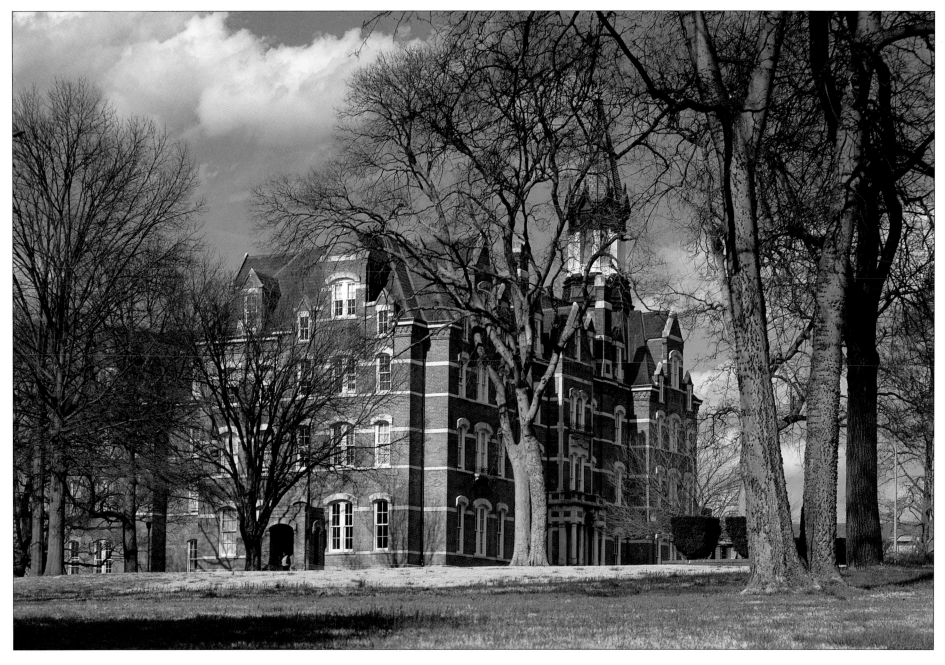

In the early 1960s, the administration of Fisk considered demolishing Jubilee Hall. The wooden interior had deteriorated and the floor space wasn't suitable for the school's needs. It was determined, however, that Jubilee Hall held too much tradition and significance to be destroyed. Goodwin and Beckett, an Atlanta architectural firm, redesigned the interior, and Boon Contractors carried out the work. Interior designer Stephen Ferris of Nashville was hired to carry out the plans. The exterior was in good condition, only needing to be cleaned, and a new slate roof was installed. Much of the original wood was reused and window frames were numbered and reinstalled. The whole interior of the six-story structure was gutted and rebuilt. Jubilee Hall was put back in service in 1966.

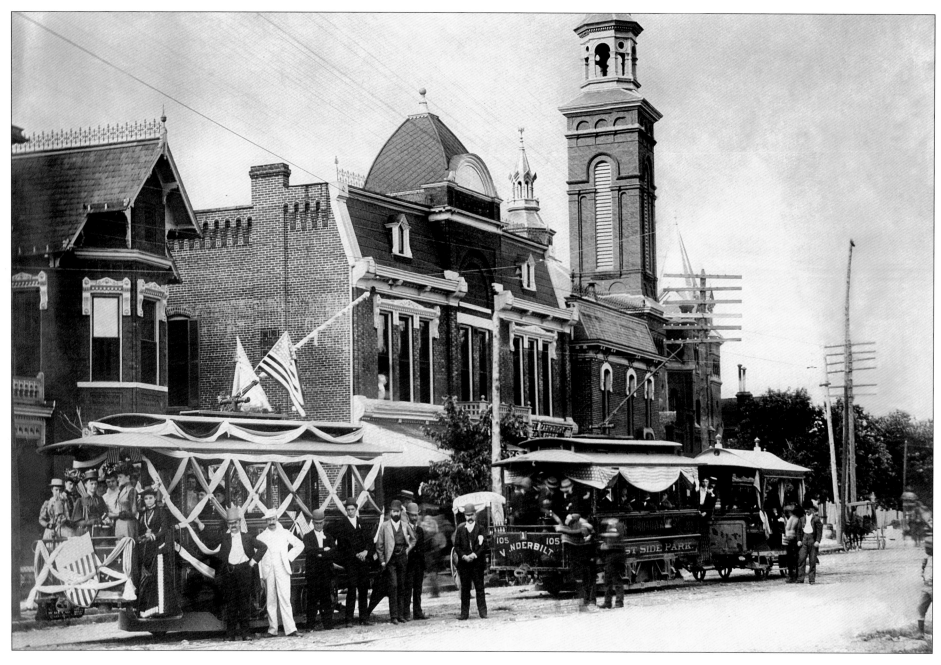

The first electric streetcars went into service on April 30, 1889. The first passengers on that inaugural run posed for a photograph with the decorated cars at the intersection of Sixteenth Avenue and Broadway. The buildings in the background were typical of new homes of the time in the fashionable neighborhood of West End. The church on the right behind the second streetcar was West End Methodist Church. Nashville was the second city in the country after Baltimore to use electric streetcars. The *Daily American* newspaper described the event: "The car moved with the greatest ease, under perfect control and went at the same pace, both up and down hill." None of the buildings in this photograph are still standing. Neither are the streetcars, which were replaced by buses in 1940.

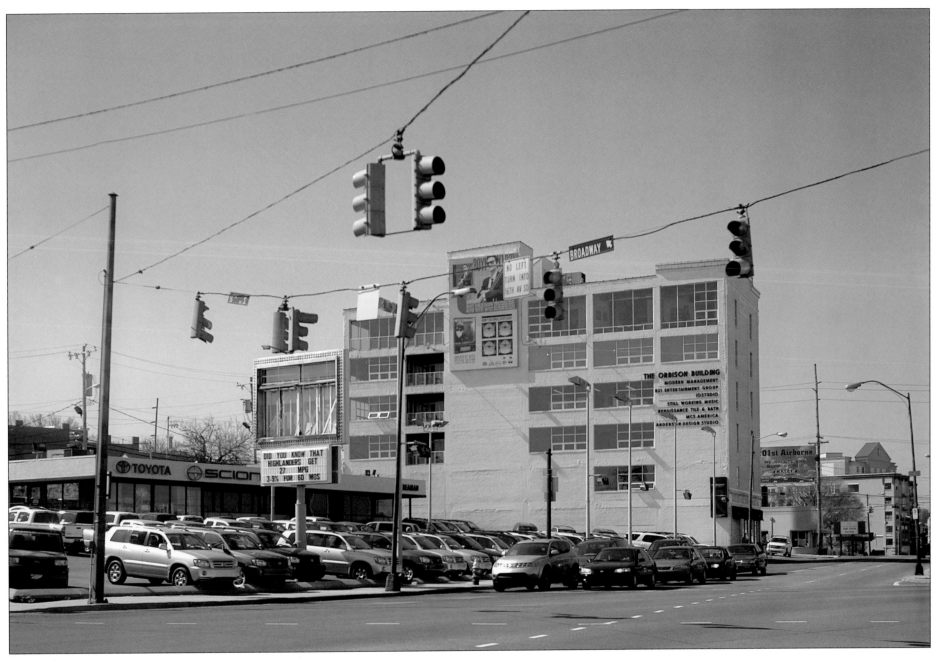

Sixteenth and Broadway is one of the busiest intersections in the city, where West End Avenue begins and Sixteenth Avenue crosses both West End and Broadway. A Toyota dealership and an office building have replaced the town houses and West End Methodist Church on Broadway. The Orbison Building, facing Broadway, houses (among other tenants) the Orbison Music Group, which markets the recordings of rock-and-roll legend Roy Orbison. Nashville Railway and Light Company is now Nashville Electric Service.

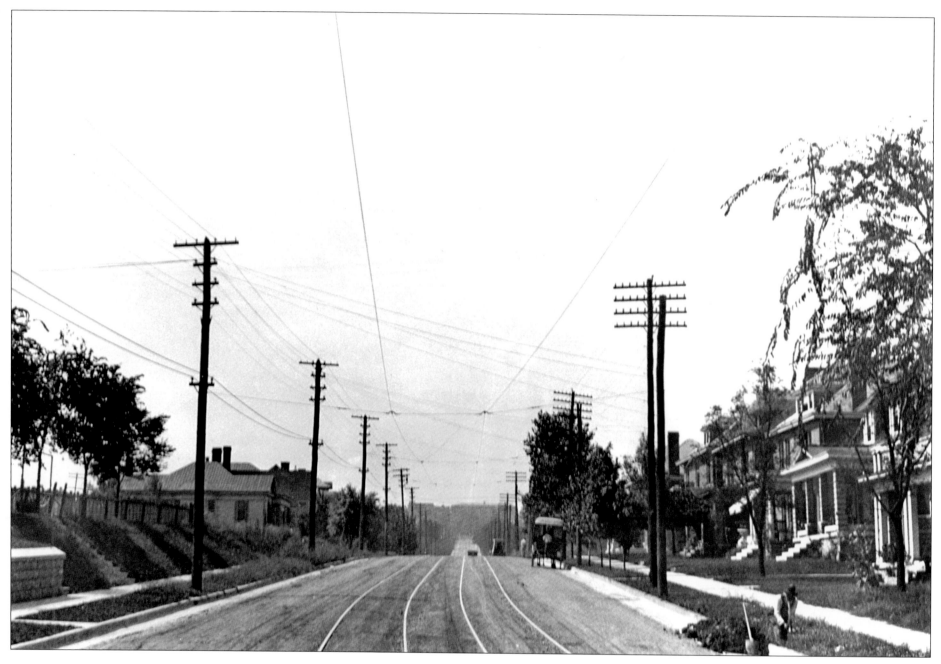

Sixteenth Avenue from Broadway to Belmont College was a fashionable neighborhood when this photograph was taken. This picture shows a tree-lined street with new two-story homes built in an architectural style known as foursquare (four rooms on the ground level and four rooms upstairs). These homes were comfortably situated among other houses that reflected an earlier style. Albert Schnell, a successful businessman of German descent, built a handsome house at 1111 Sixteenth Avenue. When he arranged a debut party for his daughters Lena and Bertha, no one showed up because of the anti-German sentiments of World War I. He vowed to get even with the neighbors and left the house and grounds untended. Albert Schnell returned to his former home on Jefferson Street. For the rest of their lives, Lena and Bertha lived in the decrepit house, which was demolished in 1977.

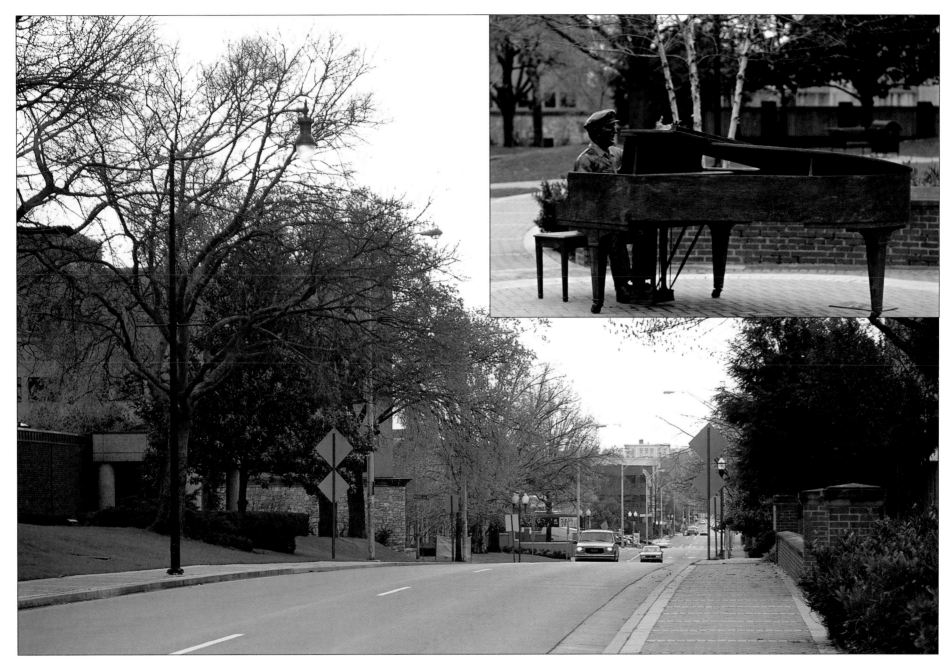

Sixteenth Avenue aged as neighborhoods do, and many of the homes were sold as rental properties or broken up into apartments, while others were used as offices. In 1954 Owen Bradley, a record producer, and his brother Harold built a recording studio in a Quonset hut in the rear of a house at 804 Sixteenth Avenue. This was the first studio in what became known as Music Row. Bradley produced records and arranged music in those early days for Hank Williams Sr., Kitty Wells, Webb Pierce, and Red Foley. Owen Bradley is credited, along with Chet Akins, with creating the Nashville sound. Today Sixteenth Avenue is the address of major recording companies and other music-related businesses. Music Row has grown to include most of the surrounding neighborhood. A bronze statue of Owen Bradley at the piano is located in Owen Bradley Park on Sixteenth Avenue (see inset).

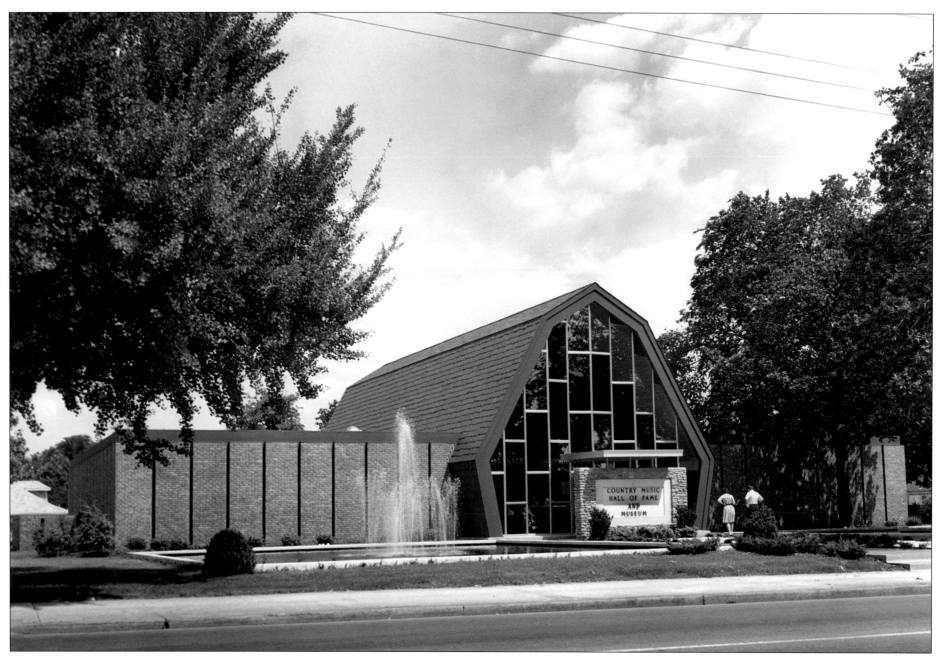

The Country Music Hall of Fame and Museum opened in 1967 on Sixteenth Avenue at the intersection of Division and Demonbreun streets. It was built on property once occupied by two nineteenth-century town houses. Millions of country music fans from all over the world visited this shrine to country music. It acted not only as a museum but also as an archive of county music.

It initiated a ceremony whereby each year one person would be chosen by the Country Music Association (CMA) to be inducted into the Hall of Fame, the highest honor in the business. In 2000 the Country Music Hall of Fame and Museum moved to new quarters downtown.

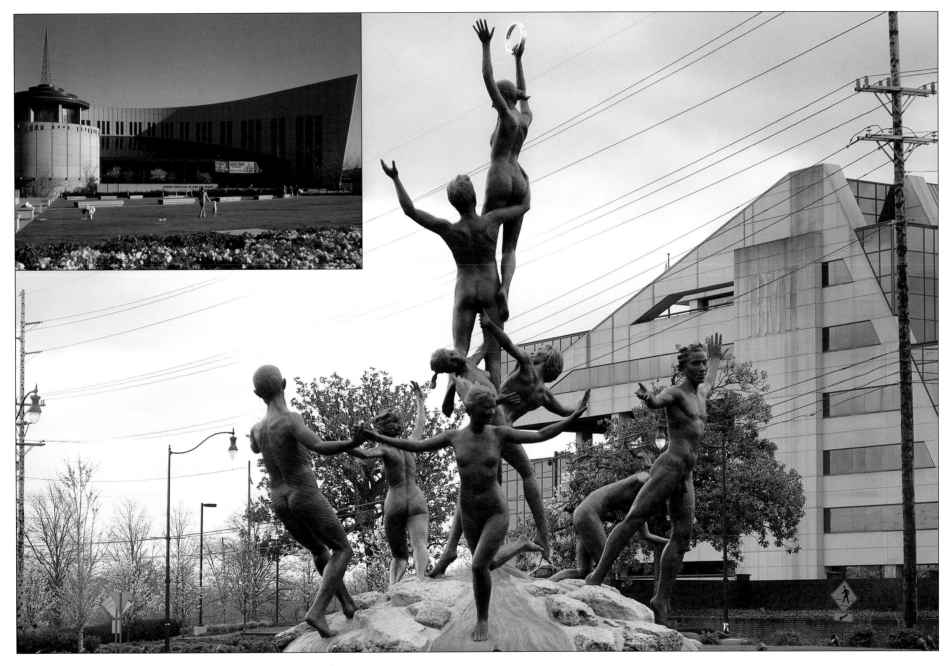

The Country Music Hall of Fame and Museum vacated the Sixteenth Avenue building and moved to a new and much larger facility downtown (see inset). Broadcast Music Incorporated (BMI), a performing rights organization, built an imposing modern building on the vacated site on Music Row. The city redesigned the intersection and installed Nashville's first roundabout. Nashville artist Alan LaQuire was privately commissioned to create a piece of sculpture for the center of the roundabout to represent all music. The result was a forty-foot-high bronze of nine nude dancers, five men and four women. The $1.1 million statue, titled *Musica*, created a stir when it was unveiled in October 2003. This view of *Musica* is looking south on Sixteenth Avenue; the BMI building is in the background.

When this photograph was taken in 1931, gasoline at the Firestone service station was going for thirteen cents a gallon. The Firestone station was situated where Elliston Place intersects Twenty-fifth Avenue at West End. Twenty-fifth Avenue is the eastern boundary of Centennial Park. One resident of Elliston Place played a quiet but important role in Tennessee's history. Mrs. Sadie Polk Gardner, a grandniece of James and Sarah Polk, had many of the artifacts from Polk Place in her home at 2224 Elliston Place, where she welcomed visitors who were interested in viewing Polk memorabilia. The items were eventually sent to the Polk ancestral home in Columbia, Tennessee. This photograph was taken as evidence in a lawsuit filed against the Firestone service station.

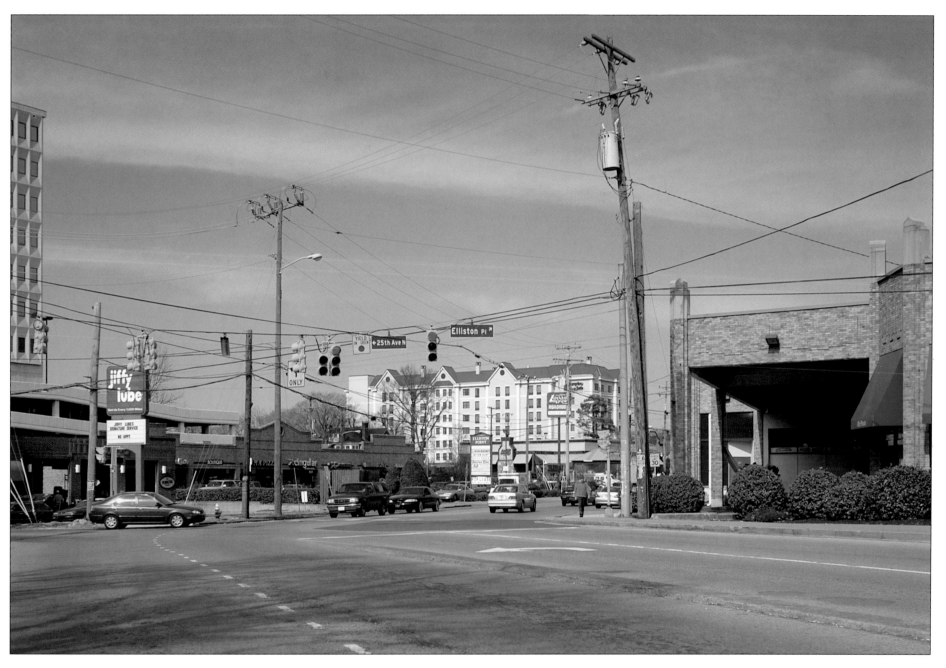

Elliston Place today, two miles from the beginning of Broadway, is a busy street of restaurants, shops, and a hotel, seen in the center of this photograph. The Firestone station is now a pharmacy and one-hour photo center. The Elliston Place Soda Shop, not seen in this photograph, has been open since the 1930s in the same location and is a favorite for breakfast and lunch; it is frequently used in music videos. The land on which the hotel was built was previously occupied by the Father Ryan Catholic High School from 1928 until 1991, when it moved to a new campus south of downtown.

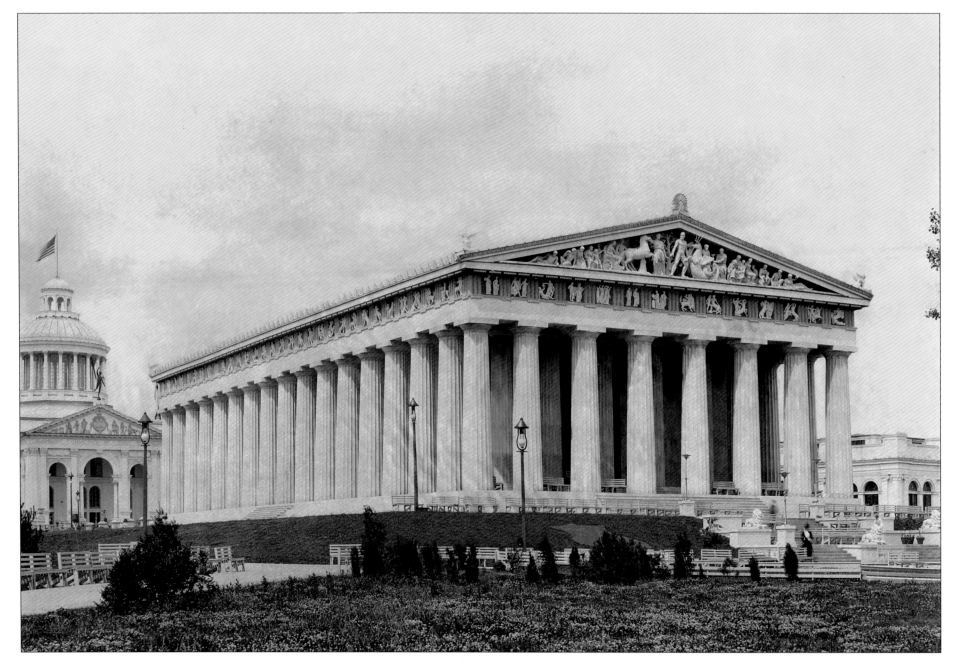

The City of Nashville undertook the construction of an exact replica of the Greek Parthenon for the Tennessee centennial celebrations of 1896. A commonly held view was that since Nashville was known as the "Athens of the South," it was only fitting that it should have an Athenian building in its midst. Much to the city's embarrassment, work was not completed on the project until 1897, with the organizers blaming a variety of external forces, uppermost being a lack of money and the 1896 presidential election.

However, the Centennial Exposition, when it eventually opened, proved an enormous success, with almost two million people attending the site over a six-month period. The plaster replica was due to be torn down after the exposition ended, but public protests prevailed. What had been known as the Gallery of Fine Arts, built to last but a year, remained standing for a further twenty-three years.

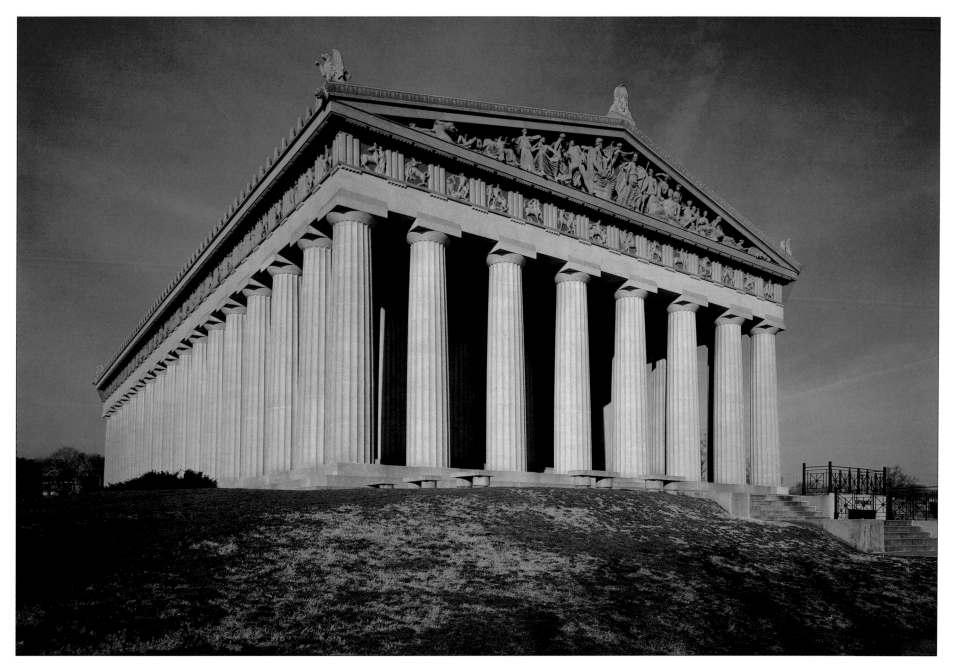

In 1902 the empty fairgrounds became Centennial Park, the largest municipal park in Nashville. The "original replica" lasted until 1920, when the Board of Park Commissioners voted in favor of a longer-lasting Parthenon to replace the first plaster-and-lathe structure. Many of the world's leading authorities in Greek architecture were consulted in an effort to make the new Tennessee Parthenon the most authentic reproduction possible. It was a task that involved copying the Elgin Marbles, held at the British Museum, which previously adorned the Athenian Parthenon. Thus, the Nashville Parthenon could be considered a more accurate version of the ancient Greek building. However, the Tennessee building material—reinforced concrete made with gravel from the Potomac River—gives the columns a yellowish hue. A collection of sixty-three paintings by nineteenth- and twentieth-century American artists, donated by James M. Cowan, is permanently housed in the Parthenon.

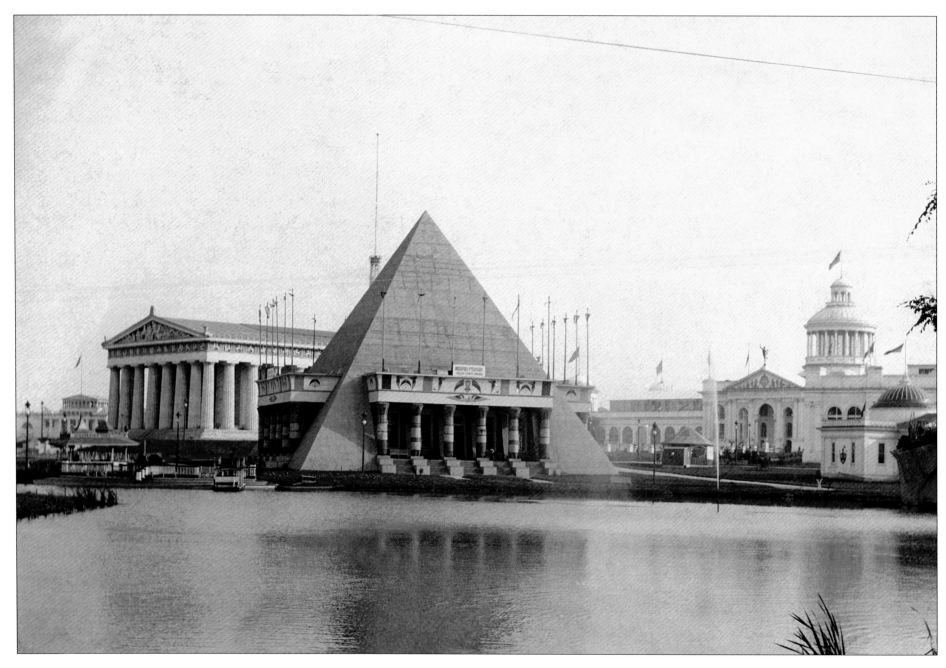

This photograph was taken during the Tennessee Centennial Exposition in 1897. The view is across Watauga Lake, with the Parthenon and the Memphis Pyramid Building in the background. Apart from celebrating a century of statehood, it was an event intended to highlight the industrial rebirth of the New South. Exhibits represented commerce, agriculture, travel, and engineering. The Chicago Columbian Exposition of 1893 served as the model for Nashville's grand design. The grounds of an old racetrack west of town were landscaped with a lake and winding roads to create the parklike setting.

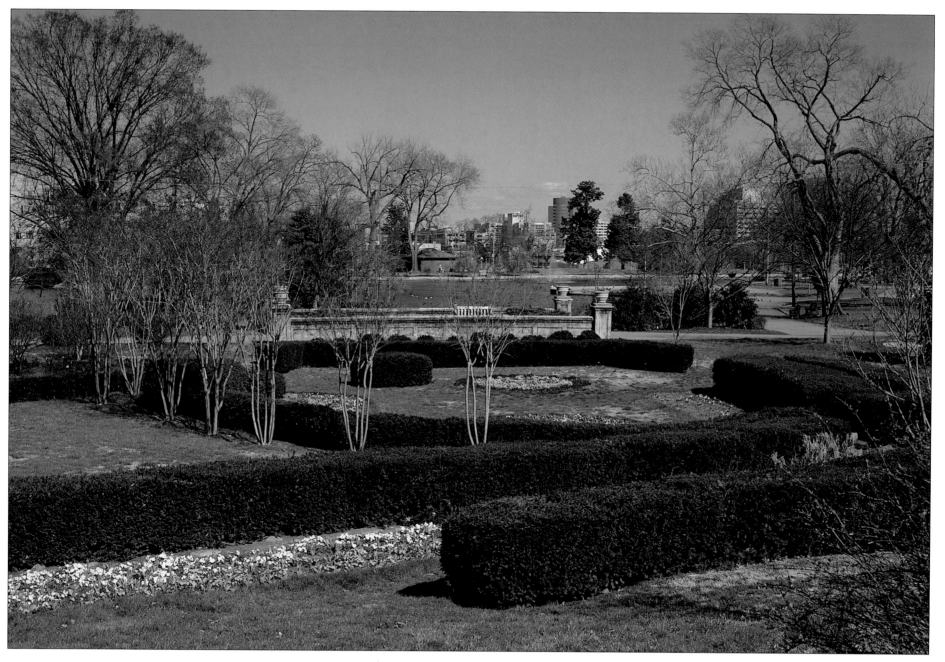

When the Centennial Exposition closed, the Nashville Park Board decided to keep the grounds as a city park. The only building left on the grounds was the Parthenon. Centennial Park today is often a hive of activity, with concerts staged in the band shell, arts and crafts fairs, and kites flown from the lawn of the Parthenon. Watauga Lake has survived since 1897. This photograph was taken looking across the sunken gardens, part of which originate from the exposition. Artifacts from Nashville's history are also on permanent display in the park: a Tennessee Air National Guard jet from the 1950s, the last steam locomotive from the NC&StL railroad, and the breastplate from the battleship *Nashville*.

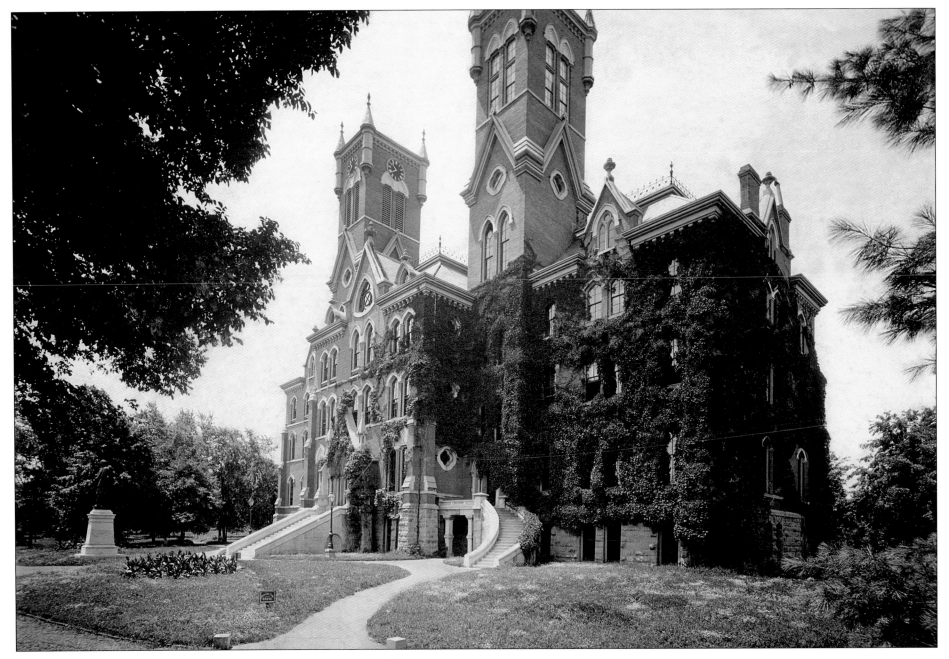

William Smith of Nashville designed this imposing structure, originally called Main Building, on the Vanderbilt University campus. The cornerstone was laid on April 28, 1874, and it was completed in 1875. The towers were designed and built with sloping roofs, which were subsequently replaced with flat roofs. On April 20, 1905, fire gutted the building and destroyed all but 4,000 of the 40,000 books in the library. William Kissam Vanderbilt, grandson of the university's original benefactor, made a donation of $150,000 to rebuild while alumni and Nashvillians raised nearly $50,000. It was rebuilt with steel roof trusses fitted into the brick walls and reinforced concrete replaced wooden beams damaged in the fire. The style of the building was changed from Victorian Gothic to Italianate. A single clock tower with a design based on the town hall in Siena, Italy, replaced the twin towers.

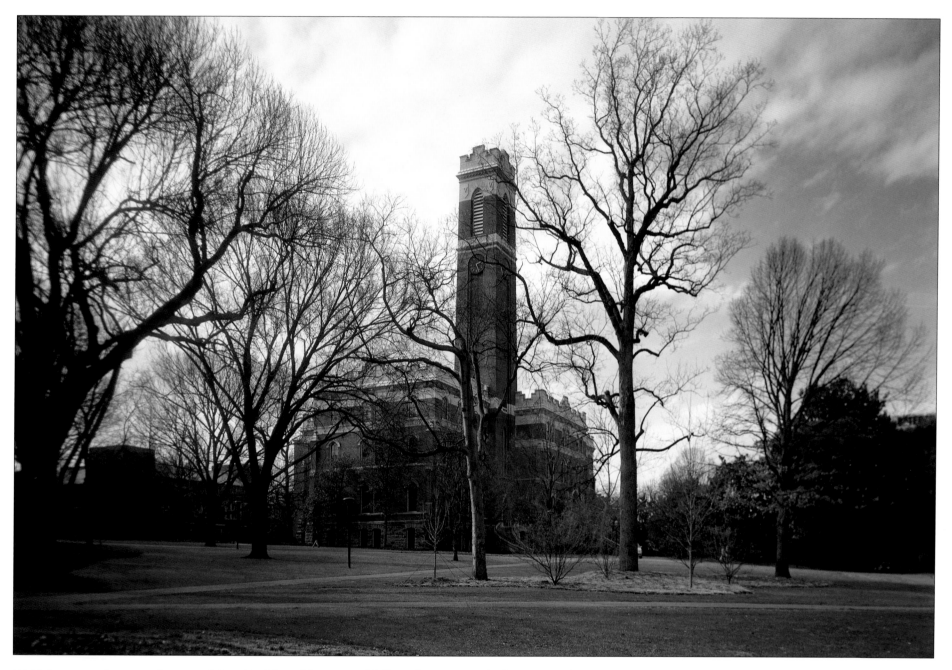

Old Main went by several names: Main Building, University Hall, and College Hall. Today it's known as Kirkland Hall, named for James H. Kirkland, Vanderbilt's longest-serving chancellor, and his wife, Mary Henderson Kirkland. The clock tower has become an architectural symbol for the university. This photo was taken from the south side of the building looking toward West End Avenue and the main entrance. When Kirkland Hall was new, Vanderbilt University's enrollment numbered 307 on a seventy-five-acre campus. Today the student enrollment exceeds 11,000 full- and part-time students, and the 330-acre campus is a national arboretum. Kirkland Hall now is the university's administration building.

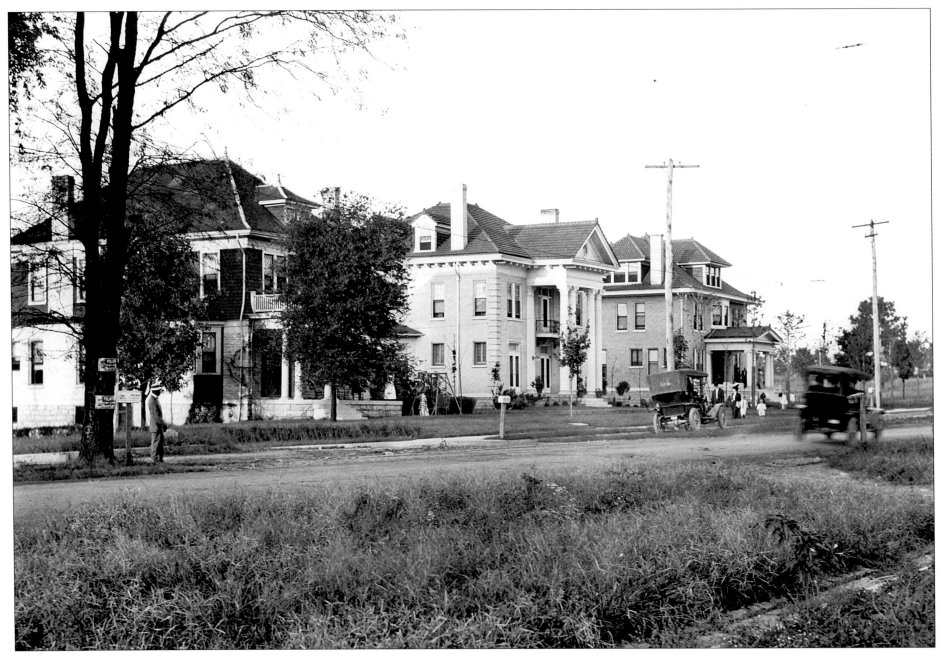

West End Avenue begins at the intersections of Sixteenth Avenue and Broadway and extends west to Woodmont Boulevard. The flight of residents from downtown began with the introduction of streetcars and automobiles, and the biggest migrations went west. The outlying areas of town were referred to as the "streetcar suburbs." People who could afford a new home in West End escaped the noise and pollution of the city. Regularly scheduled streetcar services provided an efficient means of commuting into the city, and transportation for domestic workers as well. It was commonplace at that time to pay household employees a wage plus "car fare." Not everyone who lived in West End depended on the streetcars, as evidenced by the touring car parked on the curb. This photograph of the 3700 block of West End Avenue about three miles from downtown was taken looking northeast.

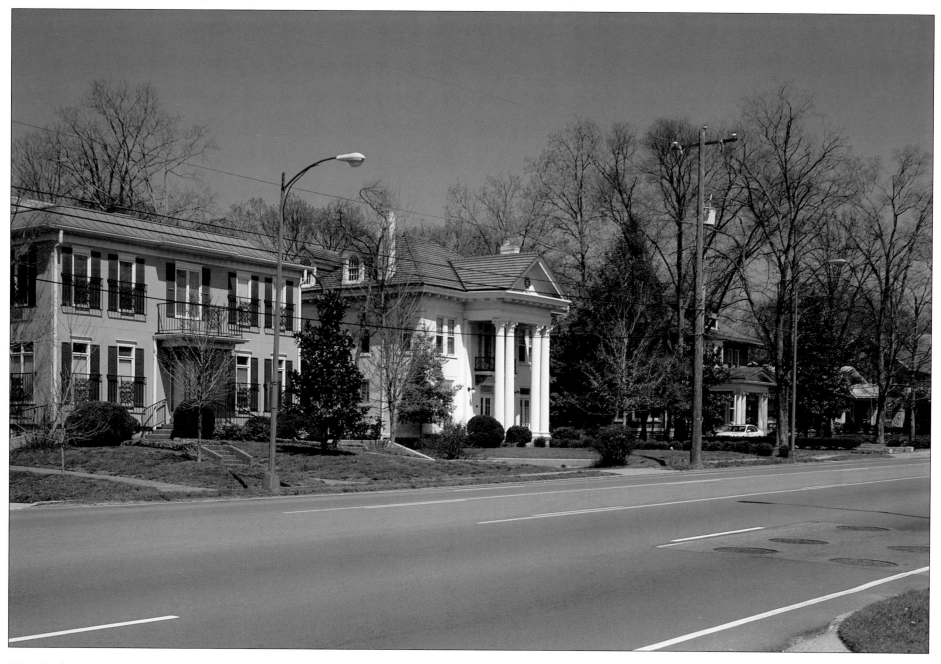

West End Avenue remains a desirable neighborhood today. Unlike early twentieth-century suburbs in other parts of the city, the houses on West End and the surrounding streets have not required restoration. It's a neighborhood where mothers push baby strollers in the evenings, and families walk to worship services. In a two-block area on West End Avenue are four churches and two synagogues. One writer described the neighborhood as "kosher grits." The building in the left of this photograph is a new apartment complex designed to blend architecturally with the neighborhood. The next two houses look the same today as they did when they were new.

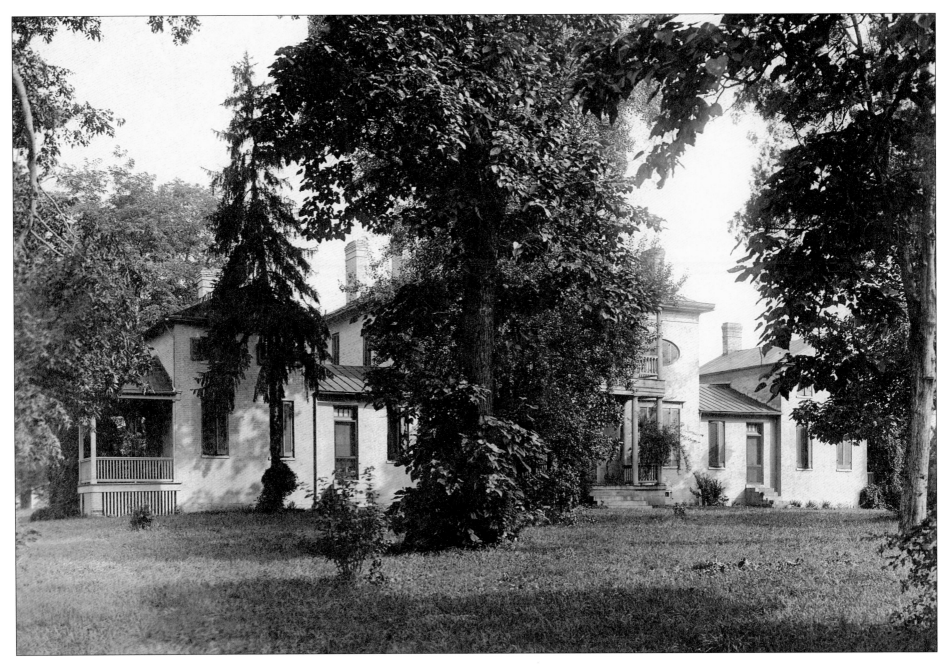

Woodlawn was built in 1823 for Captain John Nichols. The original structure consisted of a central two-story brick house with two wings, one on either side. Nichols sold the plantation to his son-in-law Willoughby Williams, who turned it into one of the most productive farms in middle Tennessee. Two of Williams's friends were Sam Houston and Andrew Jackson, both of whom were frequent guests at Woodlawn. During the Civil War, the house served as brigade headquarters and as a field hospital for the Confederate army. After the war it was used as a U.S. army camp known as Camp Harker. Duncan Kenner bought the house and the last remaining two acres of land in 1900. He removed an entire wing on the left side of the house, added a large portico to make the entrance face Woodmont Boulevard, and covered the brick with stucco. This photograph was taken before Kenner modified the house.

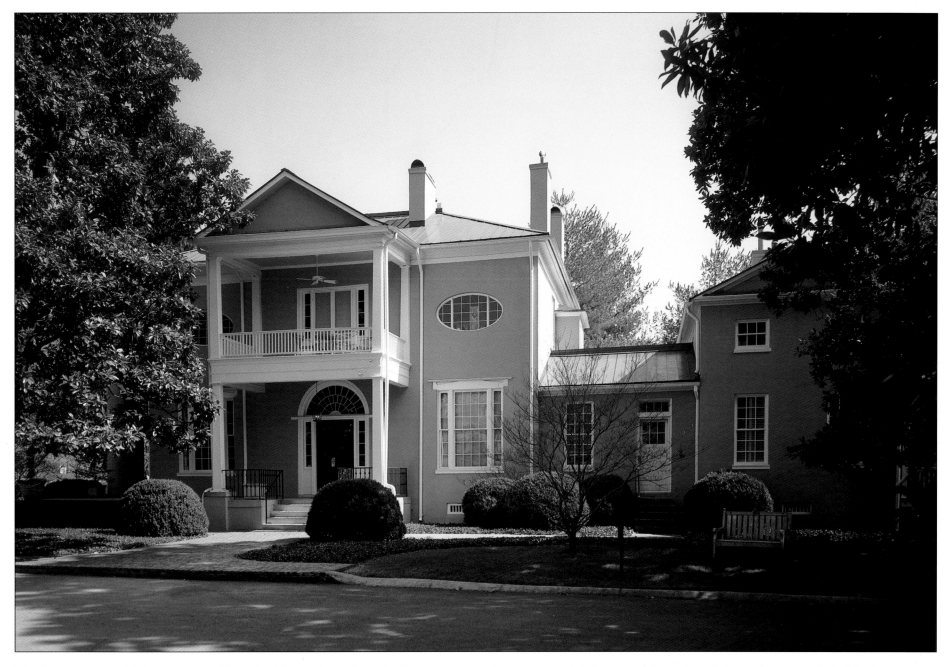

The last resident of Woodlawn was Dorothy More. Her father, Fred B. Young, bought the home in its present style in 1922. Mrs. More lived at Woodlawn for sixty years; she eventually sold it to Woodlawn Ltd., and it was placed on the National Register of Historic Places in 1978. The 6,387-square-foot mansion was then completely restored at a cost of $275,000. Modern heating and air-conditioning, plumbing, and electrical services were installed.

Attorney Randall L. Kinnard purchased the building in 1992. The home has been renovated for adaptive use and serves as the offices of the law firm Kinnard, Clayton, and Beveridge. This photograph was taken from the opposite end of the house, showing the existing wing. Group tours of the historic house are conducted by appointment.

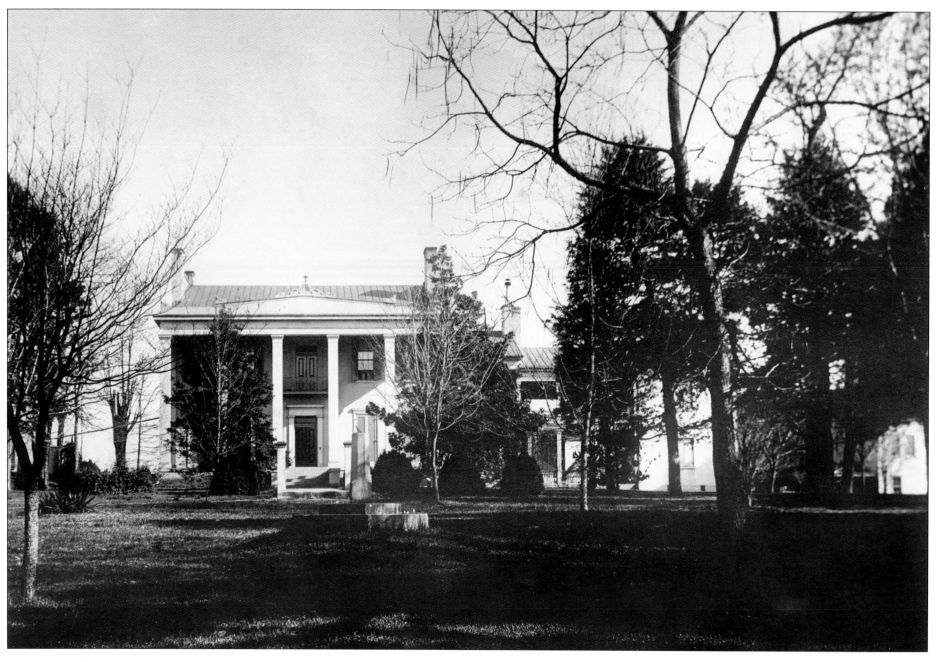

General William G. Harding built Belle Meade Mansion in 1853, a Greek Revival house with a broad veranda and square columns cut from solid limestone quarried on the property. Harding's parents, Suzanne and John Harding, founded the plantation in 1807 with the purchase of 250 acres and a two-room log cabin on the old Natchez Trace, seven miles west of Nashville. By 1853 the plantation had grown to over 1,200 acres of land and prospered.

When the Civil War broke out, William Harding, a general in the state militia, sided with the Confederates and was arrested and imprisoned for six months. After the war, Belle Meade continued to prosper as a thoroughbred horse breeding farm and produced Iroquois, the first American horse to win the English Derby. Belle Meade passed out of the family after the death of Harding's son-in-law, General William H. Jackson, in 1903.

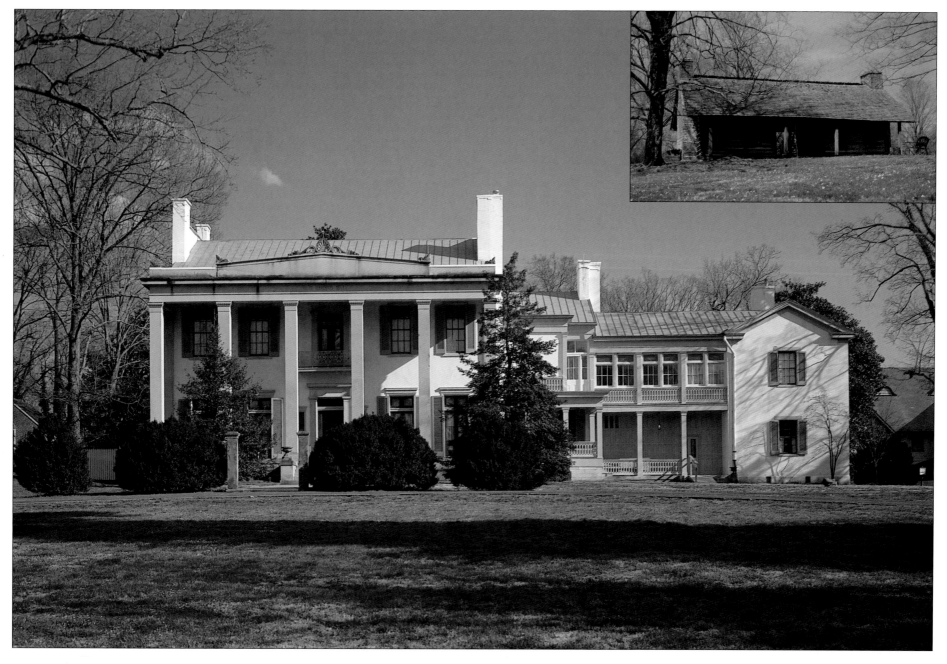

In 1953 the State of Tennessee purchased the house and remaining outbuildings, including the imposing stables, plus twenty-four acres of land and deeded the property to the Association for the Preservation of Tennessee Antiquities. In addition to the mansion and stables, visitors will find a Gothic stone springhouse, mausoleum, carriage house, smokehouse, and Dunham Station, John Harding's original two-room log cabin (see inset). The mansion is furnished with many pieces that are original to Belle Meade. The stables now house a restaurant and gift shop and space for private events. Each Christmas, the plantation house is decorated as it would have been in the nineteenth century, and guests are taken on guided tours by docents wearing period clothing.

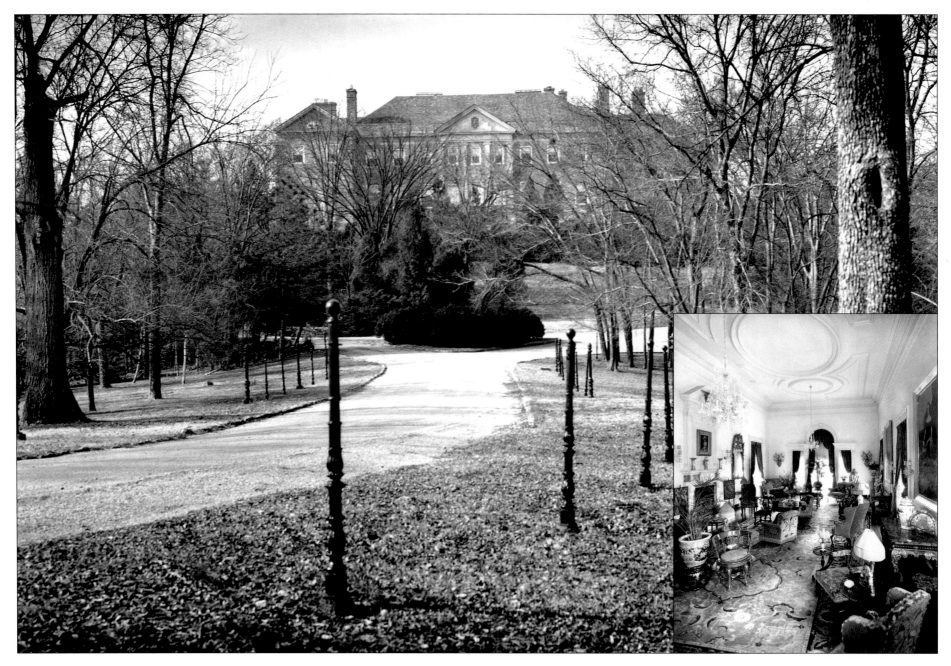

Leslie Cheek built Cheekwood, a Georgian-style mansion, in 1931–1932 with his part of a fortune made in the coffee business. Cheek and his cousin Joel were principles in the family coffee business, Cheek and Neal. Joel is said to have been the first person to blend coffees. The coffee blend was served at Nashville's Maxwell House hotel and was sold under the name Maxwell House Coffee. In 1928, Postum (now General Foods) purchased the Nashville coffee business for more than $40 million. Leslie Cheek built his country estate on a hundred acres of land west of town. He hired New York residential and landscape architect Bryant Fleming and gave him complete control over the house and grounds. Fleming completed the limestone mansion and boxwood gardens in 1931, and the family moved into the home in 1933. The inset picture shows the drawing room.

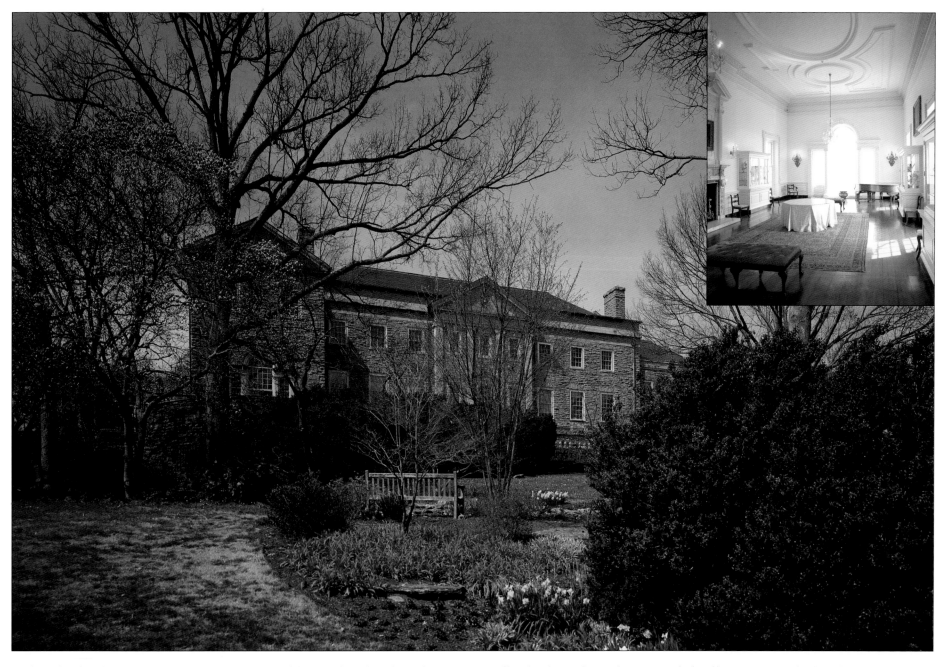

Leslie Cheek's daughter Hulda Cheek Sharp and her husband Walter Sharp deeded the estate—reduced to fifty-five acres—to the Tennessee Botanical Gardens and Fine Arts Center, a nonprofit organization, in 1959. The mansion was converted into an art museum and landscape showplace. In 1971 the Horticultural Society of Davidson County raised money to add Botanical Hall. Cheekwood now has expanded gallery rooms with the addition of the Anita Stallworth Galleries in 1980. The largest collection of Worcester porcelain in America is on permanent display in the former drawing room (see inset). The original gardens, fountains, and pools installed by Fleming still surround the mansion.

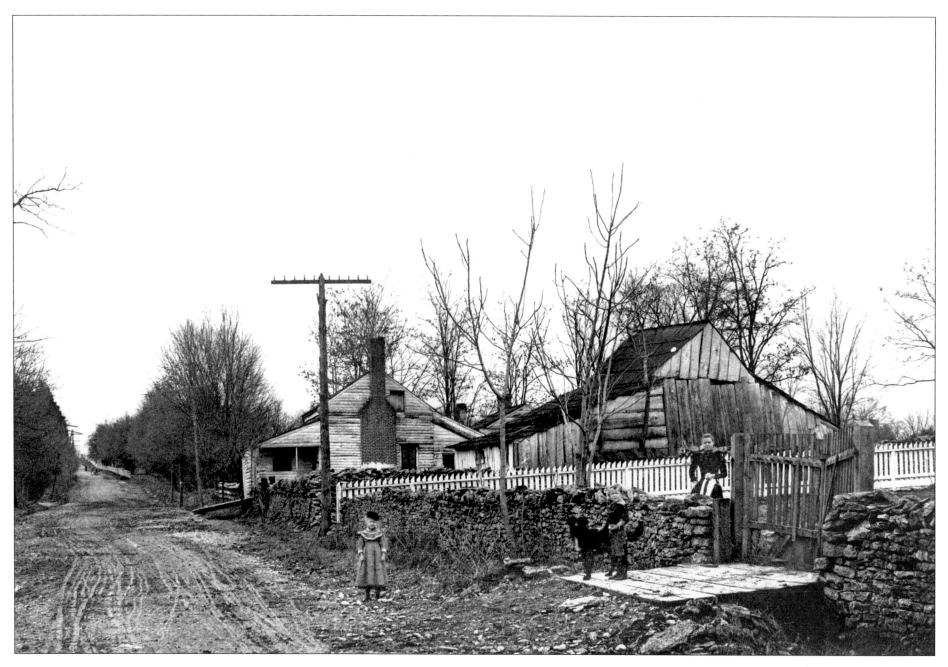

This photograph was taken on the Hillsboro Turnpike, which ran from the city limits of Nashville nearly to the town of Hillsboro in Williamson County. The state legislature chartered the Nashville and Hillsboro Turnpike Company in 1848, and the road was completed in stages as rights-of-way were acquired. Tolls were collected at gates placed at five-mile intervals. Toll fees included "ten cents for every twenty head of sheep or hogs, twenty cents for every twenty head of horned cattle"; for every horse or mule not pulling a carriage or wagon, the toll was three cents. The price increased for carriages and wagons based on the number of horses or mules pulling them. In 1901, the eight miles of the turnpike in Davidson County were sold and it became a free road to the county line in 1902.

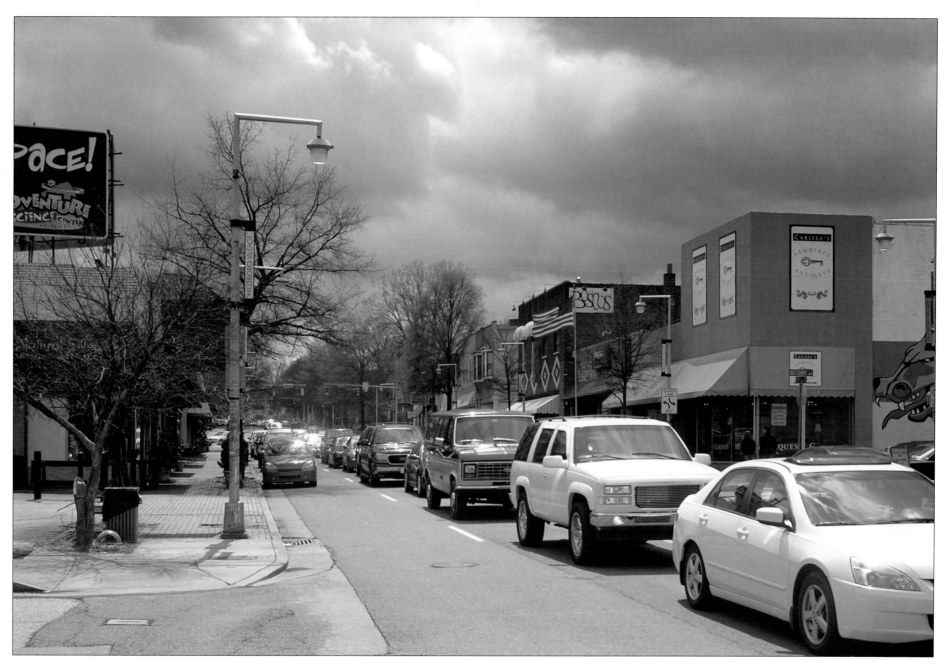

The Hillsboro Turnpike today is a continuation of Twenty-first Avenue from Broadway to the town of Franklin in Williamson County. Hillsboro Village is a neighborhood of quaint shops, bookstores, and restaurants along a short section of Twenty-first Avenue. The previous photograph was taken at what is today the intersection of Belcourt and Twenty-first, in the center of Hillsboro Village. Vanderbilt University Medical Center is adjacent to "the Village" on the north end and Belmont University is less than a quarter-mile to the east. Two popular restaurants in the Village are Provence Bread and Café and Pancake Pantry.

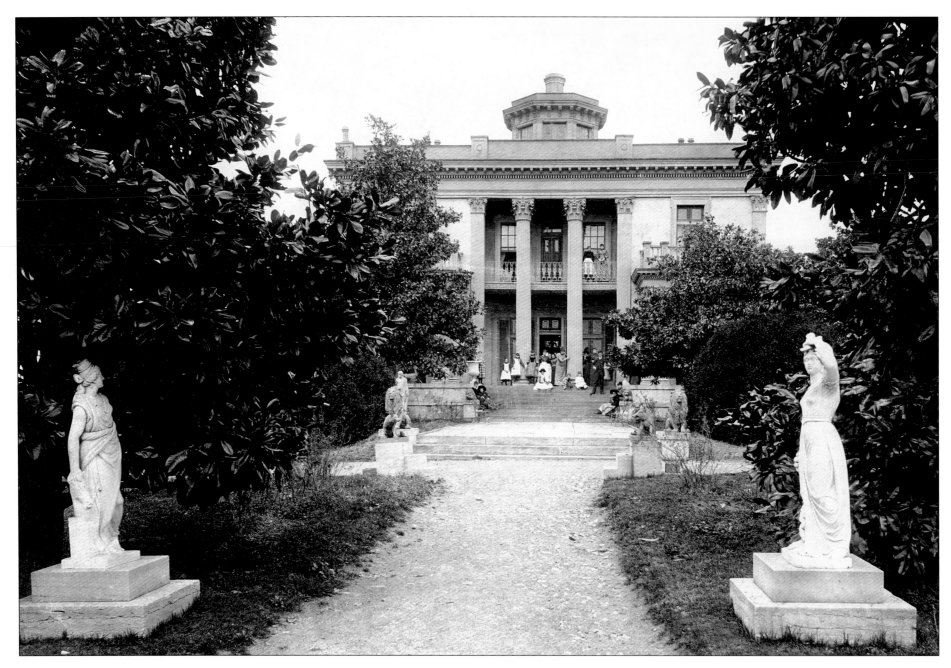

Joseph and Adelicia Acklen built Belmont as a summer home on 180 acres two miles south of Nashville between 1849 and 1853, with additions added until 1860. The 20,000-square-foot, thirty-six-room villa was originally named Belle Monte, or "Beautiful Mountain." Colonel Joseph Acklen, a lawyer and successful businessman from Atlanta, married Adelicia Franklin, a wealthy widow with an inheritance that consisted of about one million dollars, seven Louisiana cotton plantations, a 2,000-acre farm in Tennessee, and 750 slaves. The house was lavishly furnished, and the estate boasted extravagant facilities: a large circular garden with ornamental fountain, a bowling alley with a billiards parlor, an art gallery, an artificial lake, and even a zoo. The estate had its own refinery to produce gas for lighting. The house survived the Civil War intact, but 13,000 Union troops camped here the first two weeks of December 1864, damaging the grounds.

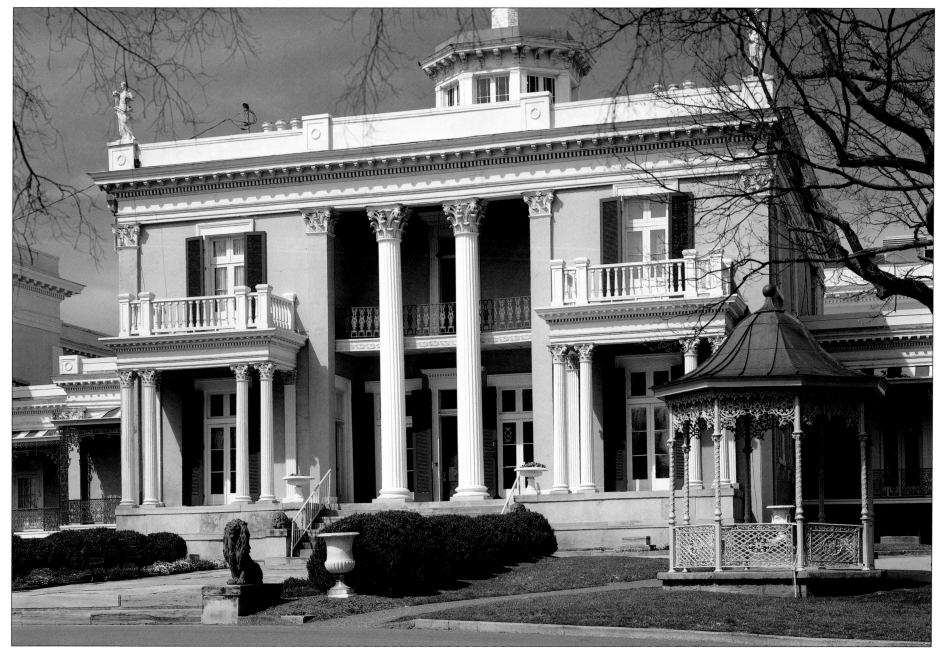

Belmont Mansion today stands overlooking the campus of Belmont University. Traces of the vast lawn can be found about the walkways and buildings of the campus. Belmont University is an institution of the Tennessee Baptist Convention, with an enrollment of over 3,000 students from almost every state in the country and forty foreign countries. Belmont Mansion is owned by the university and operated by the Belmont Mansion Association. About half of the house is open for guided tours, and restoration is underway for the remainder. The estate has the largest collection of nineteenth-century cast-iron garden ornaments in the country and an impressive collection of marble statuary, oil paintings, gilded mirrors, and marble mantels original to the Acklen family. Much of the original Venetian glass is in place in the windows, doors, and transoms.

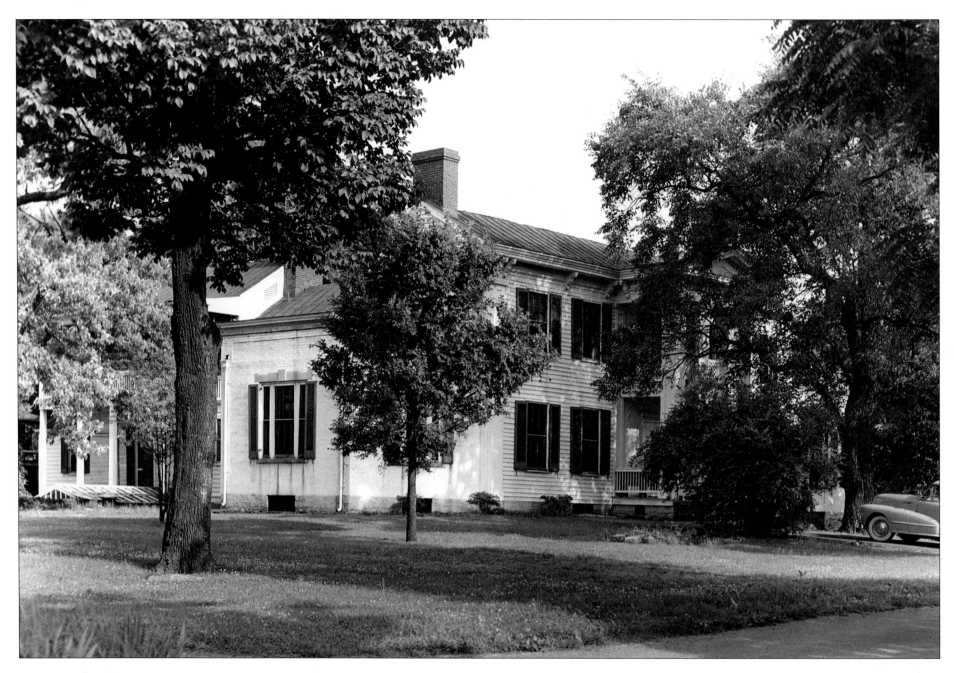

Sunnyside was the name given to this two-story Federal-style frame house by a girl named Mary Douglas. She was the niece of Mary Benton, who built Sunnyside some time after the death of her husband, Jesse Benton, in 1843. Jesse and his brother Thomas Hart Benton had been close associates of Andrew Jackson. When the Bentons had a disagreement with Andrew Jackson in 1813 over a duel involving Jesse and William Carroll, a future Tennessee governor, it resulted in a pistol duel between Jackson and Jesse Benton. Jackson was wounded in the shoulder, and the Benton brothers left Tennessee. Thomas Hart Benton went to Missouri; Mary and Jesse went to Louisiana. When Jesse died, Mary returned to Nashville and built Sunnyside. After her return, Mary met Frank Sevier, whom she married at this house in 1859.

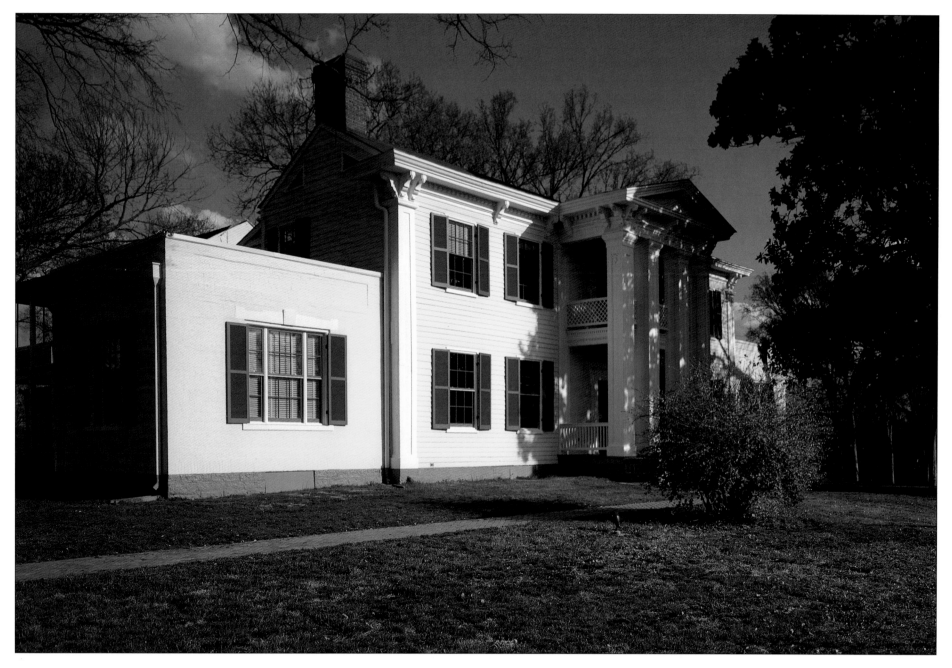

Sunnyside has been completely refurbished and serves as the offices of the Metro Historical Commission. It is surrounded by Sevier Park on Lealand Lane in South Nashville. Sunnyside had several owners and the name was changed twice until Granville Sevier bought back his family's home. After Granville Sevier died in 1944, the City of Nashville bought the house and 20.3 acres from his estate for $50,328. The property was made into a park and named for Granville Sevier. Davidson County park director Jack Spore and his wife Maryanne lived in the house until 1987 and are credited with preserving the house and outbuildings. The house was later used for various park offices.

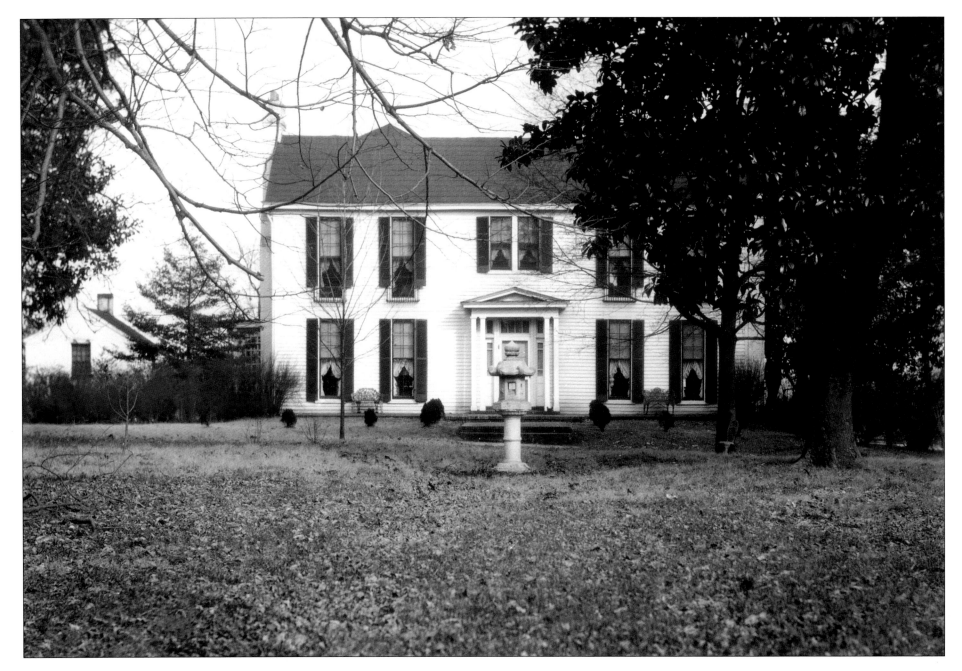

Traveller's Rest was the home of John Overton, built in 1798 on 320 acres of land south of the town of Nashville. When most houses on the frontier were built of logs, Overton built his house in a Virginia style, a small, two-story farmhouse with beaded siding—the first of its kind in the area. When the basement was dug, an ancient Indian burial ground was unearthed. Overton named his fledgling frontier plantation Golgotha, a biblical reference meaning "Hill of Skulls." Overton changed the home's name to Traveller's Rest after years on the road as a circuit judge for his new state, referring to himself as the weary traveler. As Judge Overton's family grew, he enlarged the house with a two-story brick addition on the back that connected the main house with the kitchen and a two-level veranda on the east side of the new addition. This photograph was taken in the 1930s.

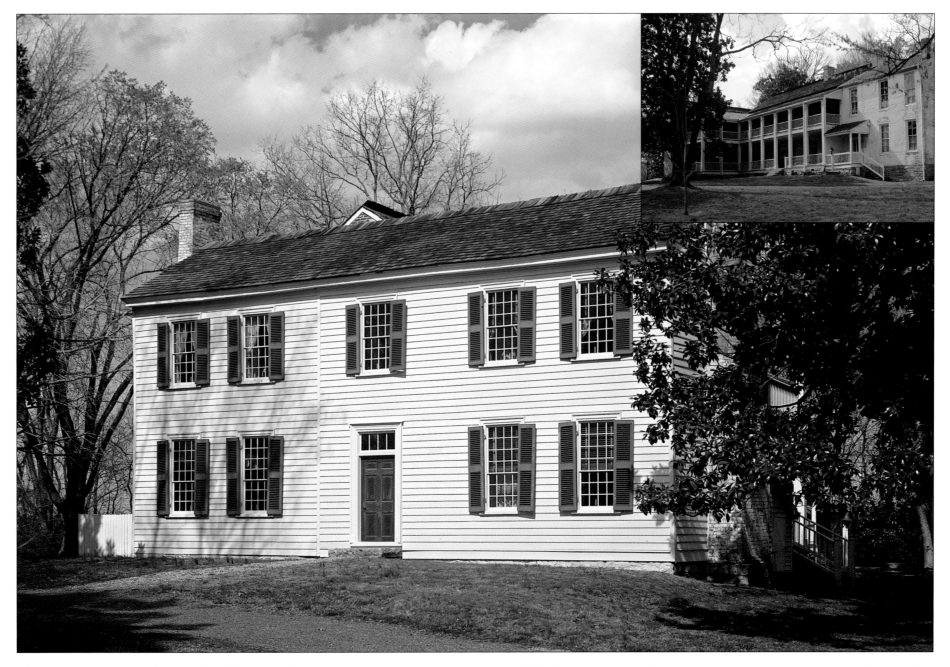

The National Society of the Colonial Dames of America in Tennessee rescued Traveller's Rest in 1954. With the help of Overton's descendants, Traveller's Rest has been lovingly restored. The once-sprawling plantation, estimated to have covered around 1,100 acres, now consists of the main house and several historic brick outbuildings, Mary Overton's garden, and a visitor center. The front porch on the previous photograph was a late addition to the house and was removed during restoration. The house is fully furnished to represent several periods of its history. Traveller's Rest is operated today as a house museum. Regular events and fairs are held on the grounds, and it is a popular location for weddings. The inset photo shows the house from the rear.

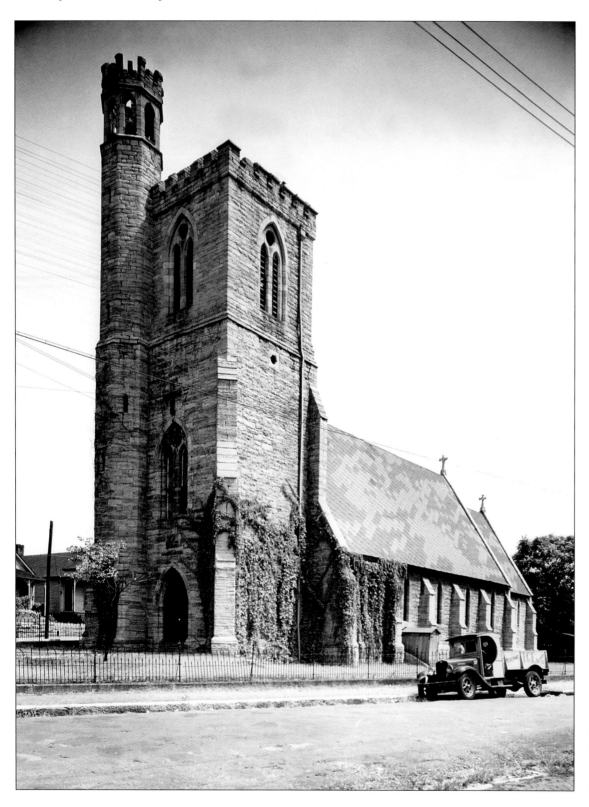

The cornerstone for Holy Trinity Episcopal Church was laid on May 27, 1852. The church was completed in 1853, with the exception of the tower. Holy Trinity was designed by Wills and Dudley of New York and was modeled after an English country church. The nave measures seventy feet by thirty-five feet. The exterior is native blue limestone with hammer finish stone for trim. Church services were discontinued during the Civil War, and the Union army used it to store gunpowder and to stable horses. After the war the federal government awarded the church $1,300 for damages. After the completion of the tower in 1887, the church was reconsecrated on May 27, 1888. This photograph was taken in the 1920s.

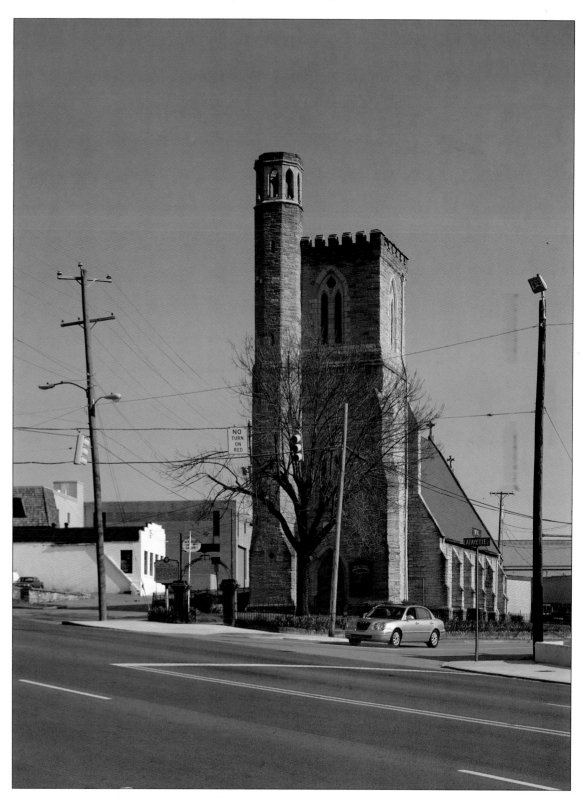

Holy Trinity Episcopal Church remains an active and vibrant church today, used predominantly by African Americans. It sits at the three-way intersection of Sixth Avenue South, Lafayette Street, and Ewing Avenue. The church looks much the same today as it did in the 1920s; the area surrounding the church, however, has changed from a working-class residential neighborhood to a business district. Commercial buildings have replaced the cottages seen in the previous photograph. One house remains in the neighborhood, behind the church, and is today used as a hot dog shop. Members attend services from all parts of Nashville, some driving from as far as twenty miles away on Sunday morning.

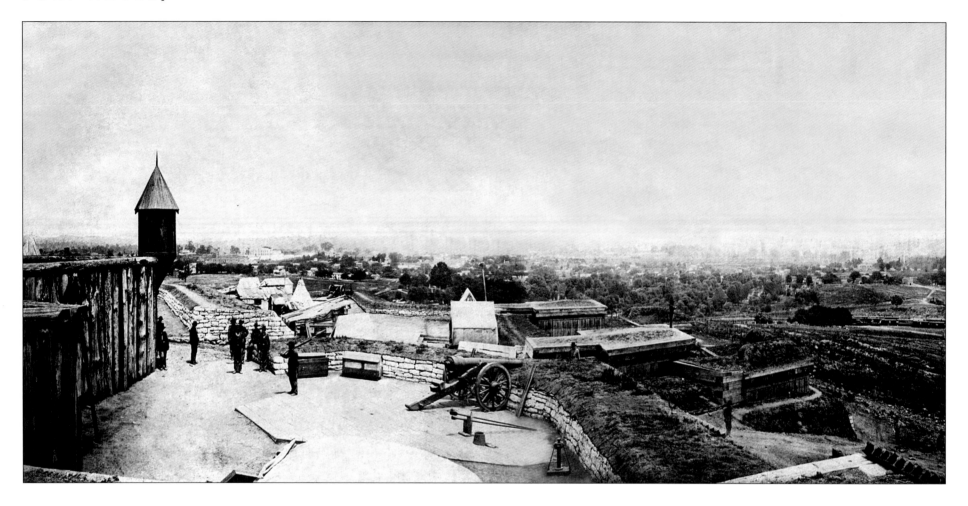

The Union army built Fort Negley in 1862 on St. Cloud Hill, overlooking Nashville from the south. It was named for General James Scott Negley of the U.S. Army, the provost marshal and commander of federal forces in Nashville. Freed slaves working for the army provided most of the labor, and the installation was garrisoned in part by African American soldiers. James St. Clair, a U.S. Army engineer, designed the fort, which was built of earth, stone, and wood and measured about 600 feet by 300 feet. A layer of soil deep enough to absorb artillery explosions covered the rock base, and grass was grown to prevent the soil from eroding. A wooden stockade twelve feet high was built with turrets at the corners, and a system of tunnels underneath was used to store gunpowder and provisions. Nashville at that time was the most heavily fortified city in North America.

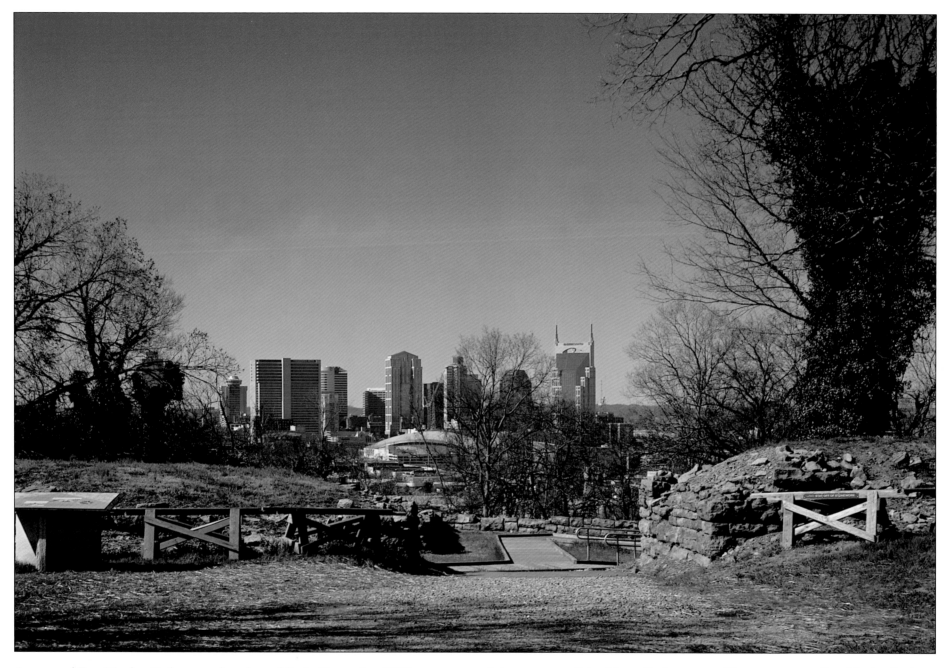

A restored Fort Negley Park opened to the public in December 2004. Wooden walkways and platforms protect the fragile surface from foot traffic, and signage along the circuitous route tells the story of the fort's construction and the Battle of Nashville. A credible attempt to restore the fort was made in the 1930s by the Works Progress Administration. However, there was little or no local interest in a Union fort, and the site was allowed to deteriorate.

It is now part of the Metro Parks system. The entrance to Fort Negley Park is located on Fort Negley Boulevard at the intersection of Chestnut Street. This photograph was taken on the north side, overlooking the city of Nashville. Located to the right of this view is the only entrance into the fort large enough to allow a wagon to pass. It was know as the "sally port" and was heavily fortified.

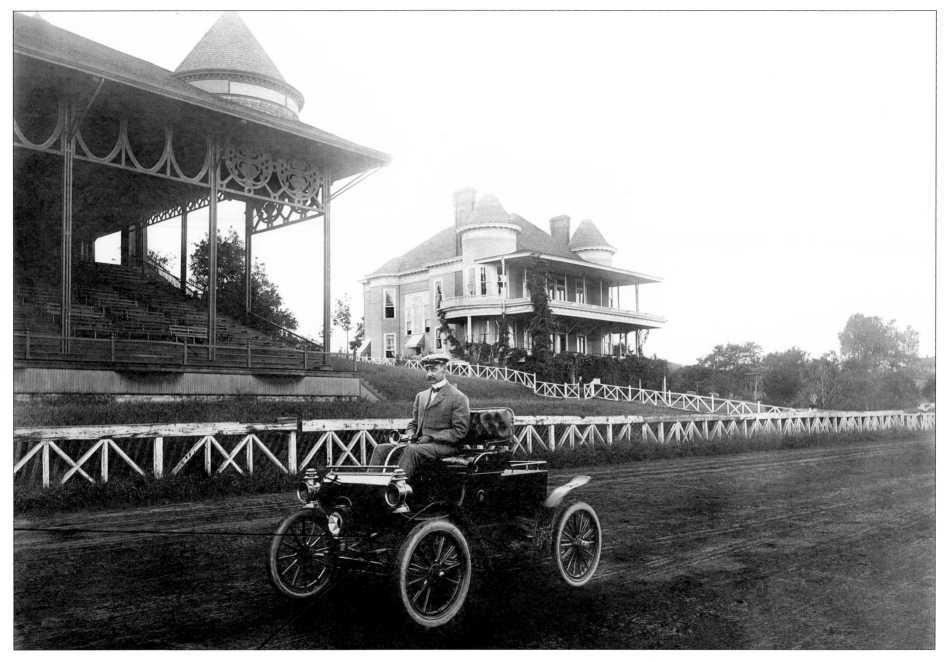

The Tennessee State Fairgrounds Racetrack was originally known as Cumberland Park, a thoroughbred track. The Tennessee Breeders Association sold the 103 acres to the Tennessee State Fair Association in 1908. In 1911, Davidson County bought the grounds for $150,000 and leased it to the state for ninety-nine years at cost of one dollar per year. This intriguing photograph taken by R. S. Patterson around 1911 coincided with the introduction of the first Marathon automobile manufactured in Nashville. To the right of the grandstand is the Woman's Building, an exhibit hall used during the state fair. Harness races were held during the fair. In the 1950s, stock car races were held on the dirt track. The Woman's Building and most of the surrounding structures burned during the state fair in September 1967.

The racetrack at the fairgrounds today is a ⅝-mile, 18-degree banked oval track built in 1957 to replace the one-mile dirt racetrack. Inside the oval is a quarter-mile track. Today the Music City Motorplex features NASCAR stock car and truck races. Regular stock car racing in Nashville began on an old dirt track behind an American Legion building on North First Street in East

Nashville in the 1950s. The cars were models, mostly V-8 Fords from 1929 to the 1940s, stripped of fenders, running boards, and glass, with a few modifications to the chassis. The car in this photograph is that of 2004 NASCAR Late Model champion Wade Buttrey, awaiting inspection on the first day of the 2005 racing season.

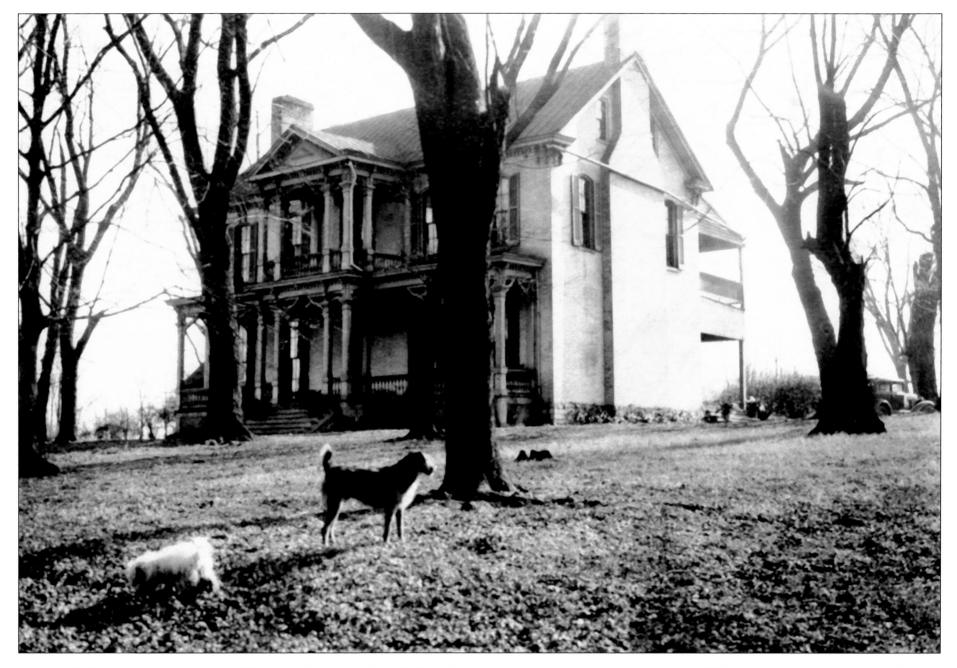

Michael C. Dunn built this house on 275 acres of land around 1810. He sold the farm to his son-in-law, Lee Shute, in 1846 for $10,000. Shute expanded the farm to 346 acres. In 1859 Shute sold the farm to his son, William Dickson Shute, for five dollars. William and his wife, Lavinia, named the farm Grassmere after the poem by English poet William Wordsworth. The home and grounds were occupied by Union troops during the Civil War.

After the war the farm prospered and William, now a widower, remodeled the plain Federal-style house in an Italianate style popular in the 1870s. The house was passed on from generation to generation, eventually ending up with sisters Margaret and Elise Croft. In 1964 the Croft Sisters, who had a deep respect for the land and for nature, deeded the house and property to the Cumberland Science Center.

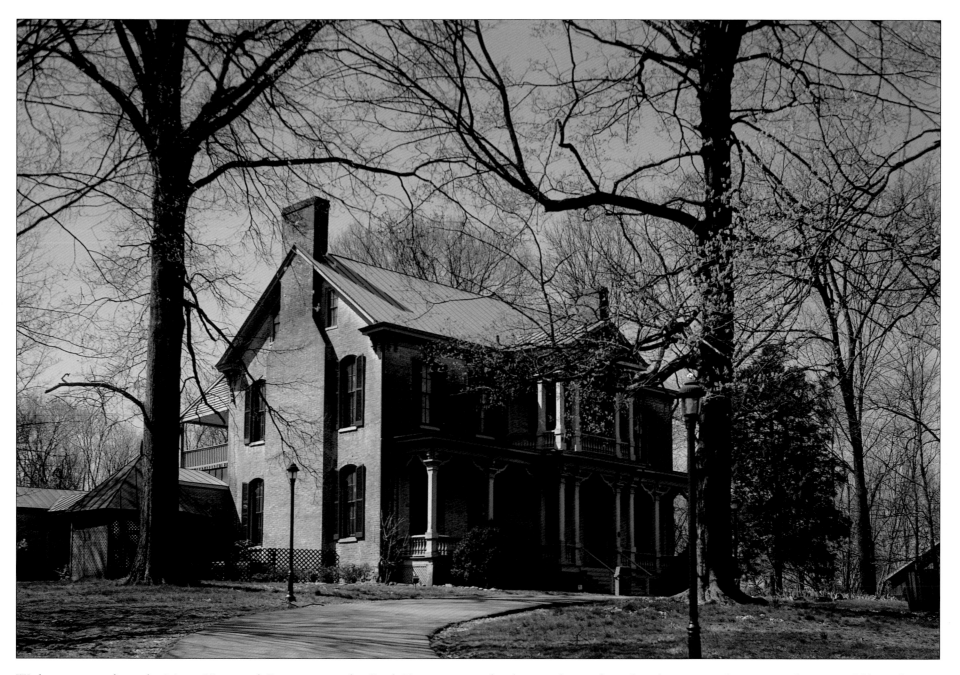

With assistance from the Metro Historical Commission, the Croft House and grounds are now operated as a museum. Visitors get a unique look at a working farm from the past. A kitchen connected to the house was built during renovations from 1876 to 1881. A smokehouse and log cabin for tenant workers were built at that time. To the rear of the house a large kitchen garden is planted each spring and maintained as it would have been during the farm's operation. A tall obelisk marks the graves of Michael C. Dunn and his wife in the cemetery on the property. Margaret and Elise Croft, the last two residents of Grassmere, are also buried in the old family cemetery. The property is now part of the Nashville Zoo.

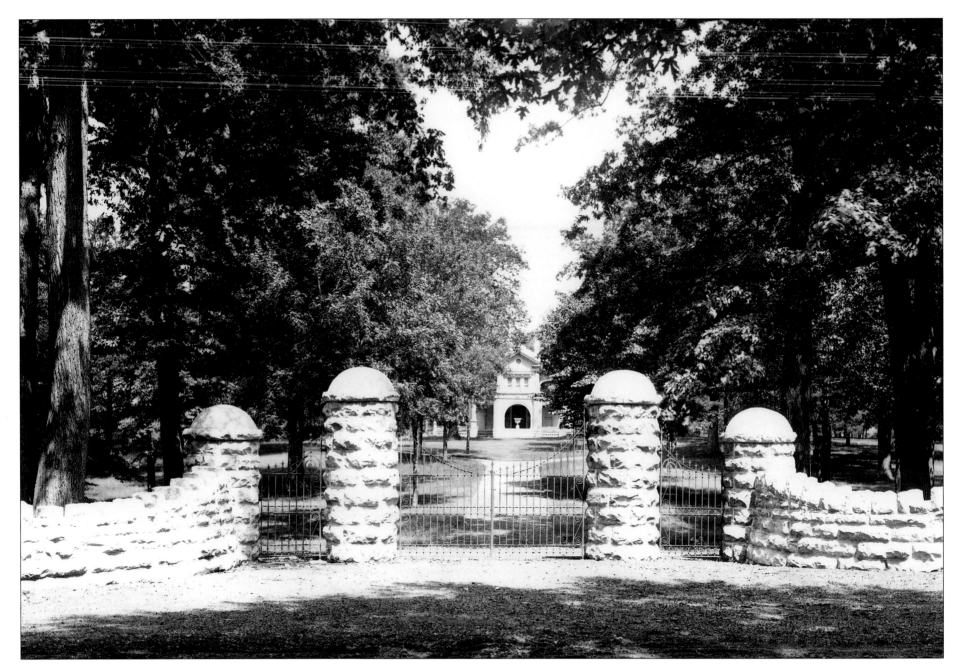

E. W. Cole retired as president of the NC&StL Railway in 1893 and built an estate on the Murfreesboro Pike. The house was located back from the highway, obscured by trees. In this photograph, only the entrance to the house of mixed architectural styles can be seen through the gate and stone fence. This photograph of the entrance was taken before 1929, when a fire destroyed the house. A new house was built on the site in 1931. Nashville architect Russell Hart based the new Colemere on Arlington Mansion in Natchez, Mississippi. The City of Nashville bought the property, which was adjacent to Berry Field, Nashville's airport, in 1940. In 1948 it was leased to a group of businessmen and turned into a private club. The Colemere Club sponsored an Easter egg hunt on the grounds every year.

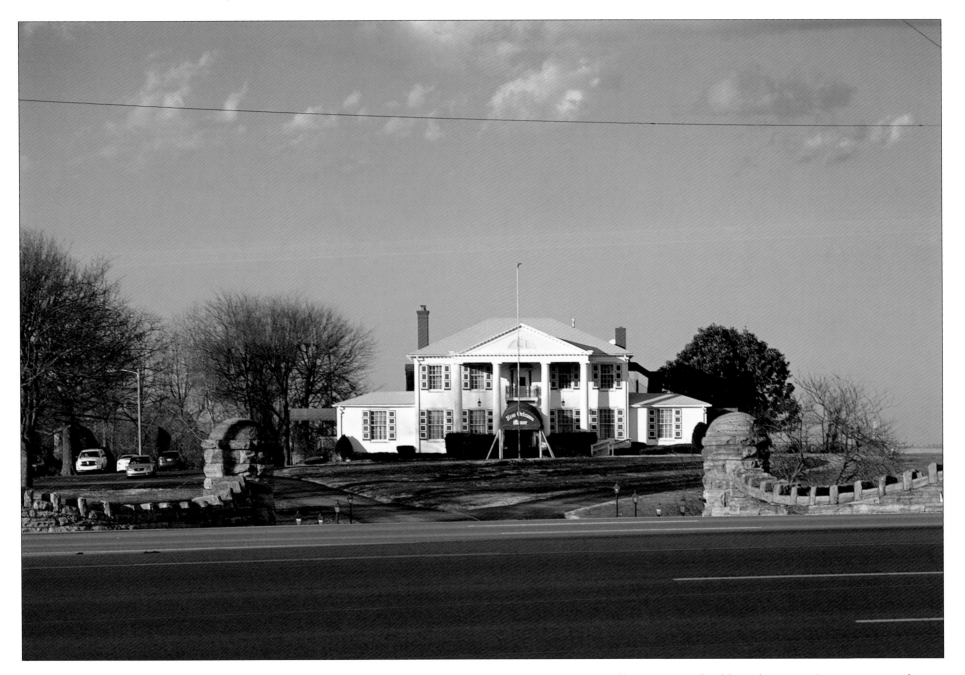

In 1977 Iona Senecal leased the Colemere Club for New Orleans Manor, a seafood restaurant based on a restaurant she and her husband had developed in Louisville, Kentucky. Berry Field next door is now the Nashville International Airport. New Orleans Manor is a proven success, a popular upscale buffet restaurant. The old stone entrance appears to be lower today, while the entrance pillars are considerably wider apart. Successive resurfacing and widening of Murfreesboro Pike has raised the level of the road by at least one foot. This entrance is across the highway from the Genesco complex near the intersection of Murfreesboro Pike and Donelson Pike. The airport is to the rear and the left of the house.

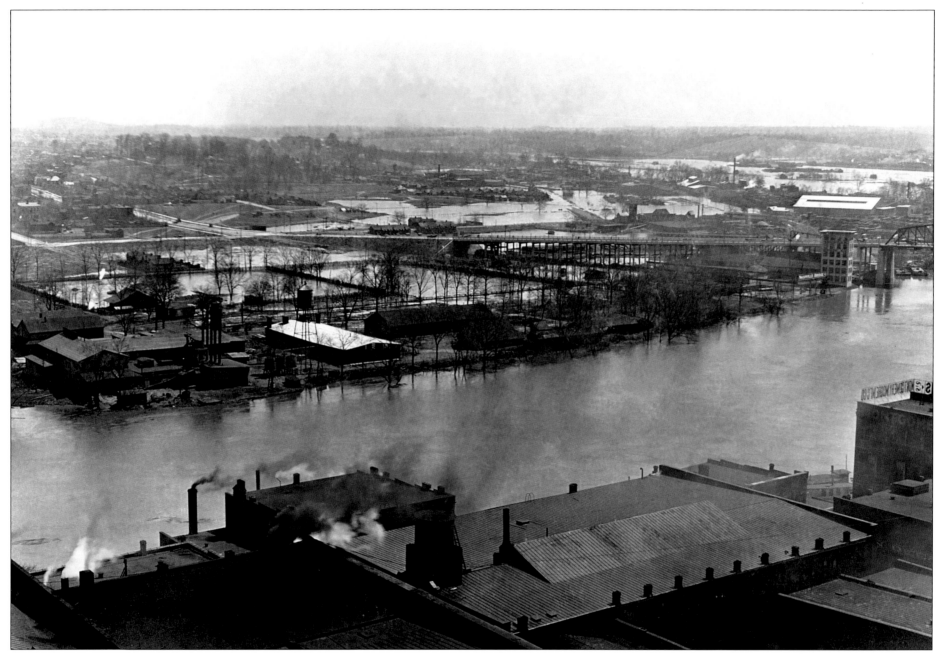

The east side of the Cumberland River was an industrial area when this photograph was taken around 1910, when river levels were high. In this view, the water is over the banks and approaching the mills. The businesses along that low side of the river consisted mostly of sawmills. Lumbermen from counties upstream waited for winter rains when the river was high enough to float rafts of logs to Nashville sawmills. Claude Watson told stories of his father, Franklin Pierce Watson, and his uncles and brothers dragging logs to the river with a team of oxen and lashing them together into rafts. When the water was high they erected tent shelters on the rafts, built warming fires in buckets, and floated the logs to Nashville from Laguardo in Wilson County. The sawmills were replaced by heavy industry after the U.S. Army Corps of Engineers built a series of locks and dams to control flooding.

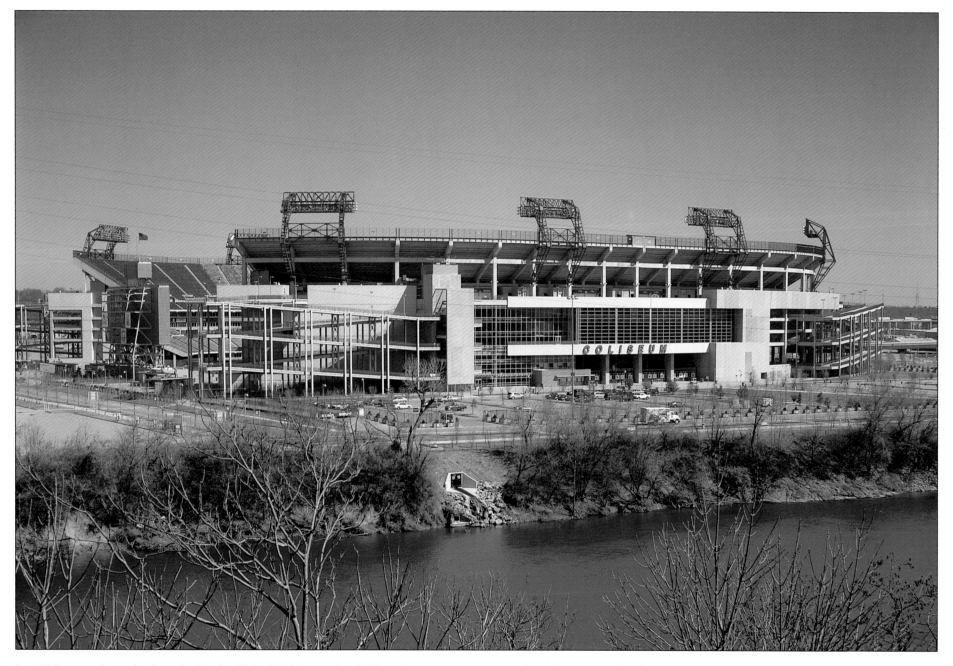

In 1997 ground was broken for Nashville's 65,000-seat football stadium to serve as home for the Oilers, the NFL team that relocated from Houston to Nashville. The team and the city entered into a $292 million contract to bring them to Tennessee. At first, the team's name was still the Oilers, but this later changed to the Tennessee Titans. To clear the land for the stadium, forty-nine businesses were relocated, water and sewer lines were moved, and streets and railroad tracks were rerouted. The stadium was financed through a complicated arrangement with the City of Nashville, the State of Tennessee, and the team's owner. Part of the agreement allowed Tennessee State University to use the stadium as their home field. The facility's name changed to the Adelphia Coliseum, but after the sponsors went bankrupt it reverted to being called simply the Coliseum.

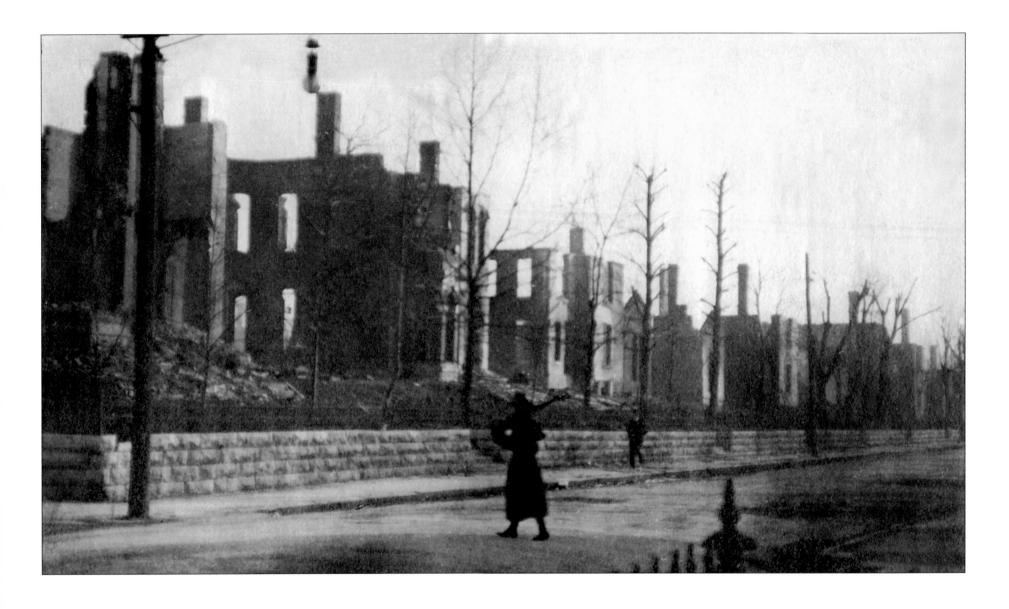

It's unclear how the great fire of March 22, 1916, began. One story has it that a boy was playing with a ball of yarn too close to a coal grate and the yarn caught fire. The frightened boy tossed the ball into a yard, setting the dry grass on fire. The fire spread to a sawdust pile. Whether that is true or not, it is known that the fire started on Oldham Street behind Seagraves Planning Mill. It quickly spread, fanned by 60-mph winds. Flames and burning debris carried by the wind spread the fire quickly, overwhelming firefighters. Fire alarm boxes were rendered useless because electric and telegraph wires were burned from their poles. One fireman raced the flames to Bridge Avenue. Soon every piece of firefighting equipment in the city was in East Nashville. When the fire ended, thirty-two city blocks and 700 homes had been destroyed.

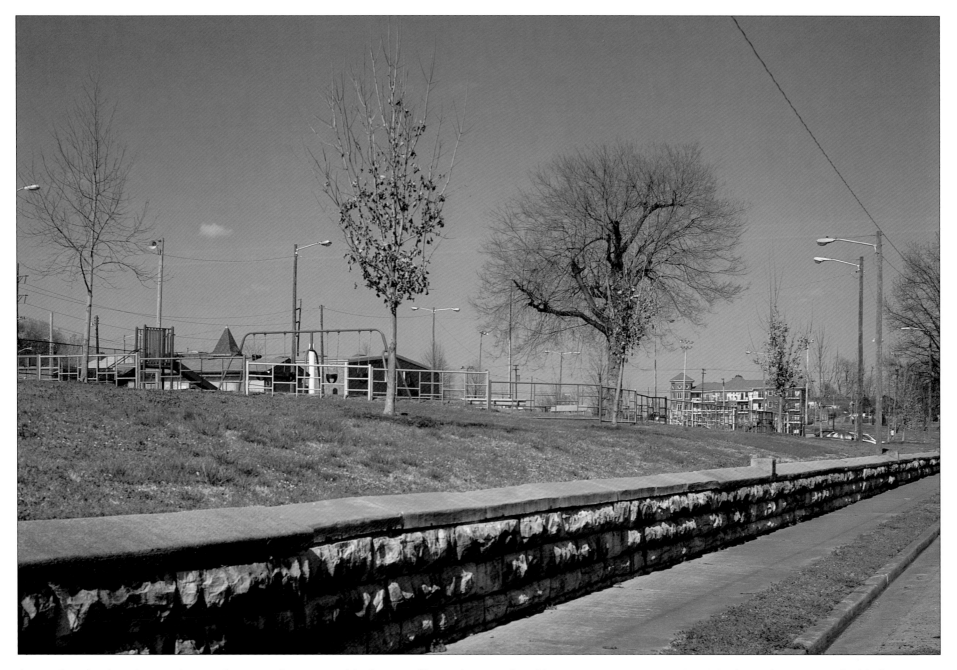

Soon after the fire, the city began clearing a four-square-block area of burned-out homes to create East Park. This was the first attempt by the park board to combine a school and a park project. Warner School had been destroyed, so a new school was built along with the park. Plans for East Park called for a Beaux Arts bandstand, flower gardens, fountains, and paved walkways radiating from the center. The park's bandstand stood until 1956 and was replaced by a community center. In 1960 the park's size was doubled in an urban renewal project. East Park is surrounded by the restored homes of Edgefield, a town that was incorporated into the city after the Civil War. This photograph was taken from the front lawn of Tulip Street Methodist Church.

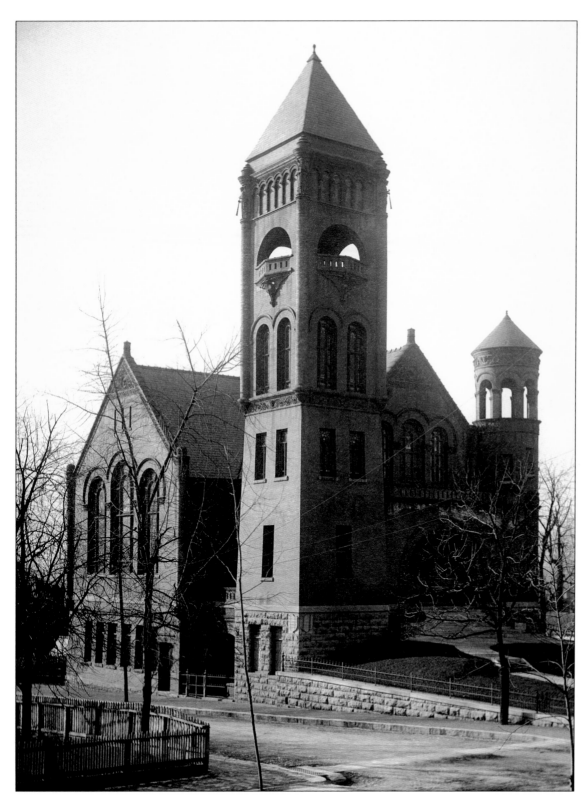

Tulip Street United Methodist Church was founded in 1859, but before the church building could be completed the Civil War reached the town of Edgefield. All the churches in Nashville were closed. The Tulip Street church was not used by the Union army but remained locked until the war's end. After the war ended the church was completed but was soon deemed too small for the growing congregation. A new church, seen here, was completed in 1892. The Richardson Romanesque–style building was designed by T. L. Dismukes and built by J. E. Woodward. The exterior is made of brick and trimmed with terra-cotta. In 1897 carillon chimes from the Tennessee Centennial Exposition were purchased and installed in the tall tower. In the fire of 1916, members left burning homes to form bucket brigades and saved the church.

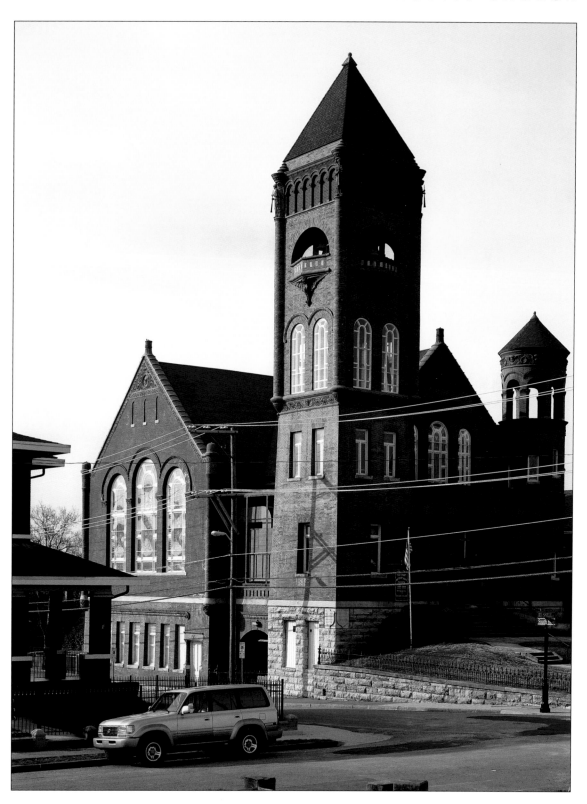

The church survived the 1916 fire and a tornado in 1933, but in April 1998 it fell victim to a tornado that tore through historic Edgefield and East Nashville. The east wall of the sanctuary was heavily damaged. Powerful winds ripped a hole fifty feet wide, taking out most of the solid brick wall. Volunteers from Grace United Methodist Church in Mt. Juliet, a community on the Davidson-Wilson county line, built scaffolding and covered the opening with tarpaulins. The following Sunday, sixty of the 174 members of the congregation attended services in the sanctuary. The night of the tornado, the chimes rang out "Amazing Grace" in the dark to reassure the community.

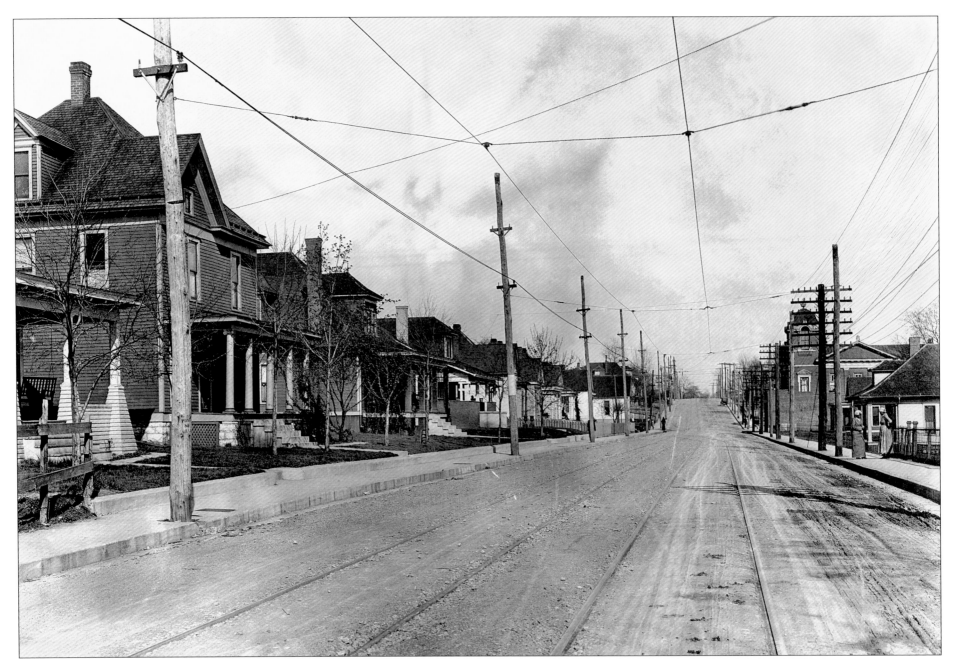

Fatherland was the name of a mansion that Dr. John Shelby built for one of his daughters in 1855. He also built a house for another daughter and named it Boscobel. Two streets were named for those homes: Boscobel and Fatherland streets, along with those named for the old East Nashville estates such as Shelby—named for Shelby Hall—and Woodland Street. This photograph of the 1600 block of Fatherland Street was taken in 1914 when the neighborhood was in its prime. The owners of the big estates had long ago moved across the river to the more fashionable West End.

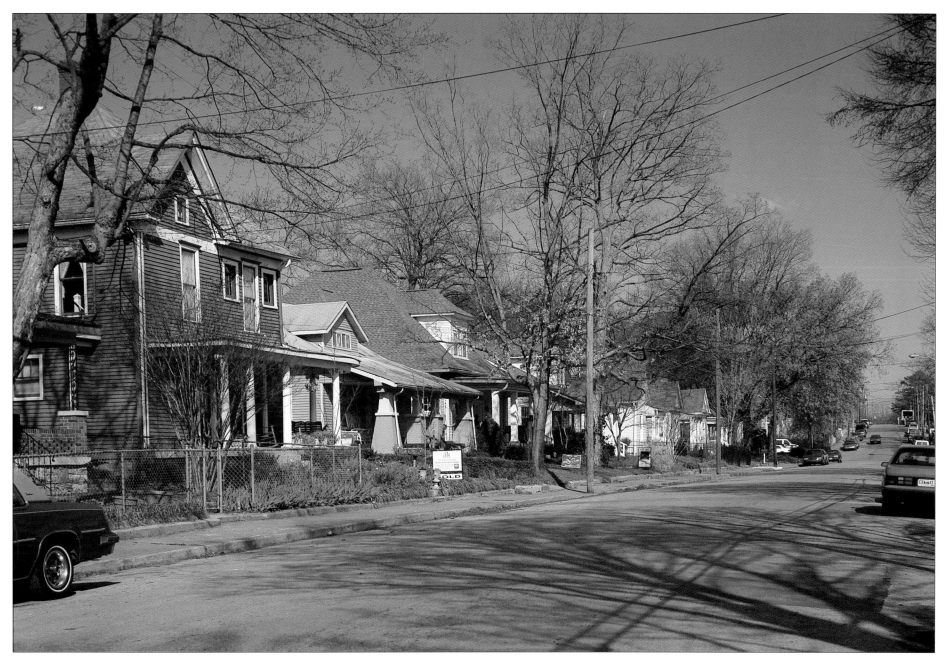

Fatherland Street began to change in the 1920s. Some of the two-story foursquares were replaced with smaller, bungalow-style box houses. After 1949, Fatherland Street and all of East Nashville began to decline at a fast rate. People were moving to new postwar subdivisions in Inglewood and Madison. Many of the homes on Fatherland Street and the other streets in East Nashville were being turned into rental properties and broken up into apartments. This part of East Nashville is now enjoying a rebirth as young families restore the old houses. It is now known as Historic East End.

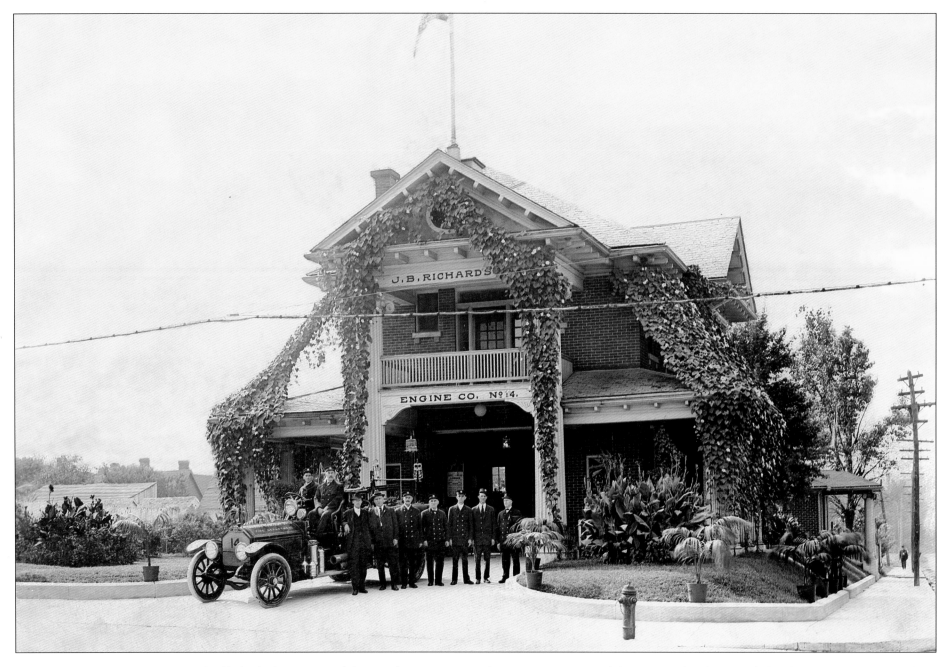

This was the first fire hall in Nashville built for motorized fire trucks. Designed to blend with the character of the neighborhood by Nashville's first city architect, James B. Yeaman, it went into service in October 1914. The residents of East Nashville purchased a small vacant lot next to the fire hall in 1921 and presented it to the city to be used as a park and playground. The fire engine was named for J. B. Richardson, a philanthropist and the president of United Charities of Nashville. The fire hall was the result of lobbying efforts by the Lockeland Springs Improvement League, a neighborhood organization. This photograph was taken in 1916.

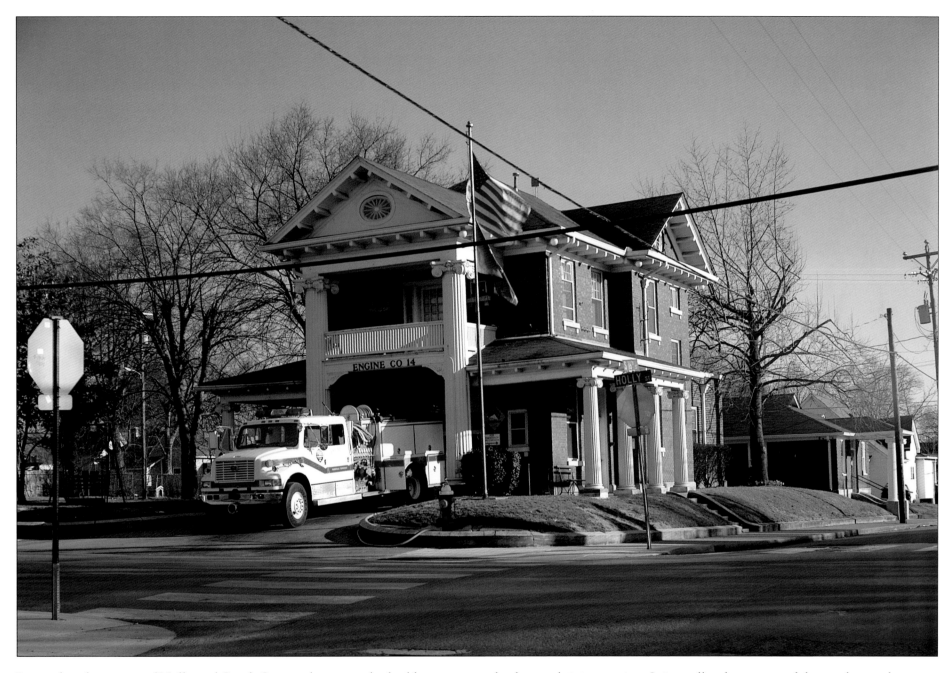

Located at the corner of Holly and South Sixteenth streets, the building is officially named Engine Company Number 14, but it is commonly referred to as the Holly Street Fire Hall. The city considered closing it in 1980; however, the neighbors had different ideas and petitioned to keep it open. The size of the fire truck is interesting. It is smaller than many of the trucks at other stations because a larger vehicle could not fit through a door designed for a 1916 fire truck. The Holly Street Fire Hall was added to the National Register of Historic Places in 1982.

This photograph was taken in 1914 from inside the entrance to Shelby Park on South Nineteenth Street at Lillian Street. Shelby Park was only two years old. The streets were unpaved, and the park entrance was a continuation of Lillian Street. The city bought 151 acres of land about three miles from downtown in 1909 and an additional eighty acres in 1911. The land had been the site of an amusement park that went bankrupt in 1903. Major E. C. Lewis designed the park with a lake and boathouse, a working Dutch windmill, a Spanish Colonial Revival–style rest house, and a baseball field. The YMCA formed the first city park baseball league in 1915 at Shelby Park. The city would later purchase an additional fifty acres of land and open Nashville's first municipal golf course in 1927.

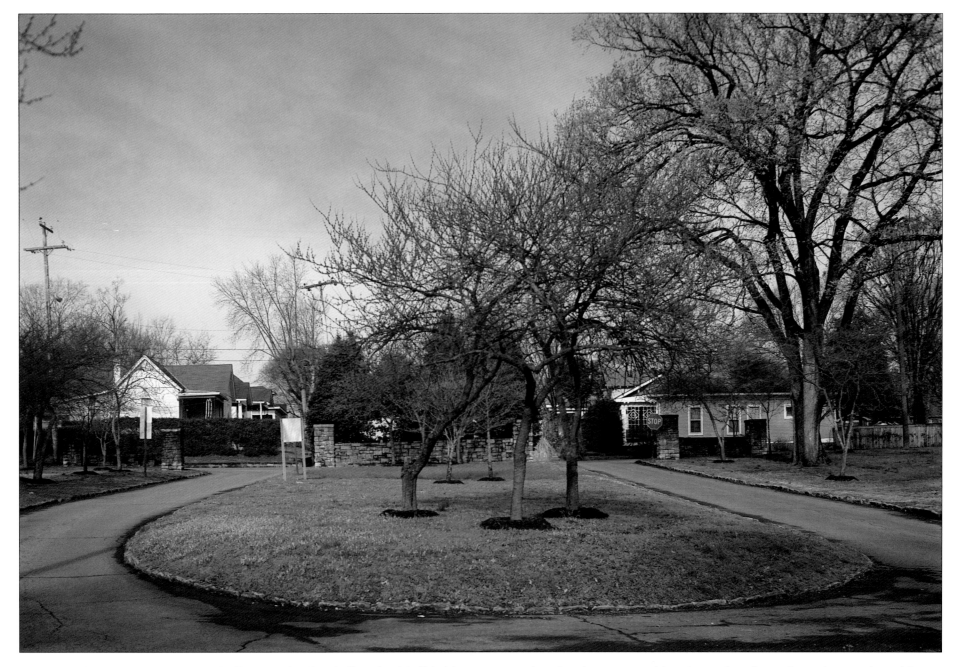

Shelby Park, named for Dr. John Shelby, now has baseball and softball fields as well as tennis courts, a community center, picnic shelters, two playgrounds, and the original golf course and lake. The latest addition is a nature park, Shelby Bottoms, along three miles of the Cumberland River. Shelby Bottoms opened in October 1997 and has five miles of paved, winding trails and five miles of hiking trails on 810 acres of natural wetland. The main entrance to Shelby Park on South Nineteenth Street at the end of Lillian Street is a landscaped double entrance that was built around 1915.

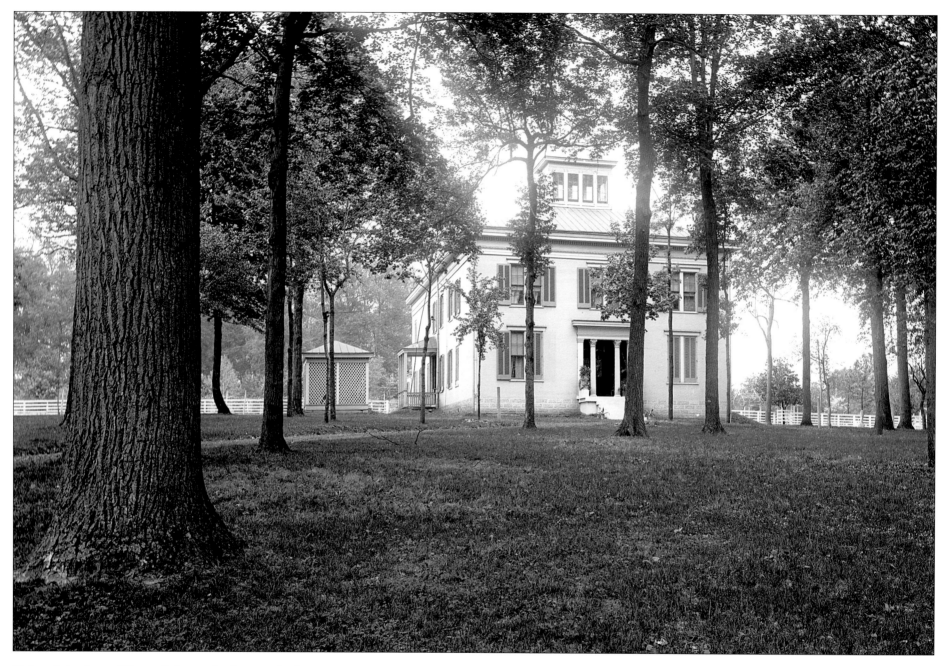

Colonel Anthony Wayne Johnson built Bransford House in 1854 on 300 acres along Gallatin Pike in East Nashville. He named the estate Edgewood. A Confederate, Colonel Johnson was imprisoned during the Civil War and released in 1863. Soon after the war ended, his daughter Mary married Major John S. Bransford. Colonel Johnson gave Edgewood to Mary and John Bransford in 1872, the year their son, Johnson Bransford, was born.

In 1907 Johnson and Annie Mary Bransford inherited the Bransford home; however, it was still referred to as the "Major Bransford place." Johnson Bransford had a successful real-estate business selling suburban homes in East Nashville and West End. In 1914 Bransford subdivided Edgewood and eventually he sold the house. This photo was taken before 1933, when a tornado destroyed the cupola.

The only evidence that Edgewood ever existed on this site is a portion of a concrete retaining wall with an elaborate corner decoration. Through the years the house fell into a state of disrepair; for a while it was used as a church. North Twelfth Street is part of the original carriageway that ran in front of the house. The house was razed in 1962 and replaced with this apartment building. Before the house came down, descendants of Major Bransford walked through the big empty rooms and shared childhood accounts of the once-elegant home.

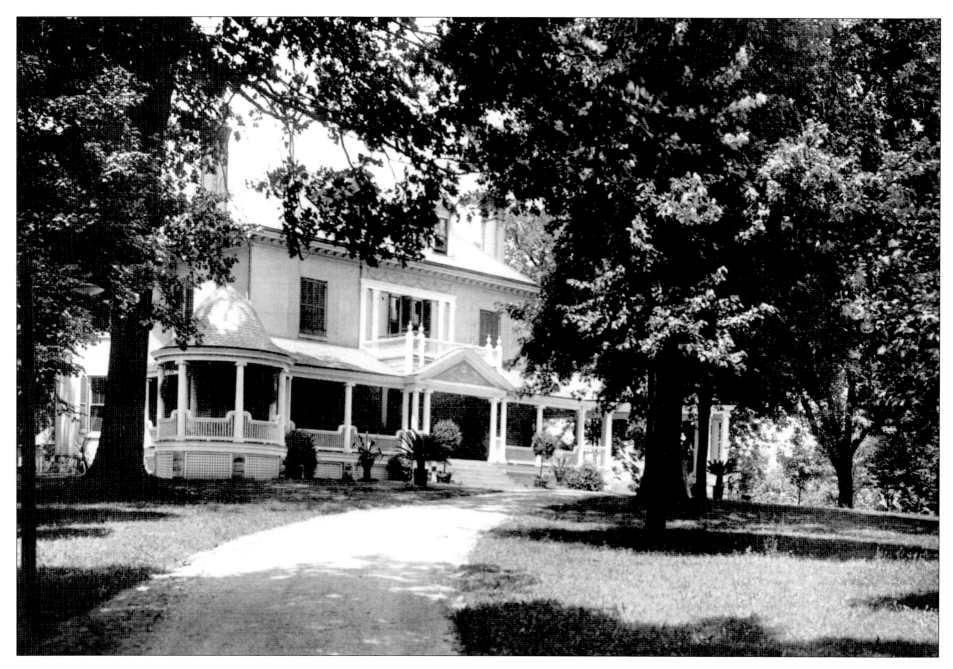

Zechariah Stull built a log cabin on land along Gallatin Pike given to him in a Revolutionary War grant. In 1855 he built this house for his granddaughter, Mary Ann Childress. Around 1886 James Warner, one of the founders of the Tennessee Coal, Iron and Railroad Company, bought the house. When he died in 1895 the house went to his son, Percy Warner. The name Renraw is Warner spelled backward. Percy Warner headed the Nashville Railway and Light Company from 1903 to 1913 and also served on the Nashville Park Board. Percy Warner Park is named in his honor. Percy Warner sold Renraw in 1912 and moved to Royal Oaks on Harding Road in Belle Meade.

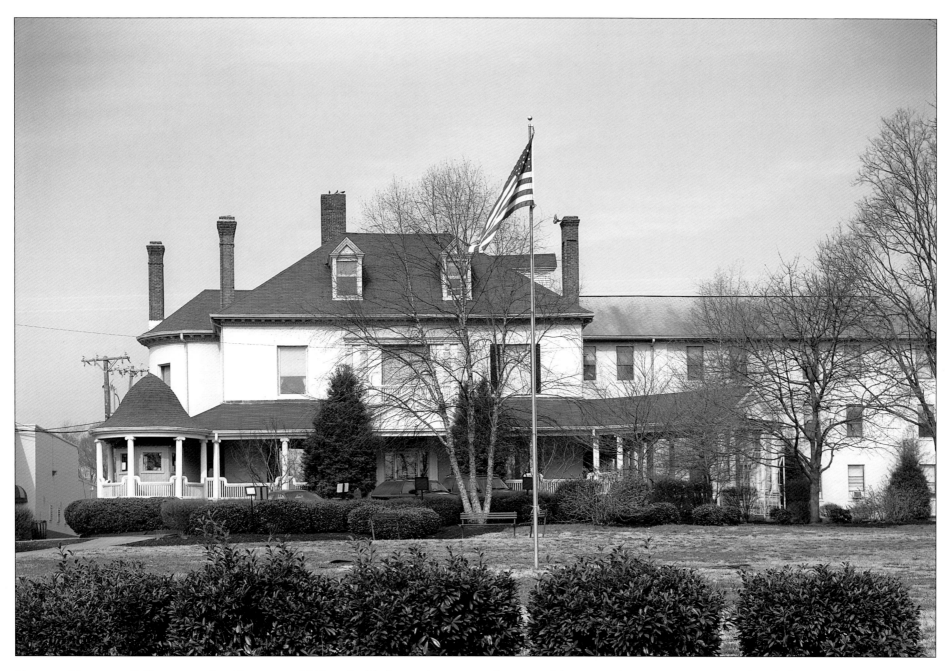

Trevecca Nazarene College moved to Renraw in 1918 and added a residence hall to the back of the house, seen in this picture. Trevecca suffered financially during the Depression and moved to the Nazarene Church on Woodland Street. The house is now the administration building for the Nashville Auto-Diesel College (NADC). The school has maintained the elegance of the original interior. NADC was founded in Nashville in 1919 and has occupied this campus since just after 1930. Automotive technicians from all fifty states in the country and from sixty-two foreign countries have graduated from NADC. The campus covers several acres of classrooms, garages, dormitories, and cafeterias.

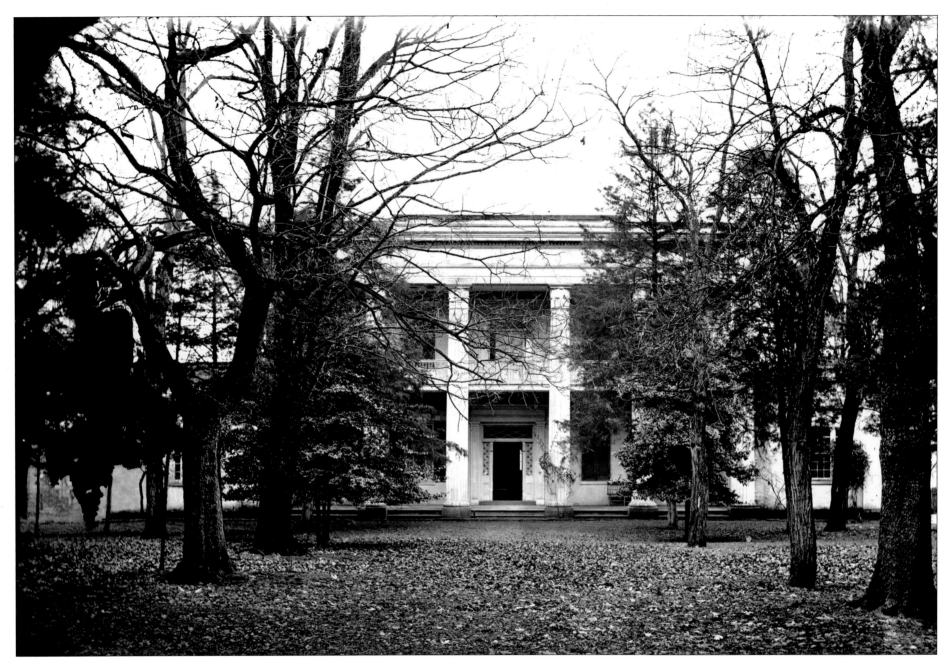

Andrew Jackson bought 425 acres, eleven miles east of Nashville in 1804 and lived with his wife, Rachel, in a simple log house. In 1819 work began on the house seen here. It was built of bricks made on the property by slaves and was completed around 1821. At first, it was a simple Federal-style house but was expanded by the addition of wings on each side for a library and a dining room. A one-story colonnade of ten columns and a two-story pediment created a Palladian-style facade. In 1834, fire nearly destroyed the house. The upper level was burned and the ground level was seriously damaged. The house was rebuilt in 1836 in the popular Greek Revival style. The Hermitage was a working plantation whose chief cash crop was cotton, but food was grown for the family and for the slaves, who numbered 140 around 1840.

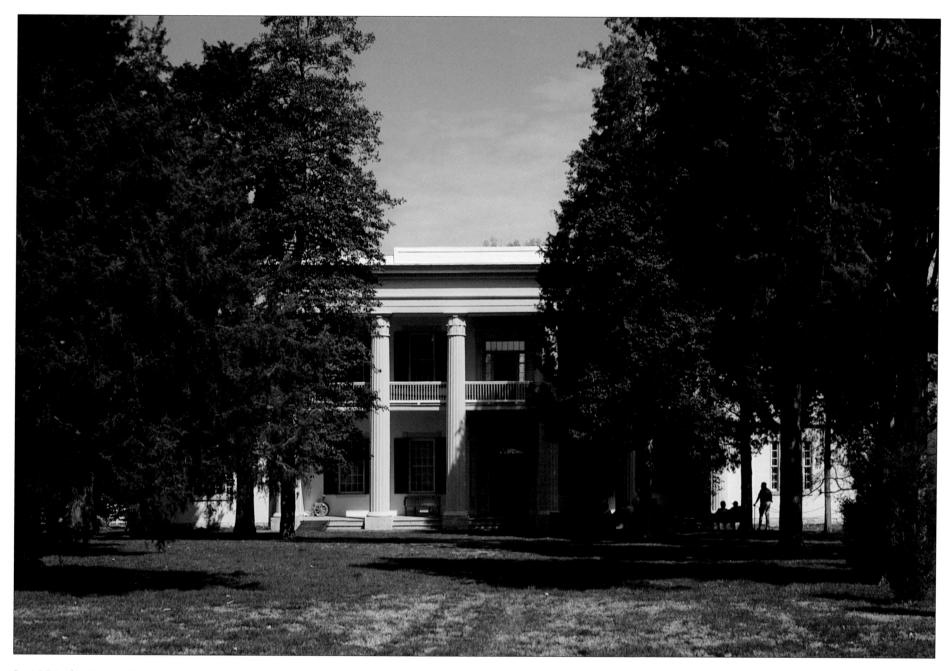

In 1856, the State of Tennessee bought the Hermitage from Andrew Jackson Jr., a nephew of Rachel Jackson's who was adopted by Andrew and Rachel in 1809. Rachel Jackson's garden, designed by English gardener William Frost in 1819, is maintained today in its original location. Several outbuildings have been re-created in their original locations as determined by historians. Many of the cedar trees that Jackson planted in 1837 along the driveway from the front gate were destroyed by a tornado in 1998.

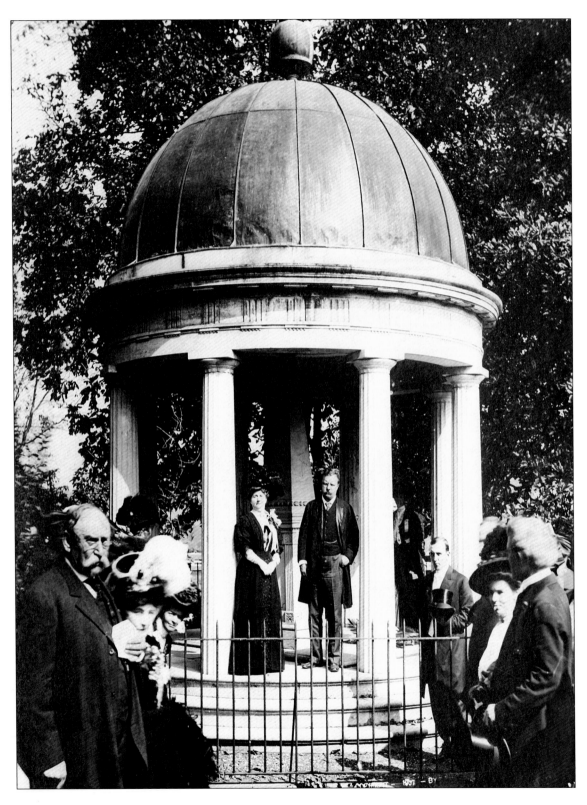

This photograph was taken in 1907 when President Theodore Roosevelt visited the Hermitage to pay his respects to the seventh president of the United States, Andrew Jackson, and his wife, Rachel. The love Andrew and Rachel Jackson shared is legendary. The presidential campaign in 1828 had been especially difficult for Rachel, who fell ill five days before they were scheduled to leave for Washington, D.C. On the eve of their departure, December 22, 1828, Rachel Jackson died. She was buried in her garden on the Hermitage grounds. Andrew commissioned this Greek-inspired monument, which was completed in 1831. Andrew Jackson died in 1845 at the age of seventy-eight and was buried beside Rachel in the garden.

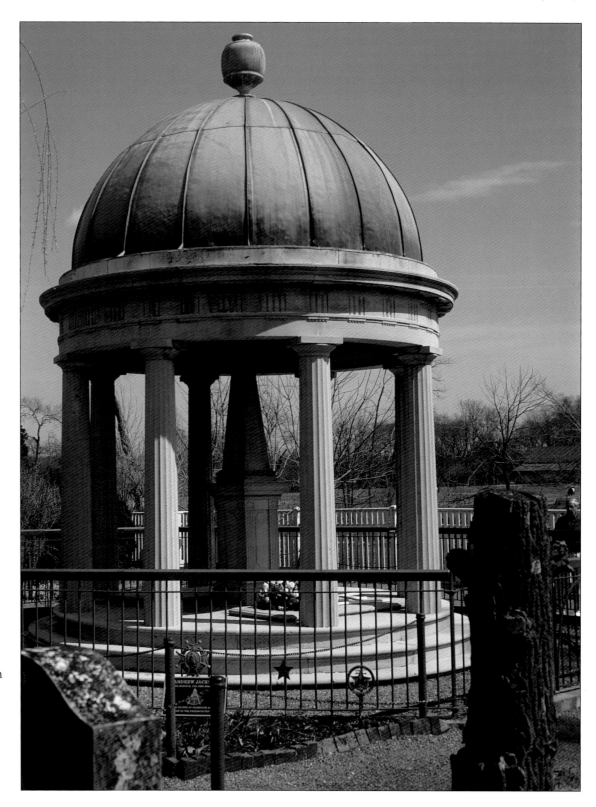

Thousands of visitors tour the Hermitage each year, and most walk the brick pathways of the well-tended garden. The Jackson tomb is in the southeast corner of the garden, next to gravestones of the rest of the Jackson family. One small gravestone is on the opposite side of the monument. This is the burial site of Alfred Jackson, who was born a slave at the Hermitage and as a boy tended horses and farm equipment. After emancipation, he remained at the Hermitage as a tenant farmer. He died in 1901, having lived at the Hermitage longer than anyone else.

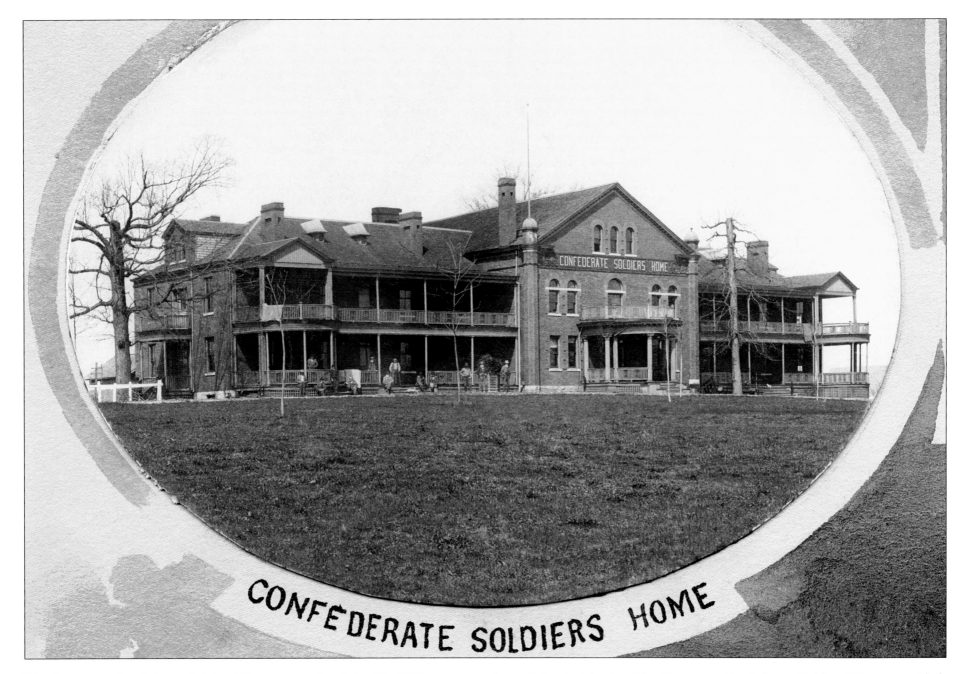

CONFEDERATE SOLDIERS HOME

The Tennessee Confederate Soldiers' Home opened on May 12, 1892, to provide a home for indigent and disabled Confederate veterans. It was at first proposed that the Hermitage itself be used, but instead it was built on Hermitage property south of the mansion. When it opened, it housed 125 veterans. The center section was used for dining and relaxation and the wings housed the dormitories. The Tennessee Confederate Soldiers' Home provided shelter and medical treatment for 700 men during its forty-one years of service. A Confederate cemetery was established in the north yard of the Hermitage Church on Lebanon Pike, located south of the home.

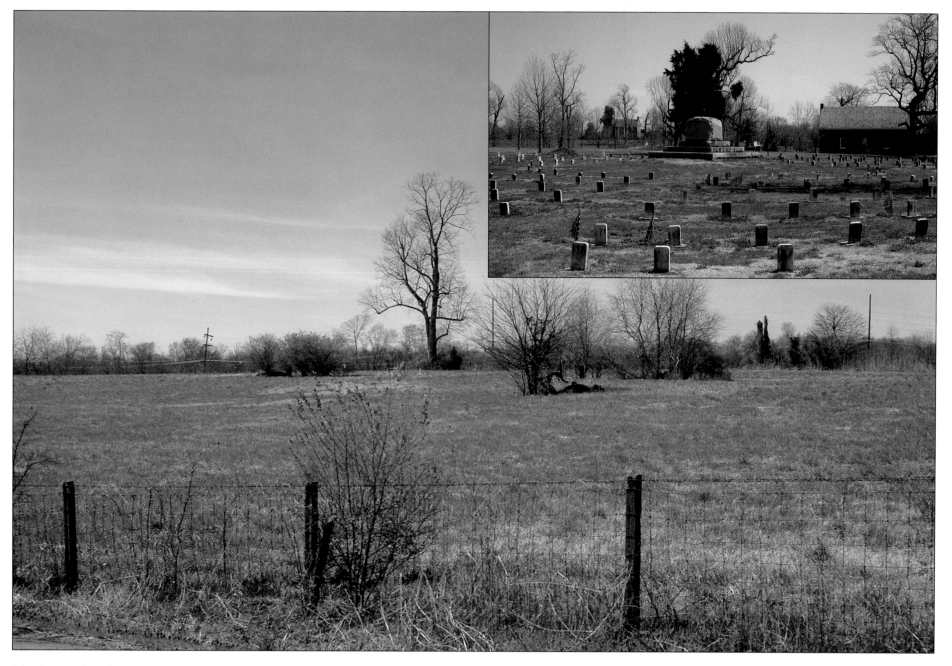

The home closed on November 22, 1933, and the last three residents were moved to a dormitory at the Tennessee Industrial School. The last veteran died in 1941. Most of the veterans were buried in the cemetery at the Hermitage Church (see inset). The graves are laid out around a central monument with walkways radiating to the corners, forming a Saint Andrew's cross—the shape of the cross on the Confederate flag. When the home was demolished, it was razed completely so that no one would know exactly where it stood. Archaeologists have so far been unable to locate the building's footprint. One small brick outbuilding, obscured by trees and underbrush, is the only evidence that the home was located in this hay field.

INDEX